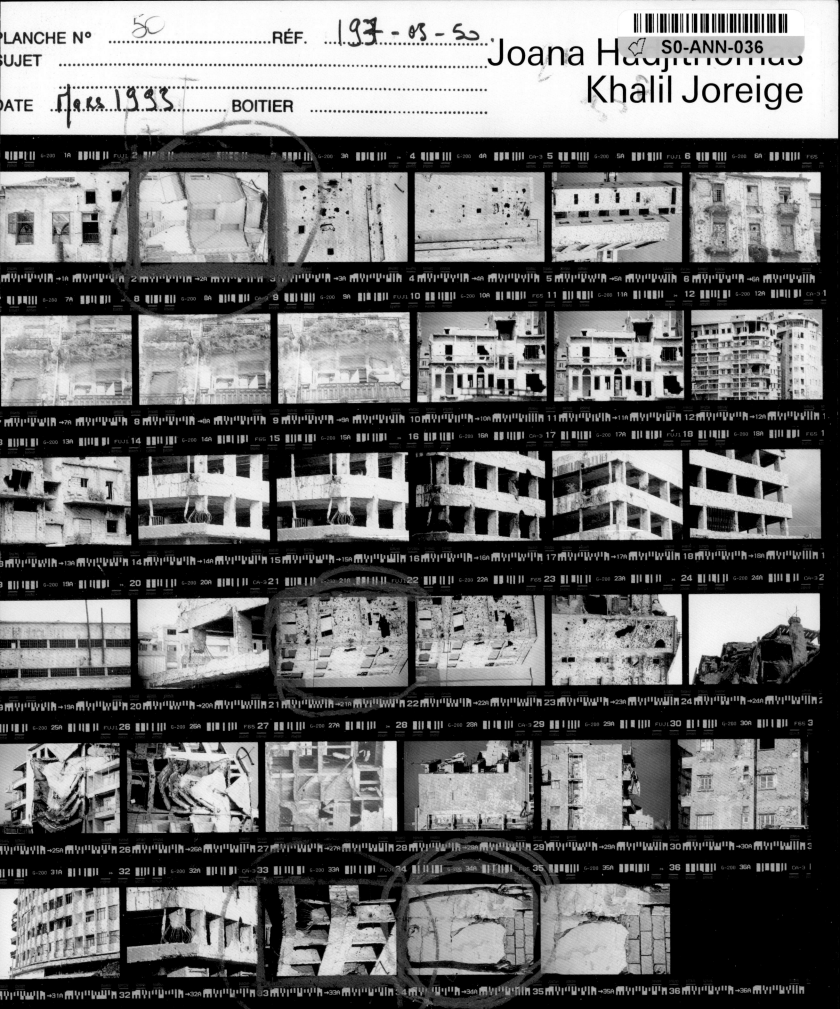

PLANCHE N°50....................... RÉF. ...197-03-50...

SUJET

DATE ...Mars 1993.... BOITIER

Joana Hadjithomas
Khalil Joreige

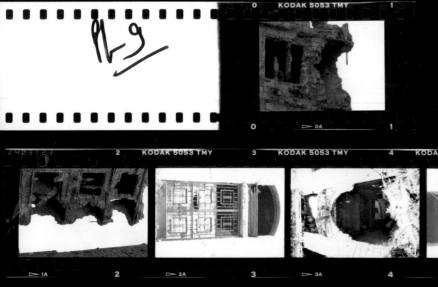
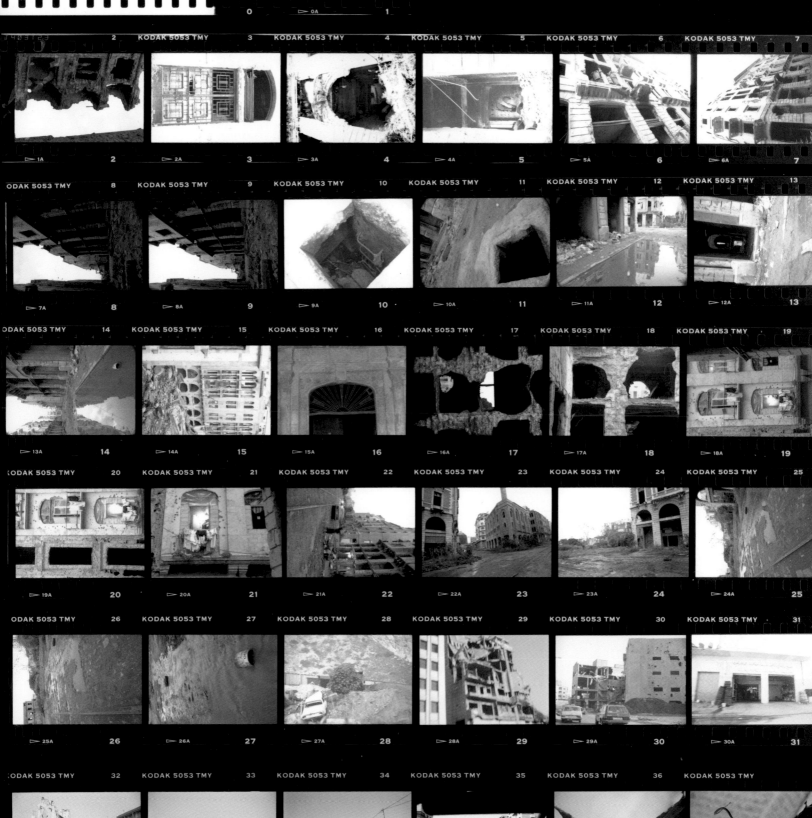

Table of Contents

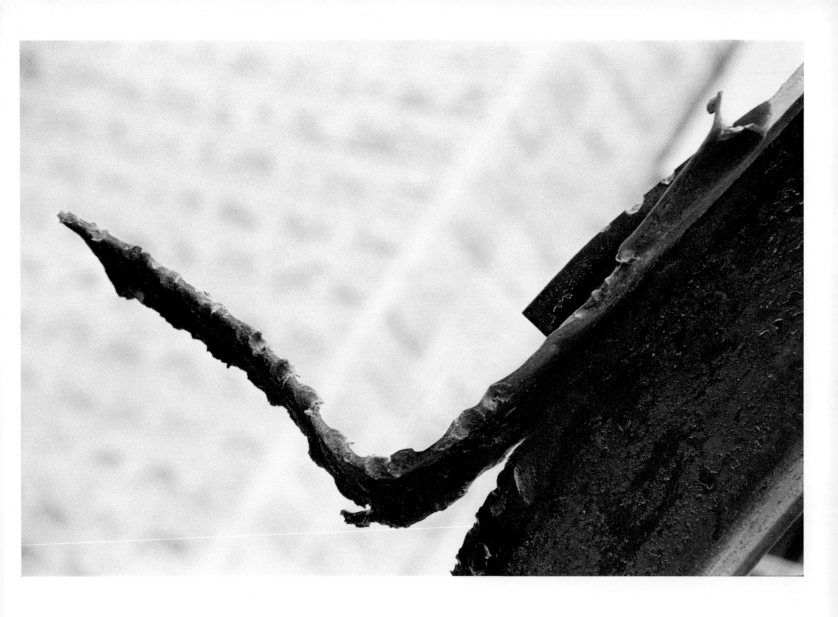

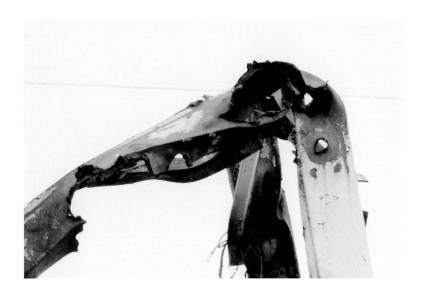

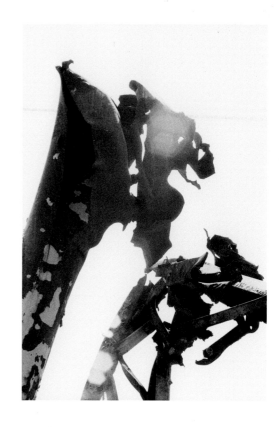

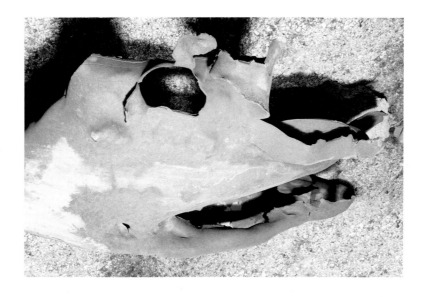

Bestiaries, 1997

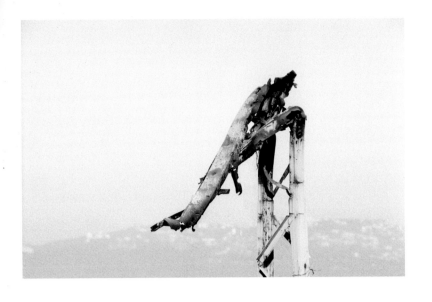

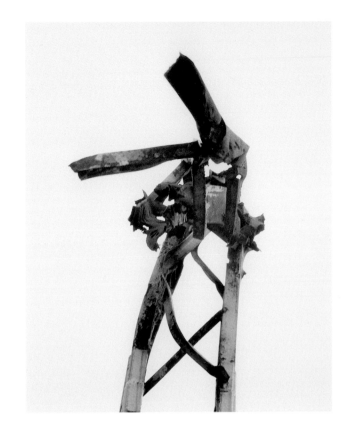

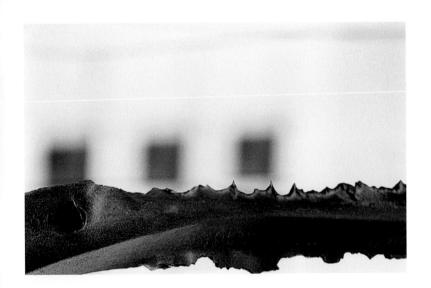

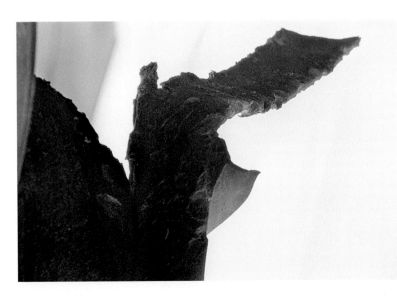

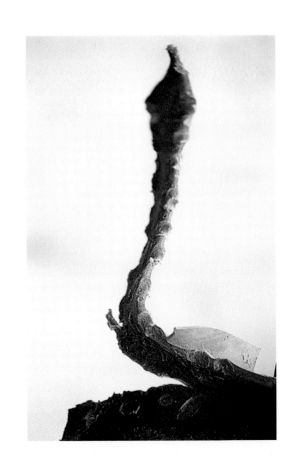

Equivalences, 1997

Equivalences, 1997

Equivalences, 1997

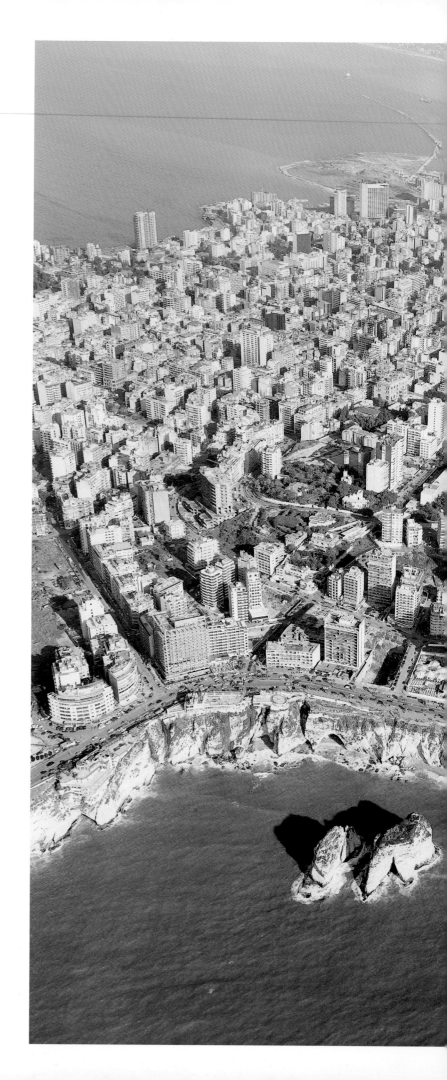

The Circle of Confusion, 1997

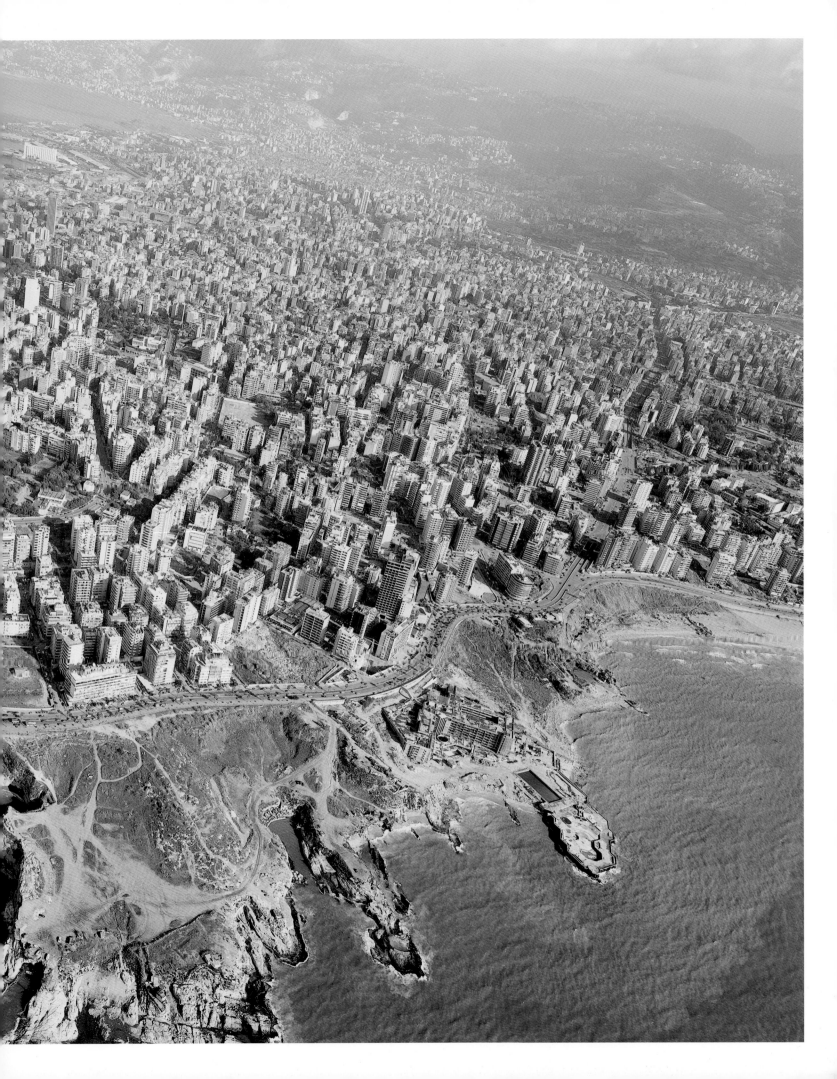

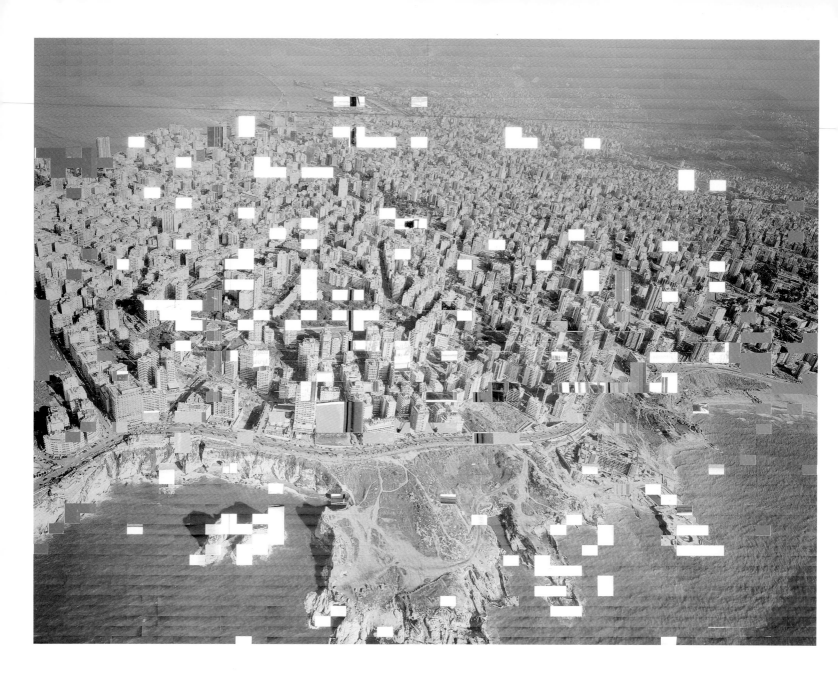

The Circle of Confusion, 1997

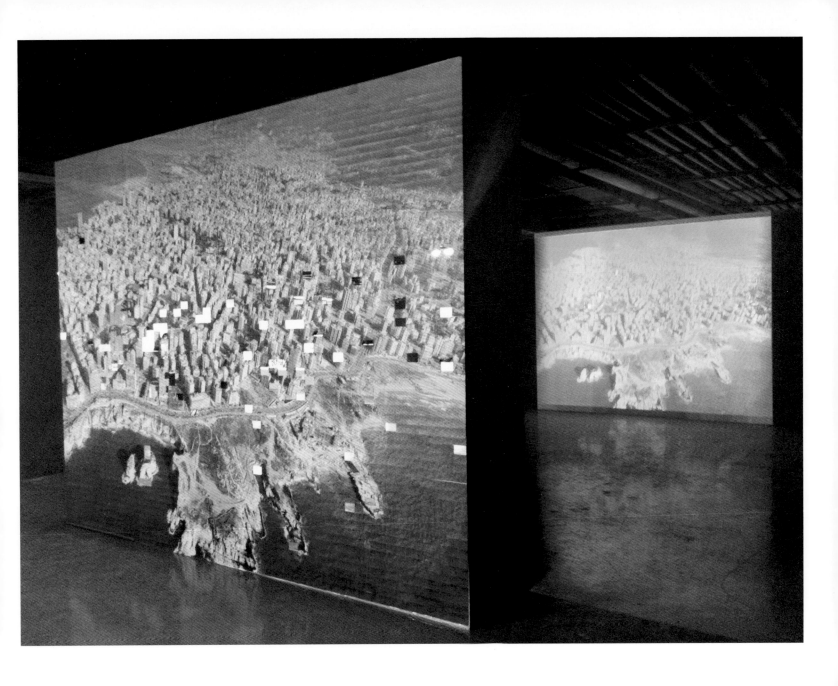

The Circle of Confusion, 1997; *A History of The Circle of Confusion*, 2009

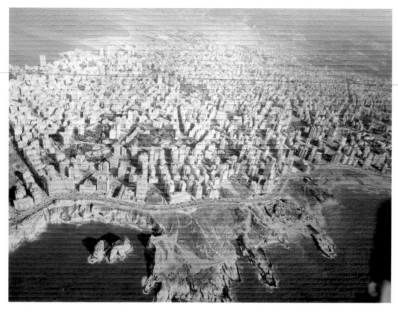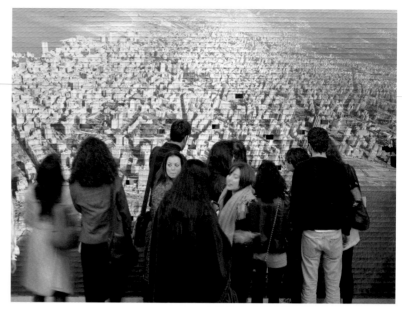
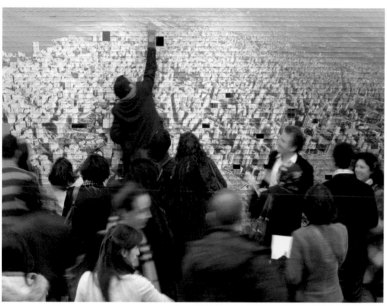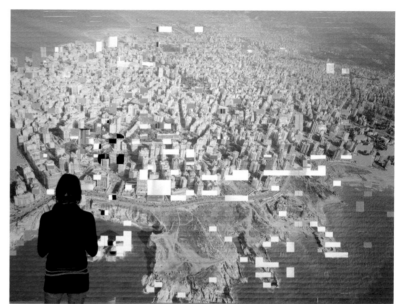
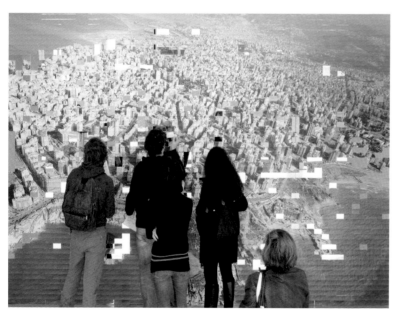

A History of The Circle of Confusion, 2009

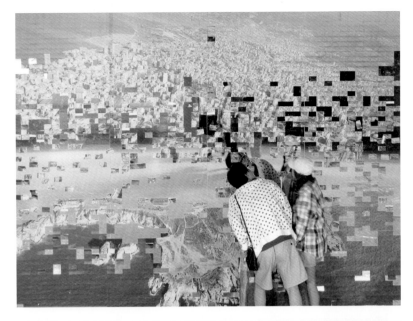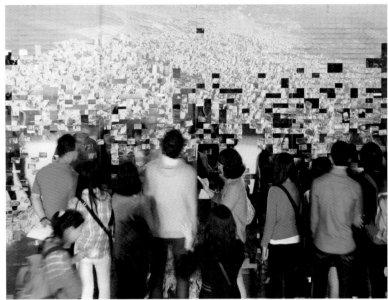

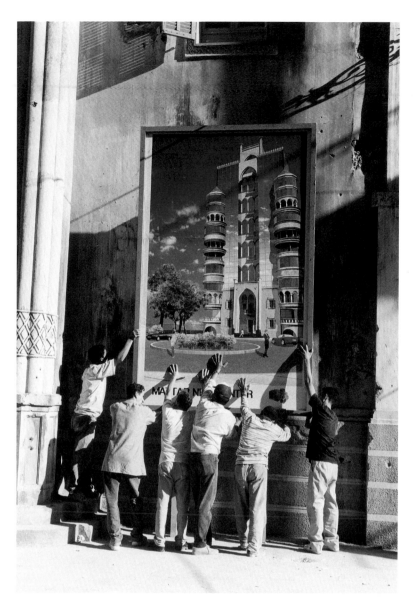

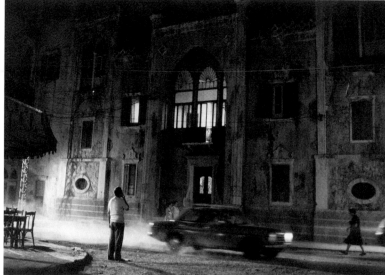

Film

Al bayet al zaher 1999
 92 min

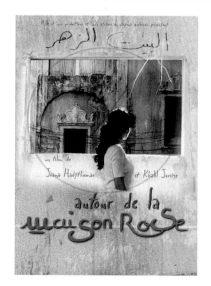

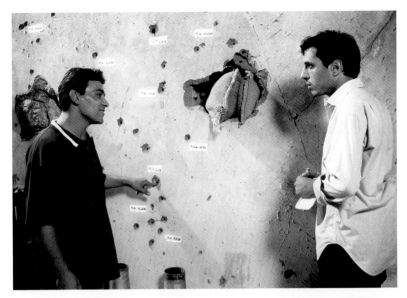

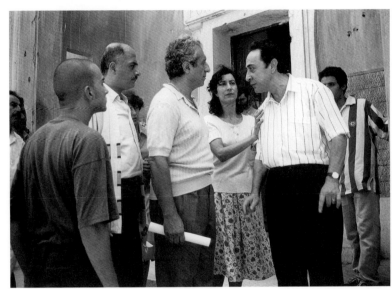

Making of

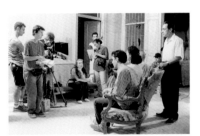

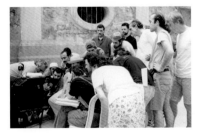

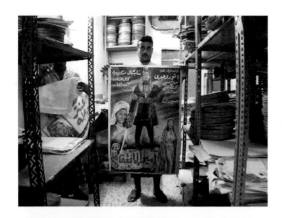 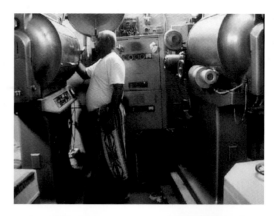

 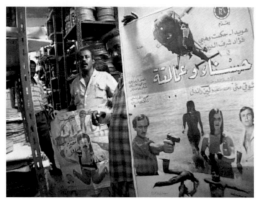

Film

El film el mafkoud 2003
 42 min

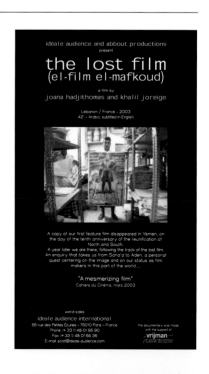

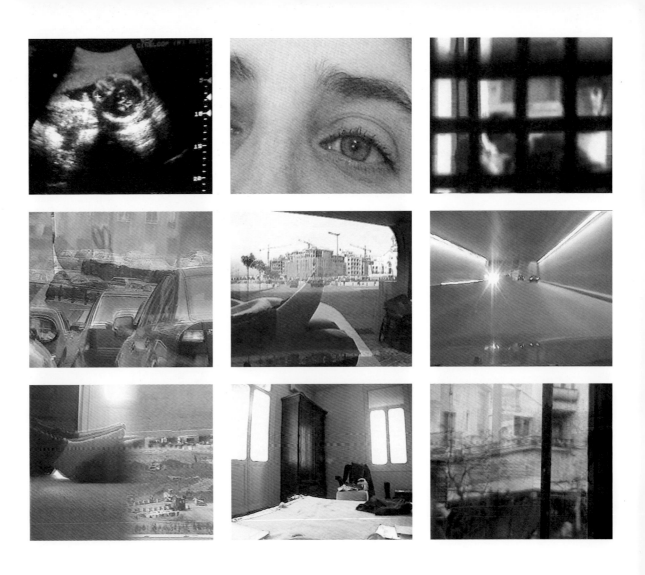

Film

Don't Walk

2000–2004
17 min

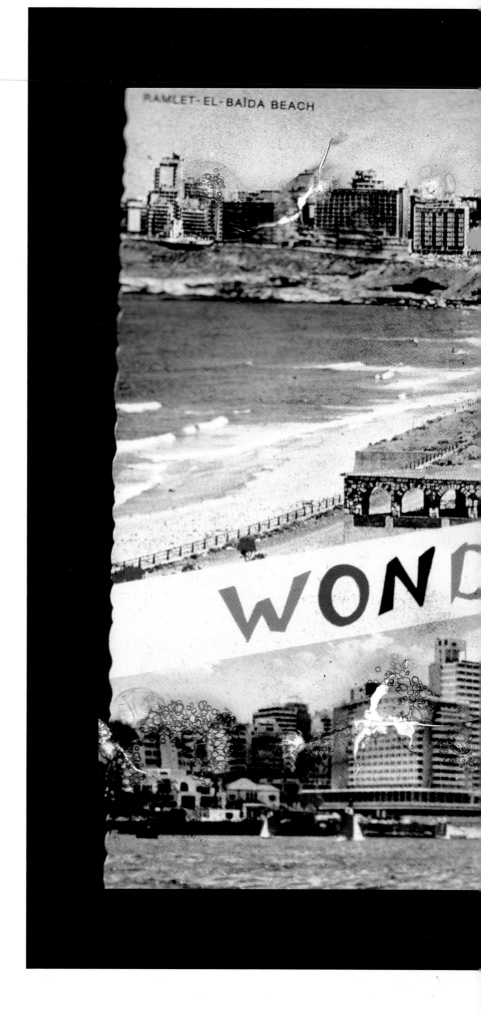

Wonder Beirut, 1997–2006

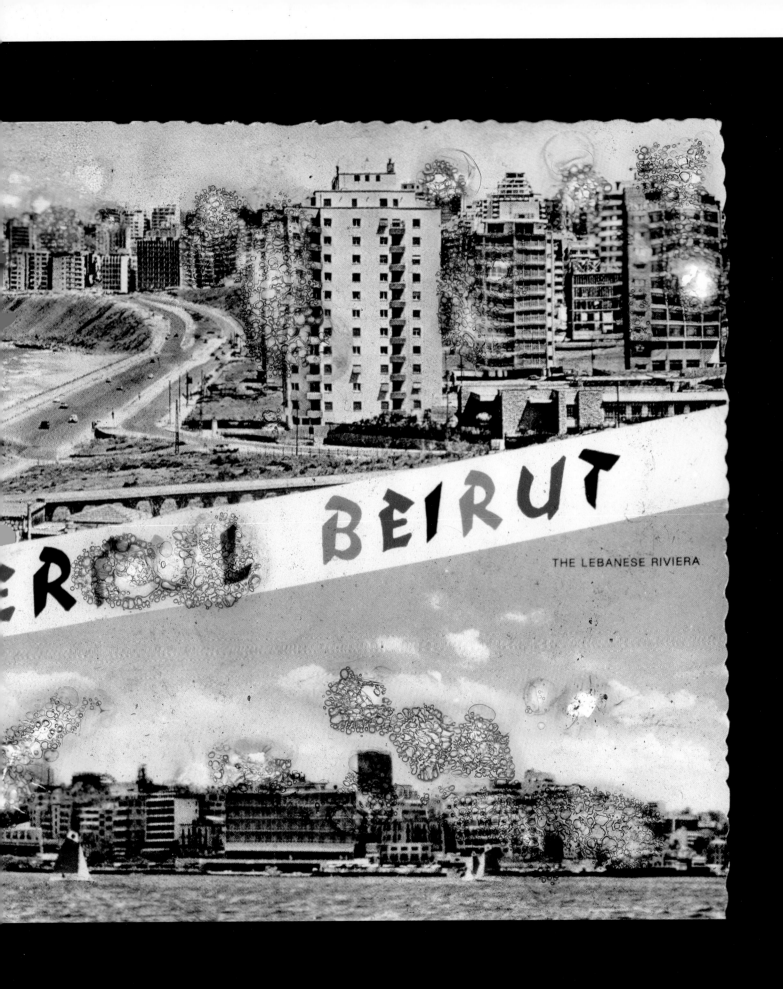

BEIRUT

THE LEBANESE RIVIERA

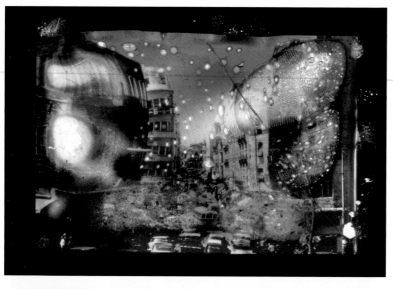
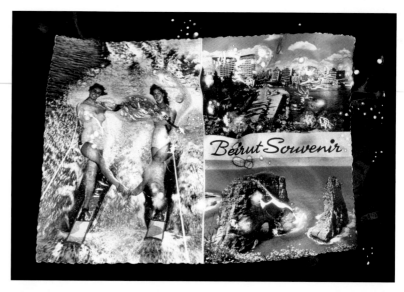
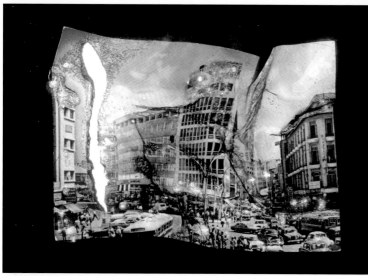
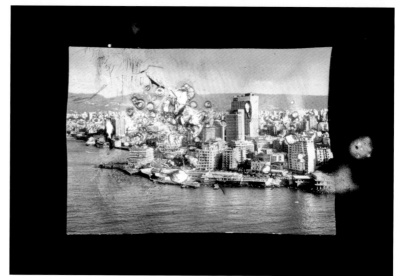
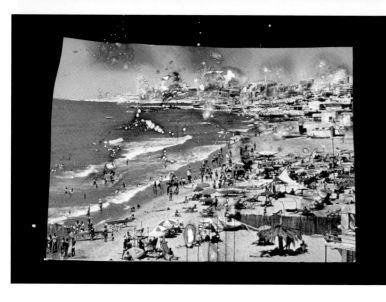
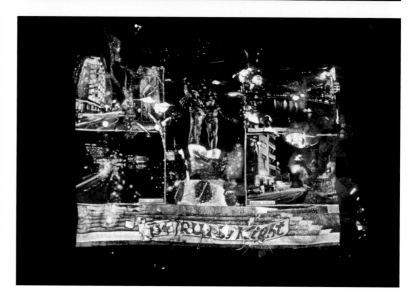

The Story of a Pyromaniac Photographer, 1997–2006

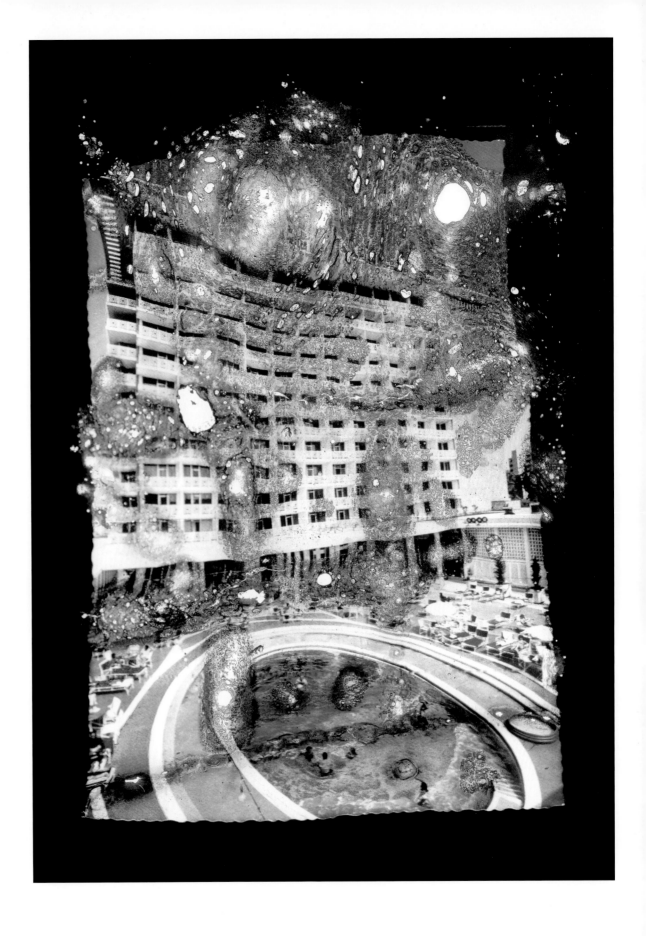

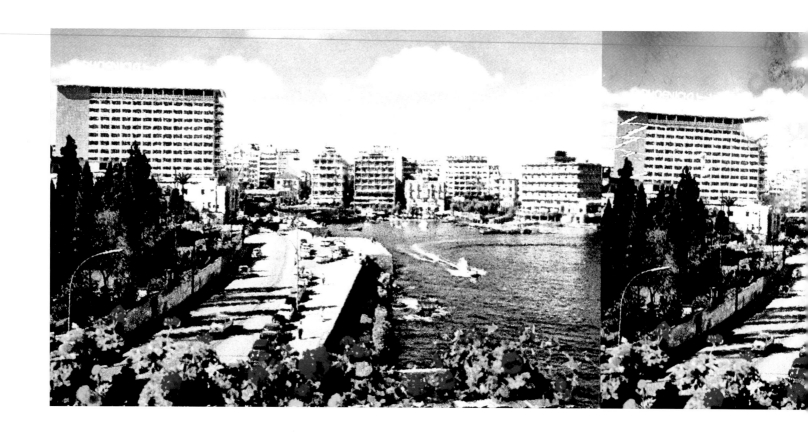

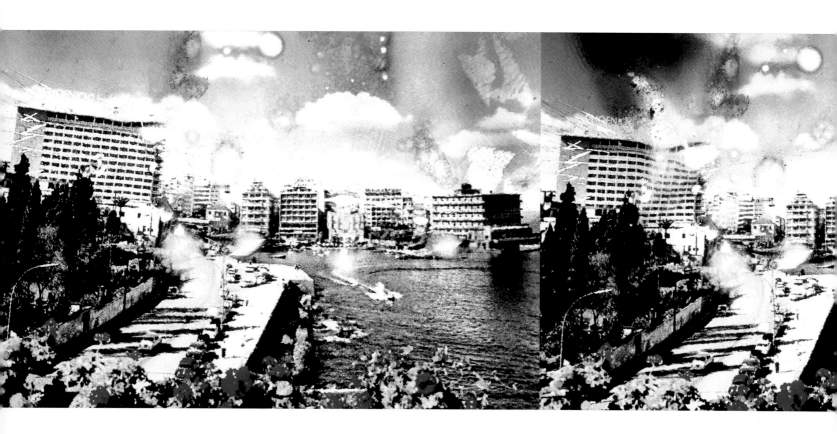

The Story of a Pyromaniac Photographer, Historical Process, 1997–2006

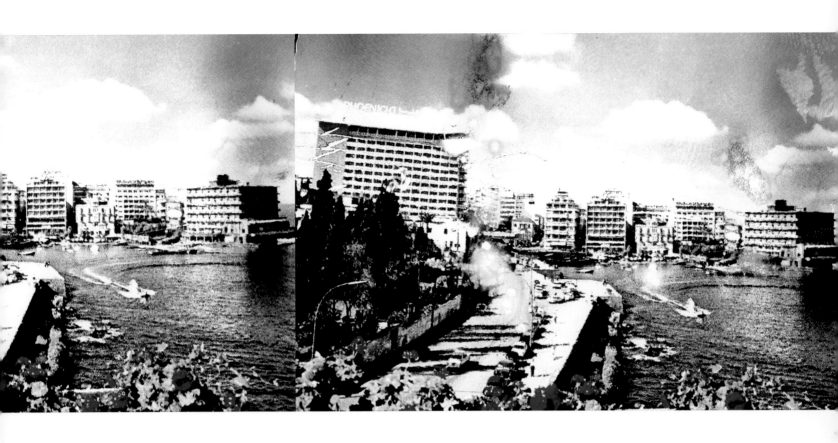

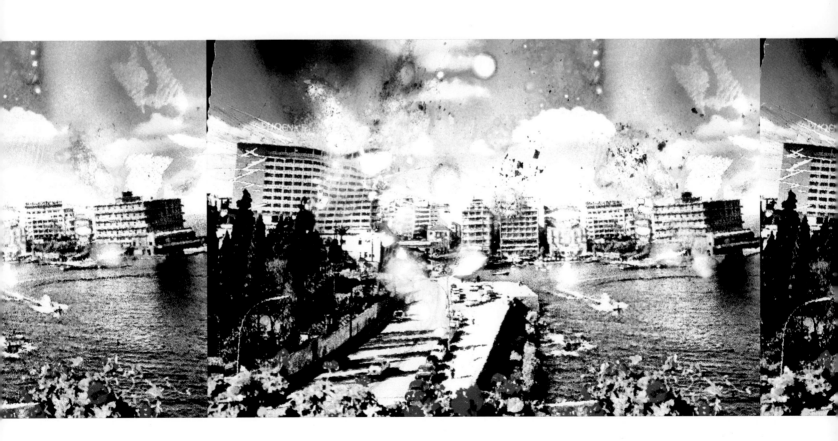

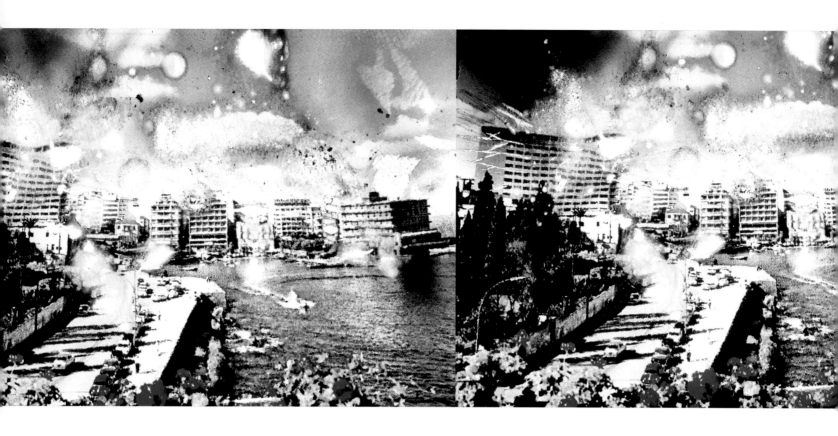

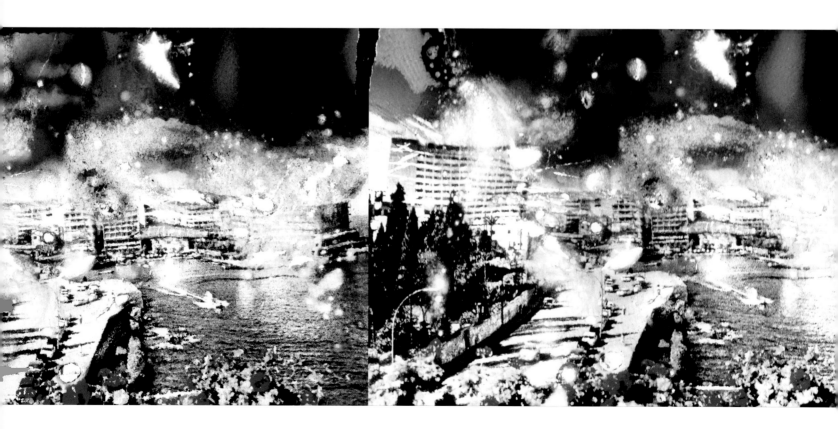

The Story of a Pyromaniac Photographer, Historical Process, 1997–2006

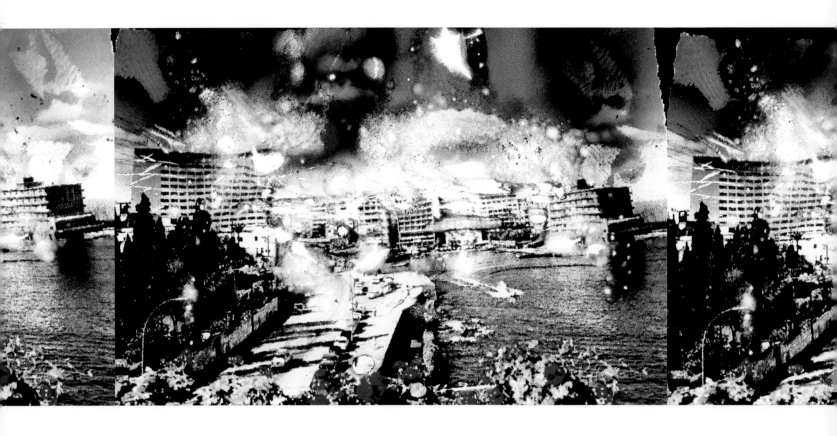

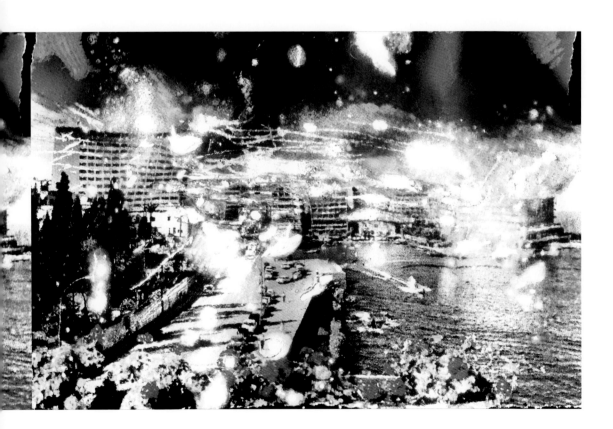

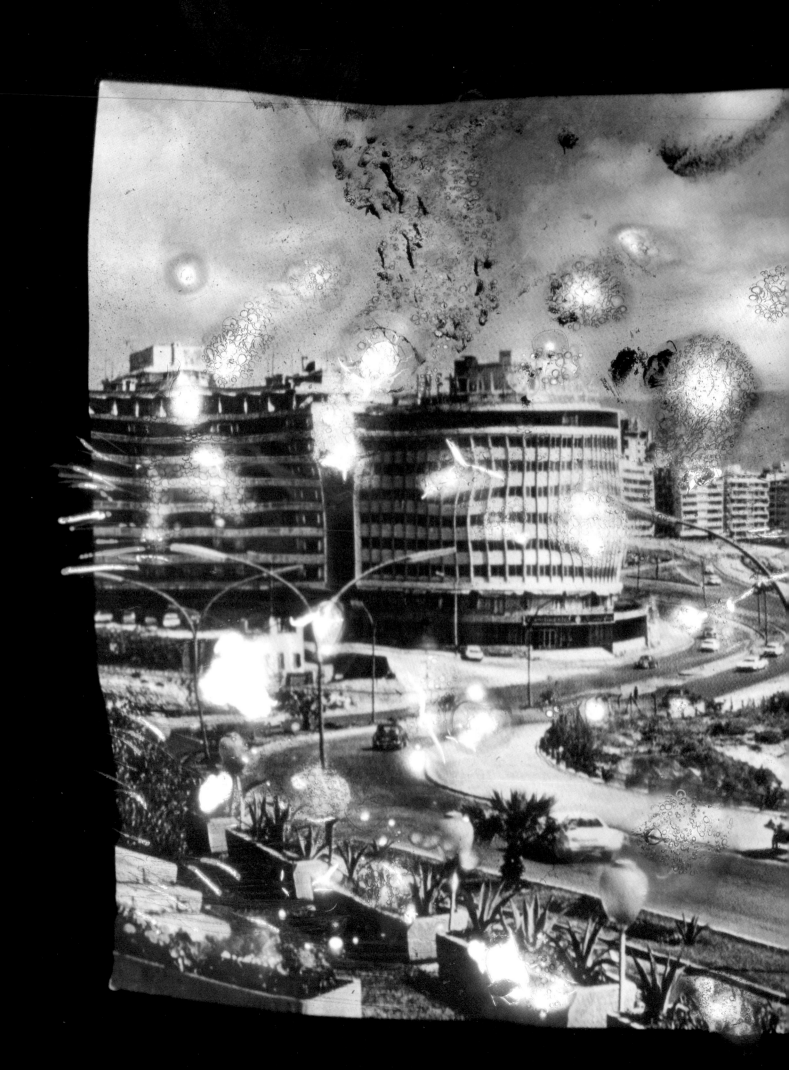

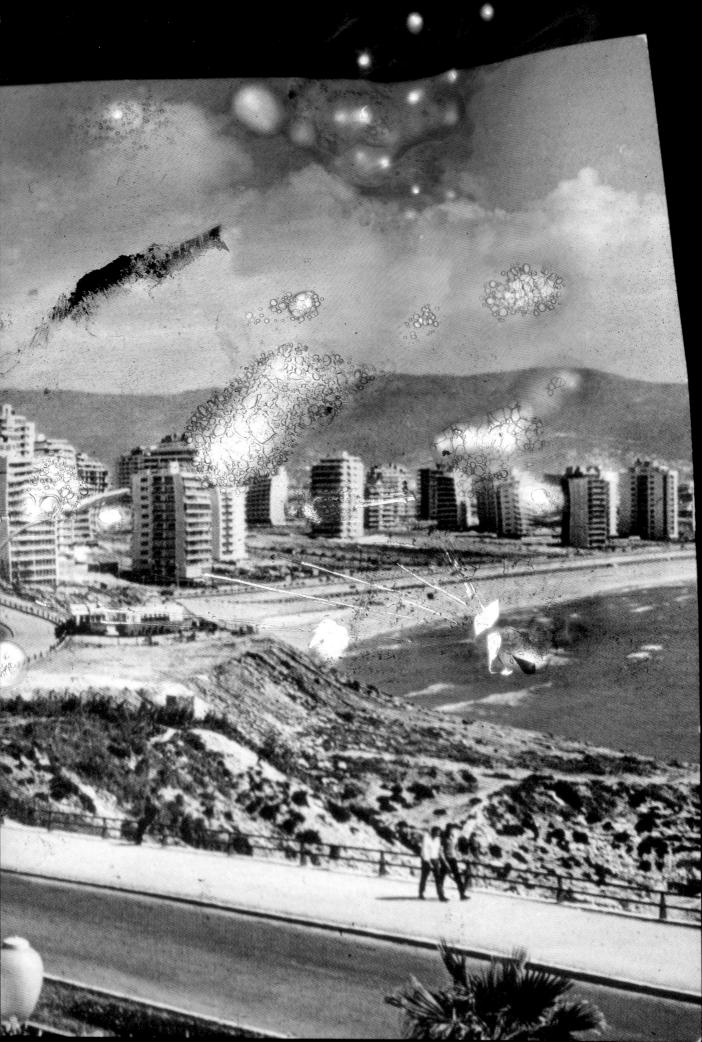

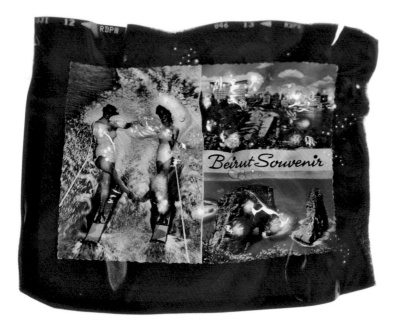

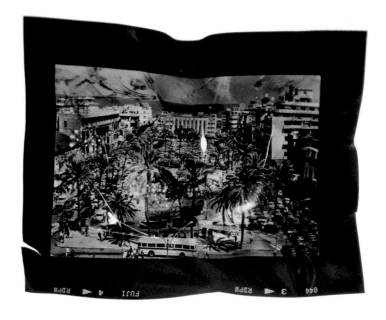

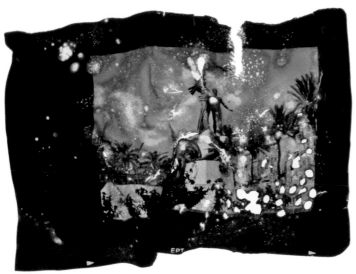

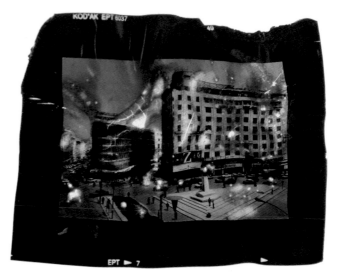

The Story of a Pyromaniac Photographer, 1997–2006

Post card of war # 18/18. Based on:
Beirut Great Hotels Quarter

From:
WONDER BEIRUT
The story of a pyromaniac photographer
by **Joana Hadjithomas** and **Khalil Joreige**

عزيزنا عبد الله،
نأمل أن تكون جيداً وان حياتك سعيدة.
لقد أنجزنا أخيراً مشروع شراكتاب حول صورك الكامنة.
وطلب منك أن تختار صوراً يمكن عرضها. هل يمكنك
أن تبقي بيدع كلمات النهج الذي سلكته تدريجياً
لكي تقرر منذ سنوات، وعدم تظهير قسم من الصور التي
واصلت التقاطها وطمسها في دفاترك الصغيرة.
بالنسبة إلينا سيكون هذا .مع نبيلة من بين الآلاف التي صورتها.
فوتوغرافية تدونها وتصف فيها الكتاب جزءاً من يومياتك
والبعض من أعمالك الفوتوغرافية فيها والأخبار الخيرة عنى
لبنان المعاصرة .ببدو لنا من المهم أن نعرض هذه القصة
في نتيجة مشروع "وندر بيروت" سيرة مصور مهدوس بالنار ربما
وأني حي جمعوعاة من مجموعة بطاقاتك البريدية.
نأمل أن تشاركنا الحماس وأن نلتقي
قريباً.
هوانا وخليل.

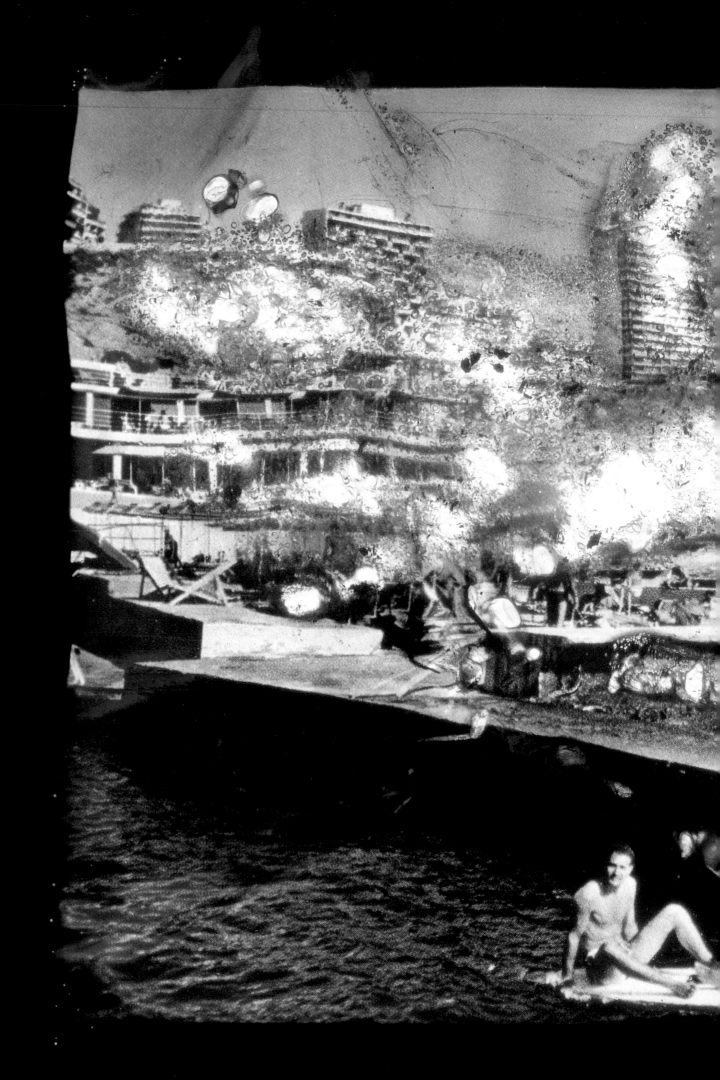

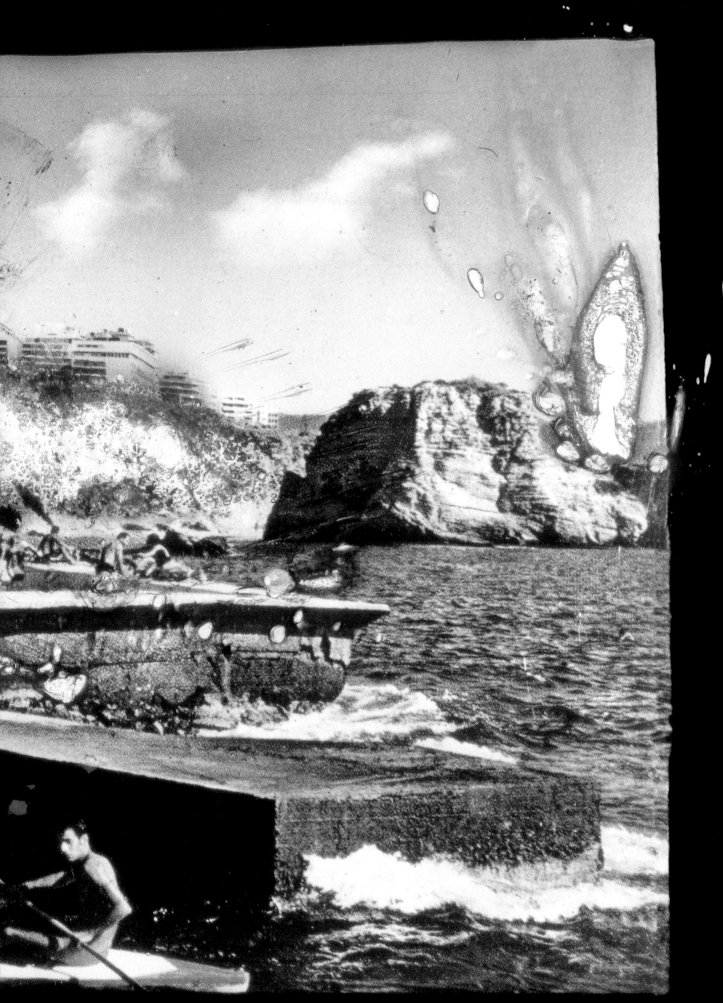

Latent Images, 1997–2006

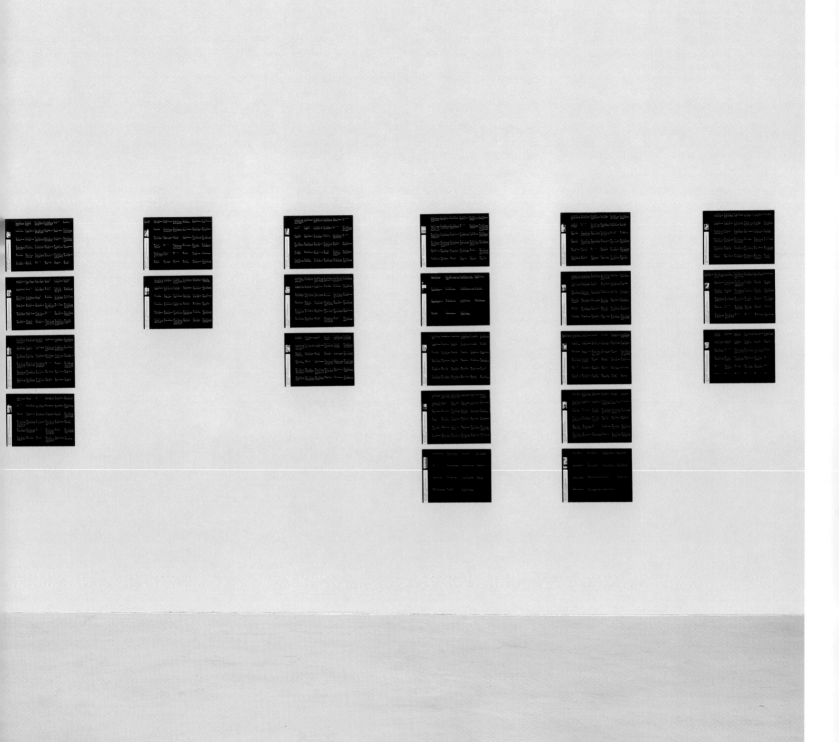

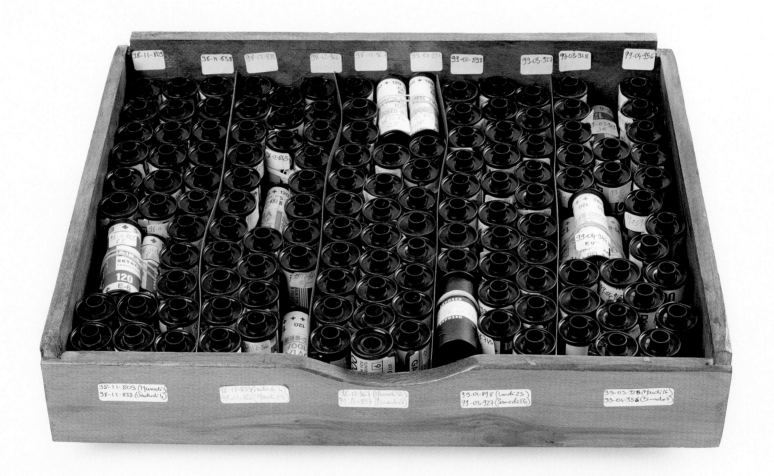

Latent Images, 1997–2006

IMAGES LATENTES *WONDER BEIRUT*

Film N°: 99-08-1003 **Date: 9 To 11 August 1999 (Monday To Wednesday)**

Sujet: Diary – Eclipse (beginning)

→ 1 99-08-1003
A. is on the bed, her body is half covered. The folds of the bed sheets and her skin merge together.

→ 2 99-08-1003
Idem.

→ 3 99-08-1003
Overexposure (+3IL), the texture of the elements is burned to mix them together.

→ 4 99-08-1003
The pink bra at the foot of the chair where A.'s clothes are placed.

→ 5 99-08-1003
Detail of the texture of the skin on the neck and shoulder.

→ 6 99-08-1003
Idem (larger plan) with the underarm.

→ 7 99-08-1003
Elbow shown under the hair fanned out of the pillow case.

→ 8 99-08-1003
Idem.

→ 9 99-08-1003
Between the mouth and the ear, a wrinkle.

→ 10 99-08-1003
A.'s knees lifted up with the sheet between her legs.

→ 11 99-08-1003
Her feet.

→ 12 99-08-1003
Our 4 knees bent like 4 mountains (door in the background opened).

→ 13 99-08-1003
Idem but with the door closed.

→ 14 99-08-1003
A., two elbows behind, buttons up her skirt, her bust still naked.

→ 15 99-08-1003
A. looking exasperated, reaching out for the camera.

→ 16 99-08-1003
Photo missed, blocked by A.'s hand.

→ 17 99-08-1003
A.'s body outlined under the sheets.

→ 18 99-08-1003
Traffic jam because of a huge building site at Sin el Fil.

→ 19 99-08-1003
Tangled cranes above the cars at a standstill.

→ 20 99-08-1003
A row of several concrete mixers on two lanes, there is only one lane left for the traffic.

→ 21 99-08-1003
In front of the concrete mixer, a policeman sorts out the traffic (he seems little in front of the foundations and the concrete-mixers).

→ 22 99-08-1003
My road empty (at lunchtime).

→ 23 99-08-1003
Adonis' Mini-Market closed.

→ 24 99-08-1003
Fady's café closed.

→ 25 99-08-1003
Empty crossroads.

→ 26 99-08-1003
Corniche, there aren't many people.

→ 27 99-08-1003
Shot of a man walking with his umbrella. Important shadow.

→ 28 99-08-1003
Establishing shot of three people exchanging protective glasses.

→ 29 99-08-1003
Hamra road empty.

→ 30 99-08-1003
Idem with my watch in the forefront. It is 1.28 pm.

→ 31 99-08-1003
The café de Paris closed !

→ 32 99-08-1003
Series of shop fronts closed.

→ 33 99-08-1003
Sanayeh empty.

→ 34 99-08-1003
Idem with my watch in the forefront. It is 1.46 pm.

→ 35 99-08-1003
Building with all the shutters closed.

→ 36 99-08-1003
Arida building with all the shutters closed + the blinds down.

IMAGES LATENTES *WONDER BEIRUT*

Film N°: 104-12-2253 **Date: 30 December 2004 (Thursday)**

Sujet: The objects of my melancholy

→ **1** 104-12-2253

Her sundries tray and all its jumble.

→ **2** 104-12-2253

The key to the house with its red ribbon in the midst of her things.

→ **3** 104-12-2253

The pillow and trace of her head on the wall.

→ **4** 104-12-2253

Some of A.'s hair, collected and placed on a white handkerchief.

→ **5** 104-12-2253

Idem.

→ **6** 104-12-2253

Her latest book on the bedside table.

→ **7** 104-12-2253

Her slippers at the bottom of the bed.

→ **8** 104-12-2253

Our photos stuck to the mirror.

→ **9** 104-12-2253

Her bottle of perfume, empty.

→ **10** 104-12-2253

Her broken powder compact.

→ **11** 104-12-2253

The bedroom curtains and trimmings; rain against the window.

→ **12** 104-12-2253

The empty hook next to my dressing gown.

→ **13** 104-12-2253

The space she has left in the wardrobe.

→ **14** 104-12-2253

A now empty shelf.

→ **15** 104-12-2253

At the entrance, the bags of things and clothes A. has still not collected.

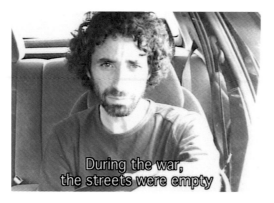 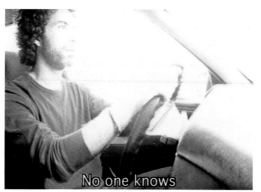

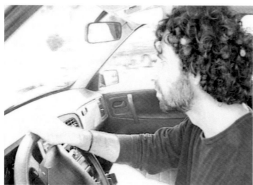 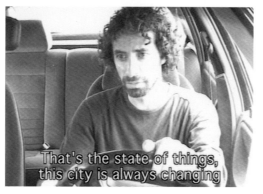

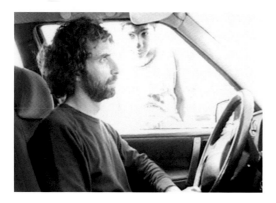 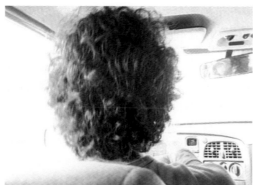

Film

Barmeh 2001
 7 min

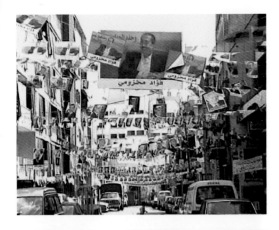 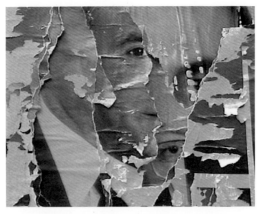

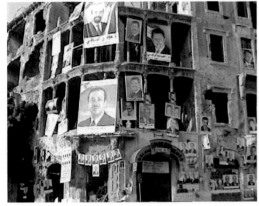

Film

Always With You	2001–2008
	6 min

Distracted Bullets, 2003–2005

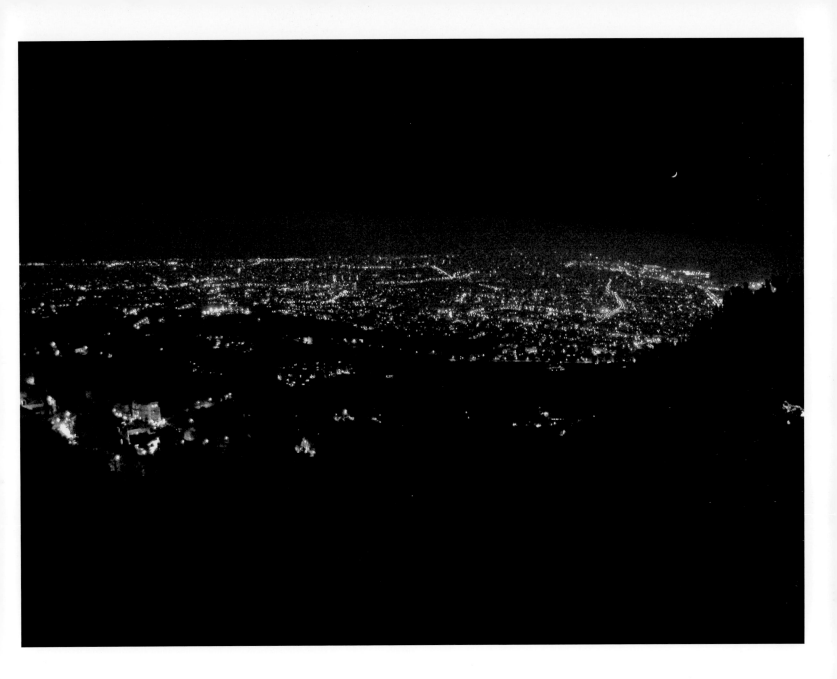

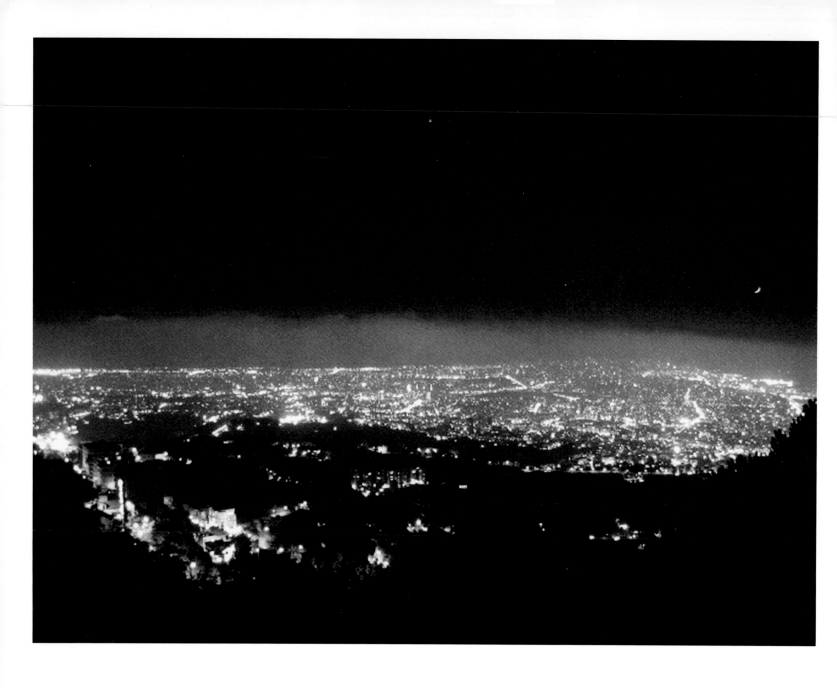

Distracted Bullets, 2003–2005

Stranger than Fiction

Suzanne Cotter

"All our works exist on the frontier of a reality where the question of the territory and its delimitation (that of art, that of personal life), the question of the social body and individual body, is constantly being posed, at a time when it is increasingly difficult to affirm one's individuality as a vector of thought and thus of possible opposition, increasingly difficult to say 'I,' to say 'I am this person here with these contradictions; I am here and, even, more than an individual, I am a singular political subject.'"[1]

Joana Hadjithomas and Khalil Joreige work primarily with the mediums of photography and film. The reception of their work spans cinema and the visual arts, worlds that, while increasingly connected, possess distinct circuits of production and distribution, a dual terrain in which they have established richly fertile ground. Through their practice the artists address and look to redefine existing regimes of representation, to engage with questions of identity and memory, and the individual and social subject. As artists for whom the practice of art constitutes a culturally multivalent carving out of a public space in which discourse and discussion are possible, the urgency of their practice cannot be separated from the urgencies of life.

Like a number of artists, writers, and cultural producers of their generation who came of age in Lebanon in the decade that followed the end of the country's 15-year-long Civil War (or wars, as they are also known), Hadjithomas and Joreige prefer other terms than that of artist. They describe themselves as *chercheurs*—literally, "those who are looking for something," but also "researchers." The reference to both a sense of personal seeking and to the procedures of scientific enquiry is highly appropriate. Investigative processes that rely on the archive and the document, and what

1 "Like Oases in the Desert," *Appel à témoins*, Le Quartier, Quimper 2004, p. 81.

could be described as an archeology of events, in which the role of the image in the writing of history is central to understanding one's position in the world, are at the heart of their work. Hadjithomas and Joreige are also master storytellers.

Since the late 1990s, they have adopted the languages of narrative cinema and documentary filmmaking structured within a taut conceptualism. Their approach is an interventionist one. If their earlier films and installations could be described as a psycho-geographic mapping of the city of Beirut, over time it has become clear how, in drawing on real events and places, their works activate and reveal less visible or repressed dimensions of the city and its inhabitants, often with compelling consequences.

In considering their conceptual trajectory as an investigative as well as aesthetic one, the artists have stressed the significance of distinct periods in their work that are related to political and geopolitical events as they have experienced them in Lebanon. Their emergence as contemporary practitioners coincided with their meeting in Beirut at the end of the 1990s with a group of like-minded artists, poets, and intellectuals that included Fadi Abdallah, Tony Chakar, Bilal Khbeiz, Rabih Mroué, Walid Raad, Marwan Rechmaoui, Walid Sadek, and Lina Saneh. Their regular meetings over the next five years and their participation in cultural events such as the Ayloul Festival for Modern Art, for which many of the artists presented seminal early works, as well as the public projects produced by the nascent art association Ashkal Alwan, led by Christine Tohmé, provided a critical community and forum. Many of these early interventions and presentations reflected upon the physical and psychological, as well as the economic and political reconstruction of postwar Lebanon. In the same period, the Arab Image Foundation was founded by Fouad Elkhoury, Akram Zaatari, and Samer Mohdad with the aim of collecting, preserving, and studying photographic images produced across the Middle East and North Africa, and the regions' diaspora.

At the beginning of the 2000s, the coordinated attacks in New York and Washington that have come to be known by the temporal coordinates of 9/11, and the subsequent invasion of Afghanistan and Iraq by US and British forces, marked a new era of historical rupture and cultural reckoning. The intellectual and artistic interrogations of Hadjithomas and Joreige converged with a larger critical generation of artists, thinkers, writers, and cultural producers in the Middle East, and a claiming of local platforms from which their multiple voices could be heard in response to the binary systems of representation largely generated by the West:

> In our work, 9/11 was a turning point. We were preparing a film (*The Lost Film*) in Yemen, and had already done our initial scouting. We were in discussion with a television station; however, at a meeting with one of its executives after 9/11, we were advised that our approach was too anecdotal. We were struck by this term which etymologically means "a stroy kept secret." We realized, then, that this could be a strategy of resistance; the world had been reduced to more binary terms, and it was necessary for us to find ways to express its complexity.[2]

The middle of the decade brought new developments that would provoke in Hadjithomas and Joreige a further questioning of their practice. The manifestations of solidarity in the wake of the assassination of the Lebanese Prime Minister Rafik Hariri in February 2005 unleashed large-scale public demonstrations and counter-demonstrations that went beyond sectarian allegiances to express broader geopolitical affiliations. Just under 18 months later, the war with Israel that unfurled and devastated much of southern Lebanon and Beirut in July and August 2006 reaffirmed the deep divisions and conflicts with Lebanon's neighboring countries, and, more disturbingly, revived what had been an unimagined possibility of a new era of war. For Hadjithomas and Joreige, this realization led to a reconsideration, not only of their approach to image-making, but of how to shift the way one might look at these images and at representations of the region in general.

AN ARCHEOLOGY OF SEEING

The approach of Hadjithomas and Joreige has always been one of problematizing the role of images in relation to history and memory, and, in particular, with respect to representations of war. The urgency of their context is informed by the collective amnesia that has prevailed in Lebanon since the end of the civil war. This repression of traumatic memory is ascribed, in part, to the political amnesty accorded to conflicting factions as part of the Ta'if Accord of October 1989, and the merging of public and private spheres and the will to reconstruction, expressed in Beirut's rapid regeneration by the development company Solidère, under the leadership of the Saudi-backed businessman and ill-fated politician

2 Email conversation with the artists, December 2011.

Rafik Hariri. In a period of optimistic precociousness in the 1980s when the war seemed to be abating, some districts of the destroyed downtown area of the city, once a bustling cosmopolitan center of commerce, of markets, and of souks, was being rebuilt as a shining simulacrum of the prewar years, only to be re-abandoned to a veritable no-man's-land until the ultimate end of the conflict.

While the artists have shared their time between Paris and Beirut since 2005, the conceptual and aesthetic epicenter of their work is Beirut. The city and the traces of events over time on its urban fabric is an abiding theme in the artists' early works that coincided with Beirut and the nation in the throes of reconstruction. As literature students, the artists first began photographing the downtown area of the city in 1988, revisiting its abandoned spaces and devastated objects of a once quotidian life and testing different approaches to the photographic image and our capacity for recognition. With the series of color photographs, *Equivalences*, made over several years and first shown with other early works at the Institut du monde arabe in Paris in 1997 in the exhibition *Beyrouth fictions urbaines: Archéologie de notre regard* ("Beirut Urban Fictions: Archeology of Our Gaze"), Hadjithomas and Joreige documented their own trajectory of encounter with an increasingly unrecognizable city in which all points of reference had been lost. The resultant images, as their title suggests, operate precisely in this realm of the non-specific. In contrast, *Bestiaries*, a series of black and white images made in 1997 of distorted fragments of iron street lamps as the result of explosions and mortar fire, dwelt upon the poetic possibilities of the defaced and the deformed—"The form of a form which has no form," as they refer to these images, citing the poet Mahmoud Darwish[3]—as generating recognition through auto-association.

In 1999, the artists made their first feature film *Around the Pink House*. Filmed in a fictional neighborhood of a Beirut neighborhood (in fact, a set created in Wadi Abou Jmil, the Jewish district of Midtown), it tells the story of a set of families fighting against eviction by a real-estate developer from a ruined palatial house offered to them as internally displaced refugees during the war. Sympathetically shot in color in a style that combines the pastel-toned theatricality of early Technicolor movies and Rossellini's war-torn *Rome, Open City* (1945), the archetypal characters in the film lack neither pathos nor heroism. Rather, they offer a glimpse into a microcosm of communitarian politics, and of a society struggling with the effects of displacement and redevelopment in the postwar period.

It is not surprising that, for a generation who has grown up with the realities of checkpoints and the loss of all built referents, acts of subjective mapping have been a persistent theme for artists from Beirut such as Marwan Rechmaoui, Tony Chakar, and Lamia Joreige, working across different media and disciplines. For Hadjithomas and Joreige, the city is rendered hauntingly spectral and is a concatenation of contested spaces. In their film and installation works from the late 1990s into the 2000s the artists engaged with the city as both physical environment and as subjectively defined through memory and association. Their large scale photographic installation *The Circle of Confusion* (1997) offers a vast panoramic view of a Beirut that is progressively fragmented as viewers are invited to take a pre-cut section of the image, leaving in its place a reflective void of a mirrored surface beneath, effecting a performed archeology in which the city asserts itself as memory at the moment of its disappearance as image. On the reverse side of each of the image sections are a number and the words "Beirut does not exist." According to the artists, the phrase, inspired by Lacan's use of the phrase "woman does not exist," attempts a similar evasion of definition, in which the city is expressed as a literal space of continual construction but also as a dematerialized territory of political and social transaction.

In their short video *Rounds* (2001) and the video/sound installation *Distracted Bullets* (2003–2005), Hadjithomas and Joreige continued to reflect upon ways in which to image the city that would expand upon and complicate existing representations. In *Rounds*, they played on the idea of the city as seen through the eyes of another. A man, played by the actor Rabih Mroué, is filmed in his car driving around the city as he describes what he sees and recounts anecdotes of occurrences during the Civil War with which different places would be forever associated in his mind. The city itself is never visible. It is, rather, the act of looking that is presented to our gaze. *Distracted Bullets* is more of a nocturnal fugue, in which the topography of the city is mapped according to contrapuntal intensities of belonging and latent violence. Shot at night from the artists' apartment in the neighborhood of Beit Mery overlooking Beirut, the work shows a sequence of panoramic views of the city filmed on the occasion of five different religious and political events that are celebrated with fireworks and the firing of guns. Here the artists abstracted the usual elements of visual and

3 Hadjithomas & Joreige, *Aïda, Save Me!*,
 Gasworks, London/Askhkal Alwan,
 Beirut 2009, p. 9–12.

narrative description into a pulsating composition of flickering light and exploding sounds. In an accompanying text, they reflect upon the source of the fireworks and the arbitrary nature of a history that will not commemorate those anonymous victims of stray bullets fired into the air.

With the multi-part project *Wonder Beirut* (1997–2006), Hadjithomas and Joreige looked to address the paradox of contemporary Beirut haunted by the traumas of the recent past, yet seemingly unable to acknowledge them. Postcards of pre-Civil War images of Beirut from the 1960s and 1970s, the "Riviera of the Levant," with its modern hotels, azure seas, and cosmopolitan exoticism, are still to be found in the city's hotels, kiosks, and stationers, even though many of the places and buildings were destroyed during the armed battles that took place across the city. Taking these postcards as a starting point, Hadjithomas and Joreige set out to articulate a visual counter-narrative. Elaborated as a suite of interconnected chapters, *The Story of a Pyromaniac Photographer*, *Postcards of War*, and *Latent Images*, *The Story of a Pyromaniac Photographer* read as a fable. It concerns one Abdallah Farah, a photographer who, during the war, according to the narrative of the artists, began to burn his negatives of postcard images as the buildings and roads he had photographed were successively bombed and destroyed during the fighting. Printing a new image each time the city, and accordingly his negatives, were subject to a new round of fighting, Farah was able to systematically chart what Hadjithomas and Joreige term "the historic process" of key events, such as the battle of the hotels that took place during the years of 1975 and 1976. With other postcard images, the photographer began to inflict further damage, which did not reflect a real event but, rather, and according to the artists, expressed motivations that may have been emotional, political, or purely aesthetic, what they termed "plastic process," an original form of destruction that was not the direct result of, but instead constituted a form of participation in, the event. Selecting images from the historic and the plastic process, Hadjithomas and Joreige had them reprinted for distribution and circulation under the title *Postcards of War*.

We are not meant to know whether the story of Abdallah Farah is true, or whether it is simply an elegantly re-counted moral tale through which the artists could intervene into the repressed popular imaginary, something they achieve with both irony and pathos. Like their fellow artist Walid Raad, the employment of fictional identities by Hadjithomas and Joreige serves as a device with which to question the veracity of historical accounts and the role of images within them. Art historian Carrie Lambert-Beattie has written about this type of appropriation of historical narrative as a "tactical deception," the purview of "parafiction" whereby "Real and/or imaginary personages and stories intersect with the world as it is being lived."[4] Those practitioners, or producers of situations who engage with parafiction do so not to produce plausible stories, but rather to engage those who encounter such stories in determining what it is they wish to believe and what they do not: "Parafictions train us in scepticism and doubt, but also, oddly, in belief."[5] Where Hadjithomas and Joreige diverge from this notion of parafiction is in their engagement with film and cinematic narrative as a discursive space of both proposition and de-sublimated reality. Farah the photographer, or Mroué the unnamed driver in *Rounds*, are not so much fictional as scripted characters who evolve and who call upon us to witness their enactment of history as a subjective form.

LATENCY AS PROMISE

The processes of burning and adulteration to which the original postcard images of *The Story of a Pyromaniac Photographer* were subject also represented for Hadjithomas and Joreige the indexical process of photography itself: "We wanted to return to the ontological definition of these images: the inscription of light by burning."[6] The choice of images, and the historic and plastic processes they articulate are also reflective of the artists' interest in the notion of the archive as a repository of historical narratives that have not yet been made visible. The archive and the registering of real events as that which is yet to be rendered visible, are encompassed in the artist's concept of latency, which informs the third chapter of *Wonder Beirut*. Here, photographs purportedly taken by Abdallah Farah in the years after the war are no longer revealed, but simply left as undeveloped spools, classified and stored, their visual dimension denied, translated instead as a set of dates and written descriptions in notebooks.

For Hadithomas and Joreige, the concept of latency is the visual translated through evocation, and the redolent potential for emergence. The re-activated image has become a well established trope within their oeuvre with which to explore and express the emotional and psychic traces of events: the burnt negatives and the rolls of undeveloped film of Abdallah Farah, or a city that can only be imagined

4 Carrie Lambert-Beattie, "Make-Believe: Parafiction and Plausability," *October* 129, Summer 2009, p. 51–84.
5 Ibid., p. 78.
6 Hadjithomas & Joreige, "OK, I'll Show You My Work," *Discourse 24.1*, Winter 2002, p. 85–98.

through the eyes of the unnamed driver in *Rounds*. Withholding the image and re-investing events with the contingency of individual narratives, the artists articulate history from the perspective of lived experience, unmediated by the logic and economy of spectacle. Crucially, latency allows for the anecdotal and the speculative, in contradistinction to the passive consumption of master narratives in the service of ideology, be they of the state, political essentialism, or religious fundamentalism.

This is brought home in their eloquent short silent film, *Always with You* (2001–2008). Shot in Beirut in 2000 at the time of a major election, Hadjithomas and Joreige reveal the obverse of latency in the multiplication of portraits of politicians that line streets, bridges, and roadways, covering the facades of buildings so that one's view is completely obstructed by images. Presented without any sound or comment, the insistence of the image and its mechanisms of propaganda are rendered inarguably evident.

Latency, or the yet to be realized, also assumes a powerful symbolism in relation to mourning. Fellow artist and writer Walid Sadek has described the work of Hadjithomas and Joreige as constituting "a fertile and extended allegory on the disappeared and those who wait for them."[7] References to the absent corpse literally haunt their works. In 2003 they produced *Ashes*, a short film about a young man who returns to Beirut for the funeral of his father whom he has had cremated in France, and his family must find a replacement corpse so as not to be spurned by their community because cremation is against their beliefs. The film is also representative of another, fundamental preoccupation of the artists, which is the emergence of individual identity within a communitarian- and sectarian-based society. As they explain: "In Lebanon, there is no civil statute for marriage, death, or inheritance, which must be recognized by one of the country's 17 confessional faiths. In certain cases, such as cremation, the custom is not acceptable to any."[8] In a published lecture, *Aïda, Save Me!,* the artists described how, in the making of *Ashes* they could not get anyone to agree to play the role of the proxy dead person because of fears that it would prove premonitory. Far from frustrating the process of making the film, the artists ended up making a short documentary in parallel, in which they interviewed the various actors about the reasons why they would not agree to play the part.[9]

Of the 17,000 people who were abducted or went missing during the Civil War, Sadek writes of "the predicament of having to *over*-live with their absence,"[10] a theme expressed by Hadjithomas and Joreige in their feature film *A Perfect Day* (2005). In this visually lush yet economically produced film, Malek and his mother Claudia go through the process of declaring his father, and her husband, legally deceased after being missing for 15 years. Taking place in Beirut over 24 hours, the film reveals the emotional state of Malek as one of existential hysteria. Just as the photograph of Malek's father in the newspaper constitutes his missing person, the absent corpse is also present in the face of the martyr.

For several years the artists have photographed the posters of men and women from different parts of the country, and from different faiths, who have been killed as a result of military battles or suicide missions. Akin to the historic process of Abdallah Farah, or their documenting of a constantly changing city center in *Equivalences*, the artists returned over several years to re-photograph these same posters and to document the gradual dissolution of their features to the ravages of time. In the resultant work, *Faces* (2009), the artists' attempt to resurrect their fading features, questioning, in their retouches of certain facial traits, their ghostly presence.

Along with the image, the spoken and the written word have always occupied an important place in the artists' oeuvre. Written or textual dimensions exist in the form of authored texts, either as intrinsic to the work or as accompanying statements in catalogues and publications. A reliance on the personal account is also part of their general strategy of counter-narrative and historical memory. With their documentary video project *Khiam*, begun in 2000 and completed in 2007, Hadjithomas and Joreige looked to verbal testimony to give tangible representation to the detention camp Khiam in the Israeli-occupied zone of southern Lebanon as a place of individual and collective trauma. Interviewing six former detainees of the camp about their experiences, the artists produced a striking portrait of both resistance and survival. On the withdrawal of Israel from the south in 2000, the camp was made into a museum. It was subsequently destroyed during the war between Israel and Lebanon in the summer of 2006. Hadjithomas and Joreige set about re-interviewing the former detainees, this time questioning them about their response to the camp's destruction and to the suggestion that the camp should be rebuilt as it was. Telescoping between past, present, and future, the artist's initial approach through remembering and evocation was interrupted by the uncanny nature of real events, transforming

7 Walid Sadek, "Collecting the Uncanny and the Labour of Missing," in Sonja Mejcher-Atassi and John Pedro Schwartz (eds.), *Archives, Museums and Collecting Practices in the Modern Arab World*, Farnham, Ashgate 2012, p. 220.

8 Email conversation with the artists, December 2011.

9 Hadjithomas & Joreige, *Aïda, Save Me!*, p. 9–12.

10 Sadek, "Collecting the Uncanny and the Labour of Missing," p. 220.

a previously denied site of shared history into one that is truly absent through its destruction. On traveling after the war of 2006 to the location of the former camp turned museum in 2000, the artists were greeted with a series of small billboard images documenting the previously extant buildings, which had been placed by the authorities in front of what was now a set of ruins. The artists' subsequent photographic series *Landscapes of Khiam* (2007) document, in turn, the staging and absurd insufficiency of these improvised memorial images in a representational *mise-en-abîme* of memory and loss.

Of the works that play on the ambivalence of the image, its haunting absence, and the possibility of its retrieval, *The Lost Film*, made in 2003, resonates profoundly in its consequences and its reflection on the status of images and image-makers in the larger Arab world in the decade post 9/11. Speaking of that time, the artists have said:

> Our work tried to define the conditions of our existence and our belonging to this part of the world. What we produced questioned what it meant to be creators of images in the Arab world without falling into simplistic tropes of Orientalism, or, of the instrumentalization of the image within different countries and different political communities.[11]

The Lost Film also illustrates beautifully the intersection of the artists' project of research with real life events. Sadek describes the methodology of Hadjithomas and Joreige as one of "necessary impasse," in which "the allegorical collapses into the autobiographical."[12] The artists themselves differ with the use of the term "allegorical" as a notion that is, precisely, not anchored in the real events that they are looking to interrogate. Existing in almost all of their works are traces of elements of the artists' lives and actual experiences, in what might be considered a subtle referential play, but which is, in fact, a situation of continuity and inseparability between their life and their art. The opening credits for *Around this House*, for example, feature the postcard images of *Wonder Beirut*. Malek's apartment in *A Perfect Day* is the one where the artists used to live. The circumstances of Malek's missing father echo those of the uncle of Khalil Joreige who was abducted during the Civil War.

The Lost Film began with another real-life occurrence— an email received by the artists in May 2000 advising them that their film *Around the Pink House* had disappeared in Yemen under strange circumstances. The news struck them as all the more intriguing coming from a country that had little interest in cinema. The date of the email also corresponded with the tenth anniversary of the reunification of North and South Yemen. One year later, Hadjithomas and Joreige decided to fly to Sana'a and to try to follow the trace of their film, visiting the cinemas of Sana'a and Aden, where the film had been screened. They documented their journey and their conversations with the people they met, from the cinema projectionists to the checkpoint authorities as they passed between the north and south of the country. It is a simple road movie overlaid with an interrogation of the cultural and political conditions that give status, or non-status to lens-based imagery. Narrated in a highly personal way by the artists, the film ends with their return to Beirut and the receipt of a package containing frames of the film that had been cut by the Lebanese censors prior to its being sent to Yemen. The irony of this coincidence is made all the more poignant in the film's closing moments, in which the only remaining traces of the missing film are spooled and projected.

THE WEIGHT OF REALITY

The war between Israel and Lebanon in July and August of 2006 marked a new period for the artists and a desire for an even greater engagement with events of the present. Their feature film *Je veux voir* (*I Want to See*), made shortly after the end of the war, takes the form of another road trip, this time through southern Beirut and into southern Lebanon to the border with Israel, which had been bombarded during the month-long conflict. Working again with Mroué, once more behind the wheel of a car, the film flirts with the fiction of a simple scenario juxtaposed with a real time situation. Mroué is to drive the French actress Catherine Deneuve, whom he has never met, to view the devastation in the south of the country, the location of Mroué's family village, and get her back to Beirut for a dinner that evening. Deneuve is riveting, as befits her status as a film star, and visibly anxious as she constantly checks that her seat belt is fastened, smokes a cigarette, or reservedly asks questions. As the two actors become more relaxed over the course of the day through their shared conversations and experience, the film effects a representational shift—what theorist Jacques Rancière might describe as a "redistribution of the perceptible," whereby the portrayal of Deneuve and Mroué's

11 Email conversation with the artists, December 2011.
12 Sadek, "Collecting the Uncanny and the Labour of Missing," p. 220.

developing relationship offers a subjective and deeply human portrayal of what it means to see and to show, and to participate in these acts, not only as characters in their story, but as real spectators in the world.

Reflecting on *Je veux voir*, Hadjithomas and Joreige have invoked Alain Resnais' *Hiroshima mon amour* (1959), and Jean-Luc Godard's *Notre musique* (2004). In the latter, Godard, who plays in the film, also interrogates the subjects of violence and reconciliation through the theme of a transient encounter between two people. At one point in the film, speaking at a literary conference in Sarajevo, Godard makes a declaration that has proved deeply resonant for the artists. Discussing two images from 1948, the year of the co-existent creation of the state of Israel and the *Naqba*, he observes: "In one, the Jewish people rejoined fiction, in the other, the Palestinian people, documentary."[13]

In *Je veux voir*, the artists hold these realms of fiction and documentary in a state of tension. In inviting Catherine Deneuve to collaborate on the film, they deliberately looked to exploit and to test the uncanny effect of a cinema icon transposed into a postwar situation. Their destablizing tactic also produced a form of heightened reality, or *sur*-reality as the reassuring pretence of fiction is confronted with concrete facts.[14] At a certain point in the film, Mroué takes a wrong turn onto an unmarked dirt road that results in the film crew erupting on camera and shouting and chasing after the car because of a fear of landmines, and ending with a distinctly shaken Deneuve. At another key moment, arriving at the Lebanon-Israel border, we see Hadjithomas and Joreige negotiating with the patrolling UNIFIL troops to allow the two actors to be filmed walking along the perimeter fence. After what seem to be lengthy negotiations, Catherine Deneuve agrees to be in a photograph with the soldiers and during these photographs the filmmakers are able to shoot one of the most surveyed borders in the world. In these few moments when the actress walks down the winding, grassy track to the border and has a small road opened just for this shot, the artists achieve through cinema a territory that transcends nationality.

Hadjithomas and Joreige are declared utopianists whose idealism is grounded in the notion of a civic space. In recent years, their research has ceded to an investigation into the speculative and also emancipatory spaces generated through interventions into real life events. Already, with *Around the Pink House*, they looked to position the film within the realm of public debate about the future of Beirut and its approach to reconstruction. Their oeuvre is peppered with strange coincidences in which reality does indeed become stranger than fiction. When they first screened *A Perfect Day* in Beirut, the film and the artists became the subjects of a court injunction when the image of a man in the 1988 newspaper announcement to represent Malek's missing father was found to relate to a current murder enquiry. The date and image of the man, it also transpired, corresponded to the wedding day and divorced husband of a profoundly upset second wife by the name of Aïda. In a further development, speaking about these unexpected interruptions into their film project at a lecture-performance entitled *Aïda, Save Me!*,[15] the artists were confronted by a woman in the audience claiming to be the man's cousin. Such is the uncanny poetics of the anecdotal that surfaces in their work that, having requested from the artists viewing copies of a number of their films prior to writing this essay, I received by post, in an envelope addressed by hand by the artists, a series of unreadable DVDs with yellow and black labels from Boeing Jet component manuals. Their inexplicable arrival in place of the artists' films provoked a state of perplexed uncertainty and consternation.

Reprising a forgotten period in Lebanese history by way of the archive, the artists' multi-pronged project *The Lebanese Rocket Society* (2011–2013) was prompted by their seeing a set of photographs in the collection of the Arab Image Foundation that led to their discovery of the Lebanese Rocket Society. Originally the Haigazian College Rocket Society, it was formed in 1960 and led by a mathematics professor, Manoug Manougian, who gathered around him a group of young mathematicians and aspiring scientists and students who were based at the Armenian Haigazian University in Beirut. Inspired by the space race between the Soviet Union and the US, and the ambition to be the first country in the Arab world to launch a missile into space, the project was ultimately supported by the Lebanese government as the Lebanese Rocket Society, which culminated in a series of Cedar rockets launched into Lebanese airspace between 1961 and 1966. The launches, the subject of national celebrations, also occasioned the printing of a series of commemorative stamps. The project was then completely forgotten.

The Lebanese Rocket Society is a work of documentation and of re-enactment. It takes the form of filmed interviews with scientists involved in the original project, archival film

13 Hadjithomas & Joreige, *Aïda, Save Me!*,
 p. 9–12.
14 Ibid., p.11–12.

15 The lecture-performance was given
 by the artist as part of the program
 Mapping Subjectivities at The Museum
 of Modern Art, New York, November
 15, 2010.

footage and photographs, a monument, and, given the logistics of realizing a project that involved replica missiles being transported from the Lebanon to the Arabian Gulf, the participation of numerous government officials. Each of these elements are also constitutive of the process of making a feature-length film by Hadjithomas and Joreige that was released in 2013. The first chapter of the project was produced in 2011 for the 10th Sharjah Biennial: *Plot for a Biennial*. Here they presented the installation *The President's Album*, 32 wall-mounted, accordion-folded prints that, when seen together, constitute an 8-meter drawing of the Cedar IV rocket as it was designed in 1963. Flat-screen monitors showed footage of the early rocket launches, and recorded interviews with some of the former society members. The centerpiece of the Sharjah work was *Cedar IV: A Reconstitution*, a scaled painted metal replica of Cedar IV, made in Beirut and subsequently transported to the United Arab Emirates to be installed in front of the Sharjah Art Museum. A second replica was installed at the same time in the grounds of Haigazian University in Beirut. Along with the commemorative zeal inspired by its placement, one should not underestimate the challenges involved in producing, transporting, and presenting the work amid intense negotiations, authorizations, and television coverage so that there was no possibility that the sculpture could be misconstrued as a real missile and provoke a military attack. It is the consequences at stake, perhaps more than the visible objects and material itself, that constitutes a singular dimension of the work. Hadjithomas and Joreige are eloquent in articulating its ambitions:

> Provoke, challenge reality, as a tribute to dreamers, create a rocket that ressembles a missile and have it circulate in the city and say, "This is not a weapon, this is what some were before, what we could be today : researchers, utopian, dreamers." It is also a way to think in the present, to say reality can be something to create and not an order of things that we simply accept.[16]

A third chapter of the project, *The Golden Record*, is a soundscape composed of recorded sounds of Lebanon from the 1960s—music, the city, nature—taken from different sound archives. A reference to the recorded proclamation "Long Live Lebanon" that was installed in the tip of the Cedar rockets and broadcast on national radio stations as they were being launched, it also alludes to a period when the world was largely divided into ideological blocs, with space travel research as the *nec plus ultra* symbols of revolutionary and liberal progressive ideals. In the new Pan-Arab of the 1960s, this was a period of optimistic self-determination. Whereas in the West, riding a wave of consumerism and Cold War propaganda, it was also a period of paranoia and encounter with "the other" against a backdrop of independent, post-colonial states. It seems telling that less than a decade after, NASA was sending off in Voyager 1 and Voyager 2 messages and sounds of the earth, selected by a committee chaired by Carl Sagan and engraved on golden records, intended for possible encounters with extraterrestrials.[17]

The Lebanese Rocket Society is a response to the question of what to do when the thread of history is broken.[18] While the reasons for the rocket society's demise are not fully known, Western and Arab diplomatic pressures are cited as influencing factors. Representative of a time of idealism and of dreaming, the Society's excavation throws light on an uncelebrated history, a time of past dreams and a present of poignant longing.

In this tender and uncertain era of the "Arab Revolutions," in which long repressed rights and aspirations have made themselves visible and heard, the oeuvre of Hadjithomas and Joreige offers a steady and eloquent reminder of broader, shared ambitions, in which the search for self-definition persists amid the fraught terrain of political and cultural self-determination and their concomitant regimes of representation. That the artists continue to both expand and refine the means with which to express these states of being through their engagement with and interventions into the present is all the more significant. We need the ironies and the disclosures, the common terrain and the exquisite distances that exist between people, and the collective histories that both separate and bind them. Their art offers a resonant "call to arms": Set the cameras rolling. Cut to action. Let the stories begin.

16 Email conversation with the artists, December 2011.

17 Another element is *A Carpet*, i.e. the reproduction of the official stamp created in 1964 to celebrate the Lebanese Rocket Society in the form of a hand-made carpet.

18 Hadjithomas & Joreige, "The Lebanese Rocket Society," *Plot for a Biennial*, cat., Sharjah Biennial 10, Sharjah Art Foundation, United Arab Emirates 2011, p. 132.

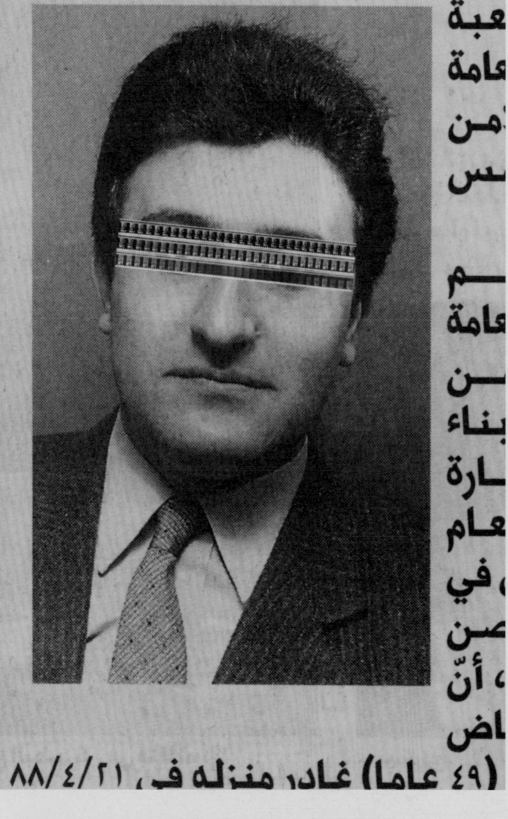

مفقود

عبة
عامة
من
س

م
عامة
ن
بناء
ارة
عام
في
ن
أنّ
اض

(٤٩ عاماً) غادر منزله في ٨٨/٤/٢١،

From Films to Cinema, Entering the Life of Traces

Jean-Michel Frodon

On Joana Hadjithomas and Khalil Joreige's website, we are told they are artists and filmmakers who have made feature films and documentaries. The site is organized under headings: films, videos, installations, publications. All this, correct and useful as it is, is a long, long way from doing justice to the reality of what they do: because their activity has resulted in a great many works that do not feature there, and do not come under these headings; but even more because the huge "work in progress" represented by the sum total of the artistic activities of Joana Hadjithomas and Khalil Joreige, which deserve to be considered as a whole, not only continually challenges the distinctions between the visual arts, video and cinema, feature film and documentary, but above all only develops by being constantly reshaped by these distinctions.

There are a great many contemporary artists who practice several disciplines, exploring their possible points of contact and oppositions. Those who put themselves in a situation of being questioned, and transformed, by the truth of the specific effects arising from the various artistic practices they use, on the basis of research that has its origin in other questions, are far rarer, and much more interesting. Khalil Joreige and Joana Hadjithomas are a textbook case

in point, partly in spite of themselves. But it is then all the more credit to them that they have been capable of accepting the challenge of the objective responses provoked by their creations, and have worked to answer them as artists who think through their practice, in an impressive interplay of to and fro. This movement which intersects others—biographical factors, the effects of the political events undergone by Lebanon—makes all their work vibrate.

It is logical that their relationship to cinema as a unique art and process should be a particularly active ferment in this movement. For the entire oeuvre of Joana Hadjithomas and Khalil Joreige is mobilized by a question that is likewise central to the cinematographic process, the question of traces. Again, the extent to which this approach is part of a fundamental movement in the art world must be stressed, in order to emphasize even more how important what Khalil Joreige and Joana Hadjithomas are doing is in view of this overall process, and how original their own approach is. For while the question of traces—the imprints left by a being, an event, an emotion, or an idea—is logically a preoccupation for many creative artists, it is a particular concern of theirs to display the way in which traces survive, as traces.

In a departure from what normally occurs, they perceive traces not as vestiges of what has been, but as existing in their own right: living beings that evolve. So their works construct the conditions making it possible to perceive that: the life of traces, the dynamics that transform them, and in transforming them affect human beings, individual and collective relationships, and representations.

It is not that the past "does not pass" in the sense that it remains present, like a stone in a shoe. It passes, and even it never finishes passing, going deeper, being transformed, metabolizing what surrounds it. Traces are not inert, they live off their strange life, like parasitic organisms, not necessarily harmful moreover, but inhabited by modes of development that are peculiar to them, and interact with that of living creatures; of all living creatures, those who have known what they are traces of, and the others, those who were not there, those who had not been born. It is in this respect that the work of the two Lebanese artists, so powerfully rooted in a time and a place, let us say the contemporary Middle East, is addressed to everyone, everywhere.

Now cinema is the supreme art of the trace. It is the practice that records the existence of what has been in four dimensions, the temporal dimension (absent from the still photograph) obviously being at least as important as the spatial dimensions. But cinema naturally tends to freeze a certain state of the traces it records, and of course always composes—by framing, editing, etc. It seems that the sensitivity and artistic intelligence of Joana Hadjithomas and Khalil Joreige have lain in accepting, then prompting, the way in which the dynamics of reality could on the contrary come back right inside their practice as filmmakers. In that, they have been faithful to this living relationship to traces that is active in all their work, before they invented the creative synthesis of what is "produced" and what is "undergone," a synthesis that would be entitled Je veux voir (I Want to See, 2008).

Looking at their films, it is clear that they have not always been aware of the extent to which the cinematographic gesture and practice challenged the spirit of their undertaking as artists. Film after film, reality took care to remind them of it—it must be said again here that reality incessantly reminds us all, but very few of us hear or understand. So it is that their first fictional feature film, Around the Pink House (1999), gave rise to The Lost Film (2003), another work that is far more than its factual complement. Around the Pink House was an artifact conceived to express[1] their perception of the effects of the postwar period on civilian life in Lebanon, represented by situations, characters, actors, a script, etc. From an incident that happened in Yemen, the disappearance of a copy of that film, they transformed cinema into a means of imprinting, capable of organizing multiple effects of reality while taking their purport and their fragility into account, as well as their diachrony. Around the Pink House had arisen from the artists' wishes and thoughts; The Lost Film was born from a real event experienced because of the first film, transposed into an art gesture.

These transformations, this movement of forms under the impact of reality, are processes of a cinematographic nature. And these processes also occur in the works of Joana Hadjithomas and Khalil Joreige that use neither camera nor screen. Thus from the conception of the body of works Wonder Beirut (1997–2006) (the "internal movement " of Postcards of War and The Story of a Pyromaniac Photographer "invents" the traces of war with this succession of identical images affected differently by the ordeal of a mental fire, imaginary yet very real), from the installation Latent Images (2003) where rolls of undeveloped film "contain" the promise—threat?—of images yet to come, from the photographic work on the twice destroyed War Trophies (2007), from that on the portraits of the martyrs along the "film" spread out in space, a metonym of the street and a metaphor of the passage of time.[2] A luminous variant, Lasting Images (2003) or the projection of a family film mortally obscured by a fire in which both "something" that was filmed (people, loved faces) and something that was recorded without being filmed (the optical and chemical effect of exposure to extreme heat, an accident, an explosion: we do not know) survive, verging on the subliminal. And all these things live together, engender and configure one another.

Yet another scenario: Khiam which in 2000 was not a cinema film when the artists recorded the testimony of prisoners on video, but became in 2008 a truly cinematographic installation[3] with Khiam 2000–2007, when they placed the screens of the two series of testimonies from the same former Communist militants alongside one another, recorded at an interval of seven years, the seven years that separated the two screens: the dynamics of the trace.

But as a manifestation of the truth of their work, truth that is doubly critical—critical of reality and critical of their creative output—and is transmuted into fertile creation,

1 The distinction between exprimer [express] and imprimer [(im)print] was discussed theoretically as early as the late 1960s by Jean-Luc Godard. See esp. "Lutter sur deux fronts," Cahiers du cinema no. 194, October 1967. To the vulgate of cinema thought of as allowing the author to express (i.e. an outward process) his internal world, Godard opposed the powers of a cinema capable of taking note of reality while giving it shape, inverting the artist/world (power) relationship in an approach that likewise intersected with the opposition between the sexes (the "camera-phallus" imposes itself on what it films, as against the "camera-vagina" that receives the world).

2 A Faraway Souvenir, a six-meter-long photographic frieze that aligns posters bearing the portraits of the fighters of Hezbollah and Amal in Ouzaï, a large avenue in Beirut. These posters were photographed twice, at an interval of seven years; their presentation in two parallel rows spatializes the passage of time as we follow a regular sequence of images that also conjure up the photograms of a camera film. The scale of the work, in which each image is very small—preventing us from looking from a distance—engenders "movement": the need for the viewer to move along.

the frieze if s/he wants to be able to see the portraits.

3 On "cinematography" as "aesthetic figures, relationships between the power of words and that of the visible, between the linking of stories and the movements of bodies, that cross the frontiers assigned to the arts" rather than as a technique or method of distribution, see Jacques Rancière, Les Écarts du cinéma, La Fabrique, Paris 2011, p. 19.

Aïda, Save Me!, 2009

nothing equals what happened with their second feature film, *A Perfect Day* (2005). *A Perfect Day* is a fictional film, with a script enacted by the actors to "recount something." It so happens that this "something," as always in the work of Joana Hadjithomas and Khalil Joreige, specifically concerns the relationship between reality and fiction. An unstable relationship: Is it fiction or reality that Malek's father, Claudia's husband, is dead? Is it an acknowledgment of reality to "declare him dead," or on the contrary a fictional gesture, a fabrication that suits one person and increases the suffering of the other even more? In the film script, as in reality, there is an authority that settles this conflict, and that authority is the law. The law as an instituted artifice which has determined for instance how many years after a man has disappeared he can be deemed dead, and in what circumstances. In Lebanon, where tens of thousands of people have disappeared, in particular because of abductions during the Civil War, this is very far from being incidental.

So Joana Hadjithomas and Khalil Joreige had no concerns. On the one hand they had the regulation of fiction and reality instituted by the professional practice of filmmaking, and on the other the legal regulation that organizes a "reasonable," "realistic" form of division between objective fact and a fact acknowledged in law, a dividing line where the feelings, interests, hopes, or need to live of those who are there are separated from those of others, who are not. Therefore *A Perfect Day* could blithely set out on its cinematographic journey, which it was doing brilliantly. Except that as early as the preview in Lebanon, wham! Reality comes in like a boomerang, emerging from a quite unexpected corner. The photograph of a man (actually a fleeting image!), the uncle of an assistant, who had died some time previously, had been used in the newspapers to represent the fictional character who had disappeared. And suddenly that man's second wife was asking for an explanation, rejecting this exploitation of her husband. A threat of seizure, a lawsuit, ruin for the film, its authors, its producers, its distributors: an abrupt twist of reality, and the law. Of course they had taken precautions, believed they were respecting the rules, but reality, and a woman's grief, wanted more. It was going to be necessary to confront one another, defend themselves, occupy the place assigned by the social distribution of roles, which defines individuals socially (filmmakers, artists) and legally (guilty or innocent). Then it did not happen. Something else happened, something very beautiful and very human. It was the joint invention, by the artists and the woman, henceforth called Aïda, of a way to move beyond those oppositions, with intelligence and respect.

That story is told in another work, *Aïda, Save Me!* (2009). In concrete terms, it was about a public lecture where the two filmmakers recounted what had happened. And what happened, what they did, but also caused to be done, made possible, was cinema in the purest meaning of the term. Cinema is obviously not the video recording of their lecture, it is the joint "production" of the work by Joana, Khalil, and Aïda: a collective gesture accomplished that makes it possible to move beyond the law, beyond the antagonism between reality and fiction, to elaborate a different state of problematizing our relationship to the world, to the living and the dead, the past and the present, to loved ones and human beings, whoever they may be.

And it is enriched by this already long experience that runs through all their work, but which has taken on a kind of theatrical form in the adventure of the photograph that comes back, that Joana Hadjithomas and Khalil Joreige were able to devise the great cinematographic machination that *I Want to See* represents. Catherine Deneuve *and* Rabih Mroué, the woman and the man, the foreigner and the Lebanese, the star and the actor, are necessary. The awkwardness and determination of each of them are necessary. The pasts and the present, the tranquility of the landscapes and the violence of the traces and testimonies, the threat of the militias and the buried mines, the niceness of the inhabitants, the madness of the frontier, are necessary. The car and the walking on foot are necessary. Seeing *and* not seeing. All those things combine to make cinema, i.e. manufacture step by step, shot by shot, minute after minute and frame after frame, an organization of knowledge and ignorance, phantasms and facts, visible and invisible: with elegance, affection, and humor, they engender the conditions for a different perception, a different understanding.

With *I Want to See*, Joana Hadjithomas and Khalil Joreige, who up until then had, among other activities, directed films, features, and documentaries, were most exactly, most concretely, what they had never ceased to be in spirit since they had started working together: filmmakers in their souls.

Envelope of the Super 8 film shot by Alfred Junior Kettaneh
Found in March 2001
Developed in May 2002
Telecine and color correction in June 2003

المغلف الأصفر الذي وجد فيه فيلم سوبر ٨ ملم صوره ألفرد جونيور كتانة
تم العثور عليه في آذار ٢٠٠١
تم تظهيره في ايار ٢٠٠٢
تلسينيه و تصحيح ألوان في حزيران ٢٠٠٣

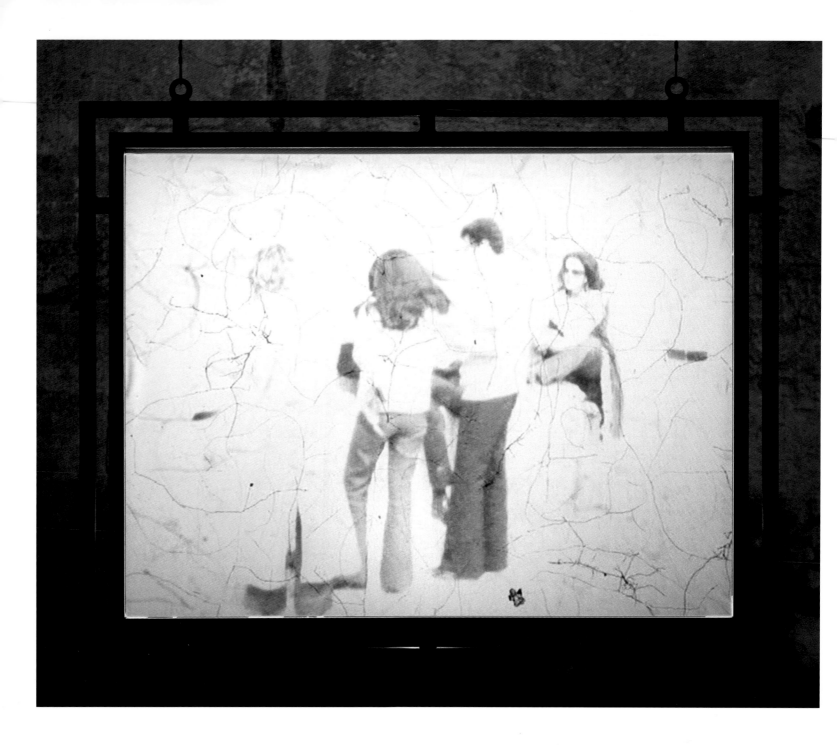

Lasting Images, 2003

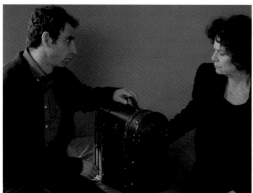

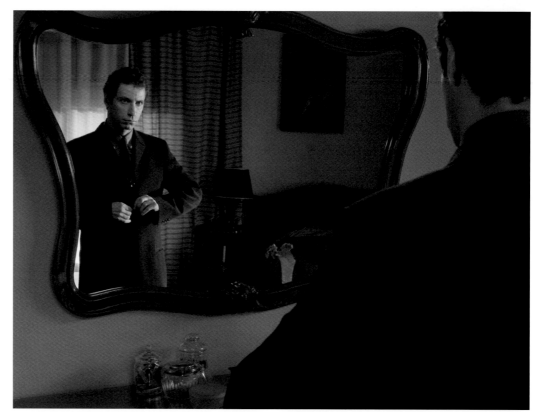

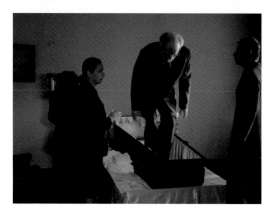

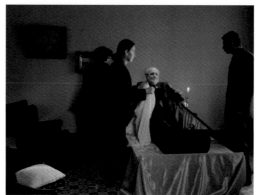

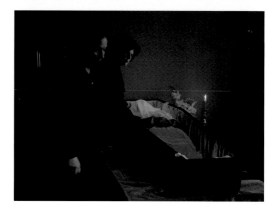

Film

Ramad

2003
26 min

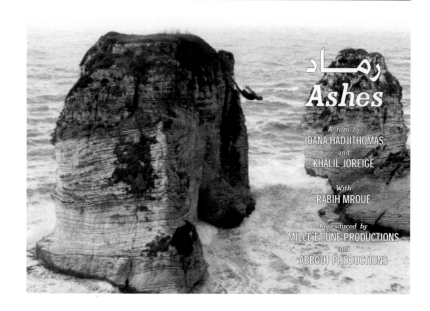

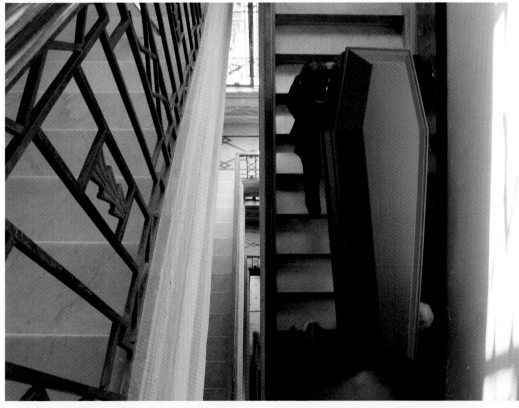

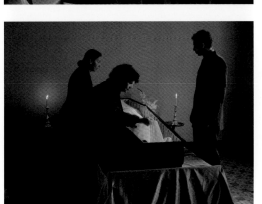

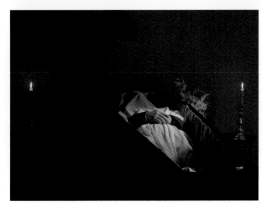

Making of

71

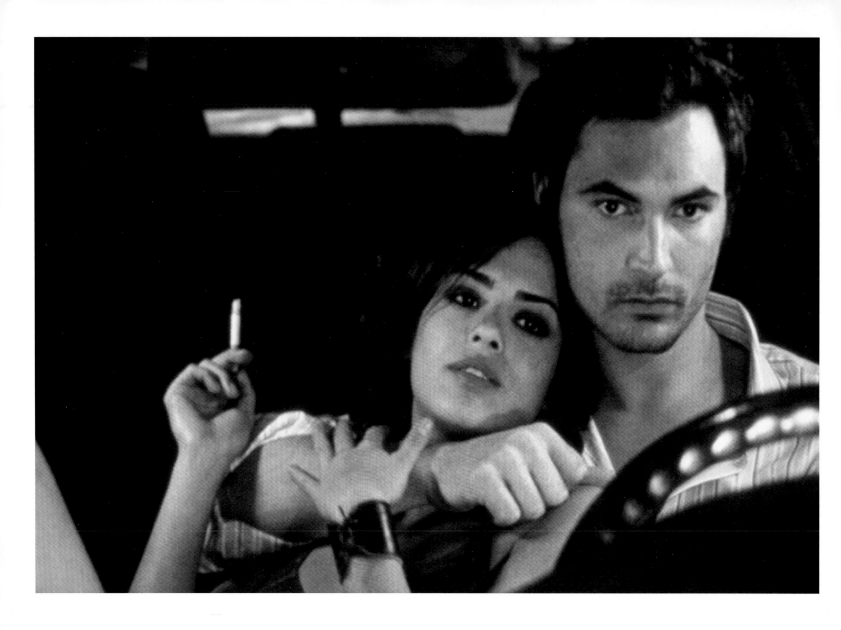

Film

A Perfect Day

2005
88 min

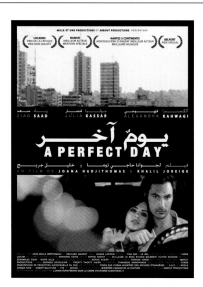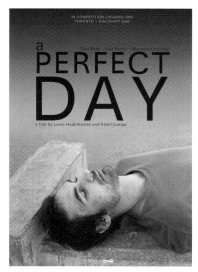

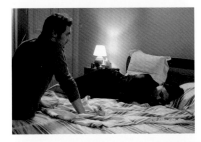
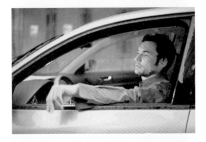
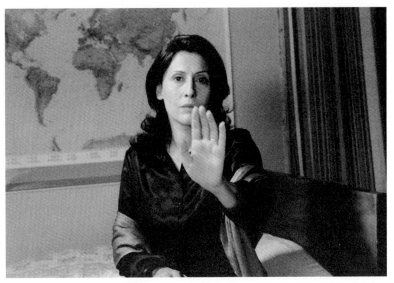
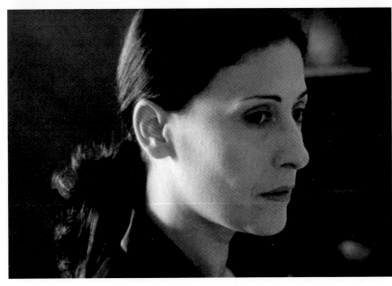
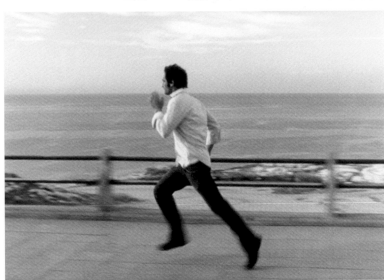

Making of

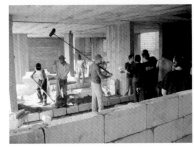

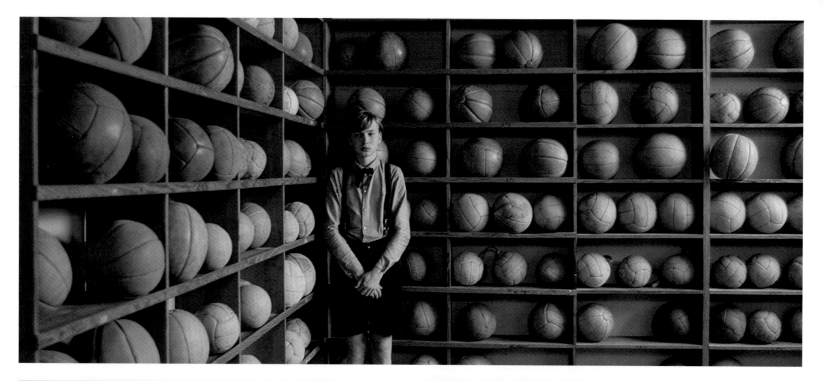

Film

Open the Door, Please 2006
 11 min

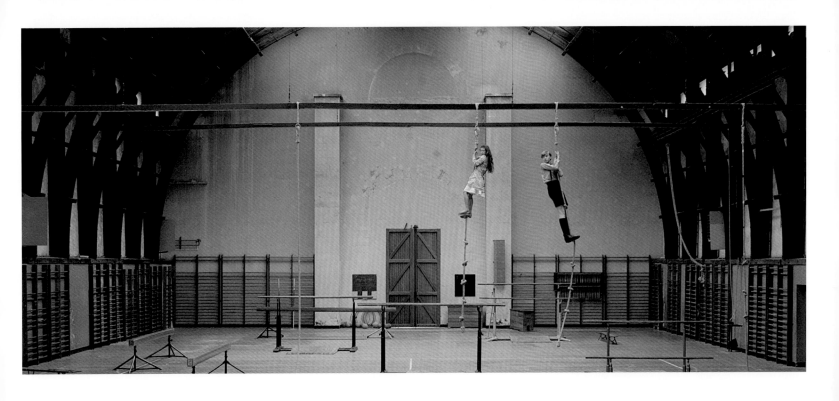

Making of

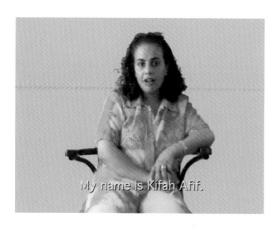

My name is Kifah Afif.

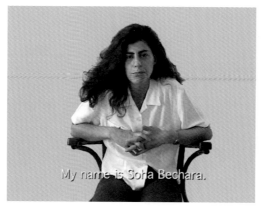

My name is Soha Bechara.

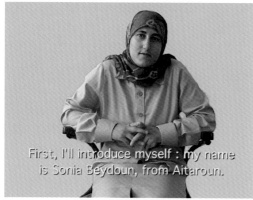

First, I'll introduce myself : my name is Sonia Beydoun, from Aitaroun.

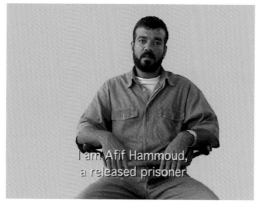

I am Afif Hammoud, a released prisoner

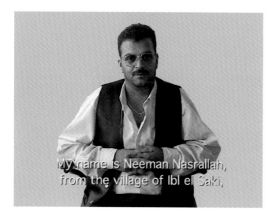

My name is Neeman Nasrallah, from the village of Ibl el Saki,

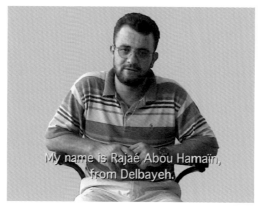

My name is Rajaé Abou Hamaïn, from Delbayeh.

Film

Khiam

2000
52 min

Kifah Afifé

Soha Bechara

Sonia Baydoun

Afif Hammoud

Neeman Nasrallah

Rajaé Abou Hamaïn

Film

Khiam 2000–2007 2008
 103 min

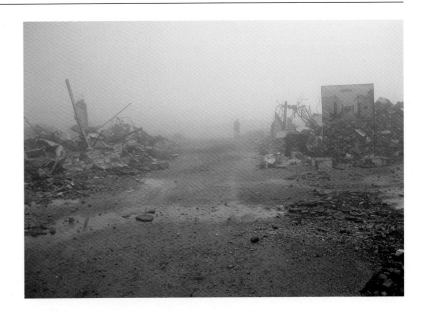

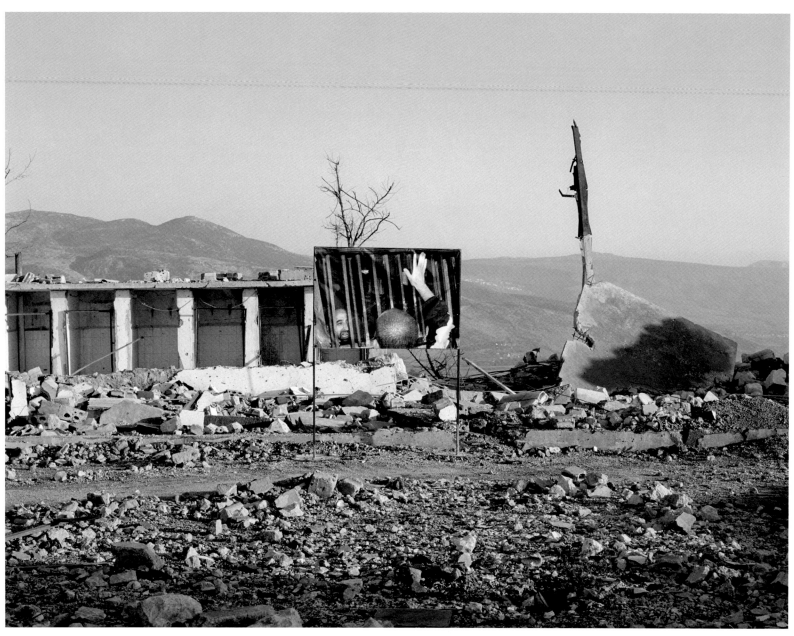

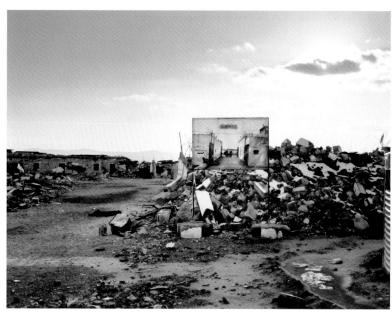

← *Landscapes of Khiam*, 2007

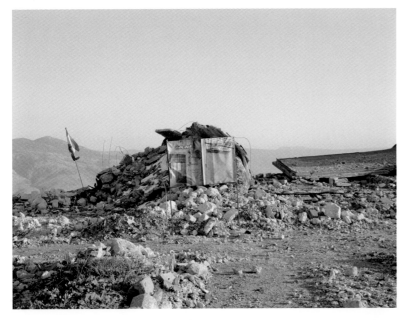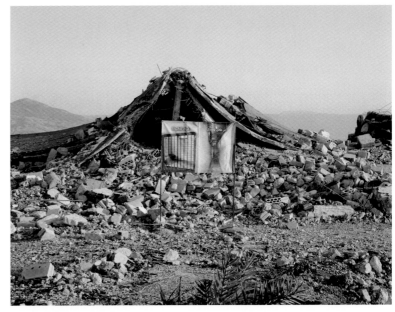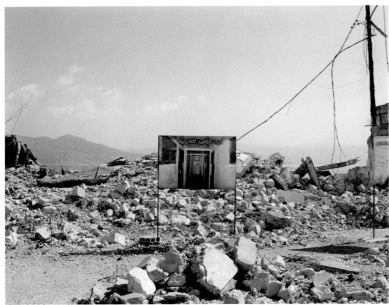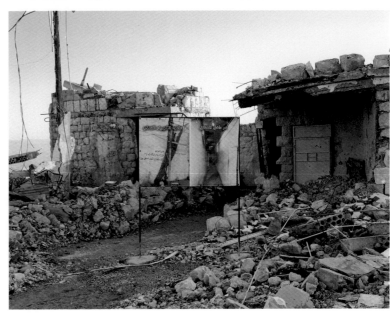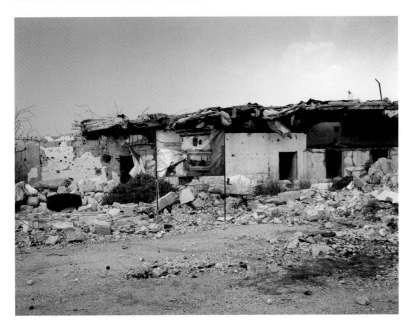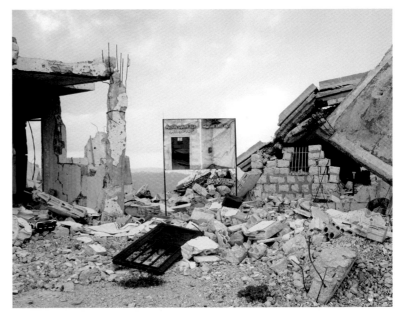

Landscapes of Khiam, 2007

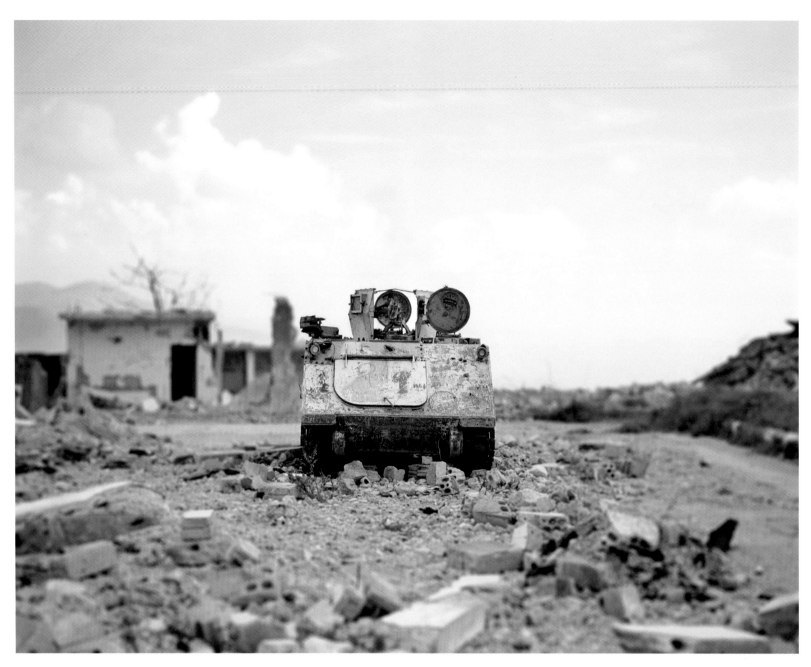

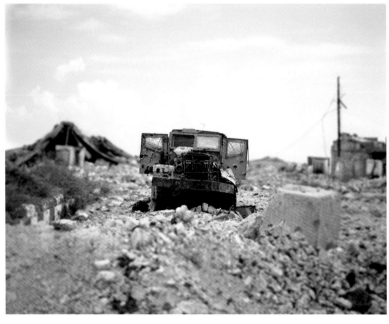

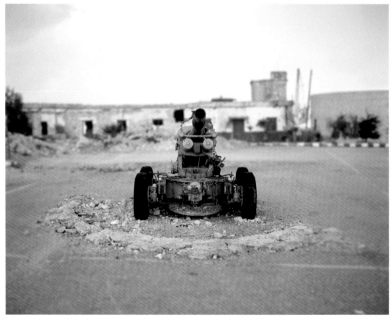

War Trophies, 2007

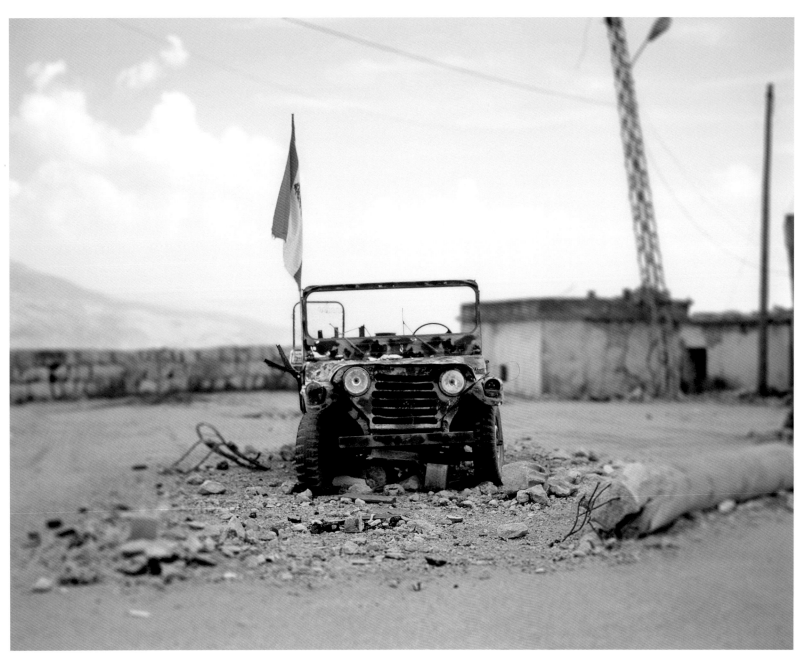

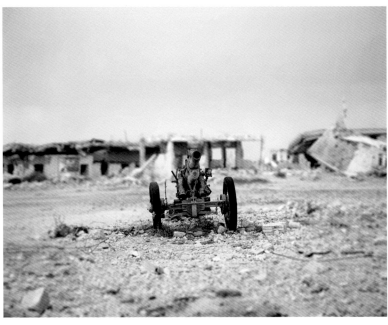

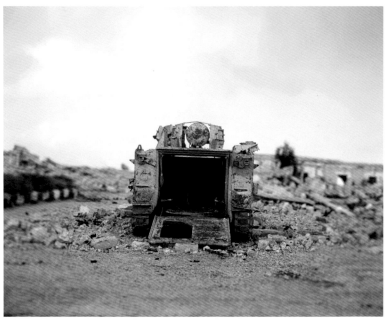

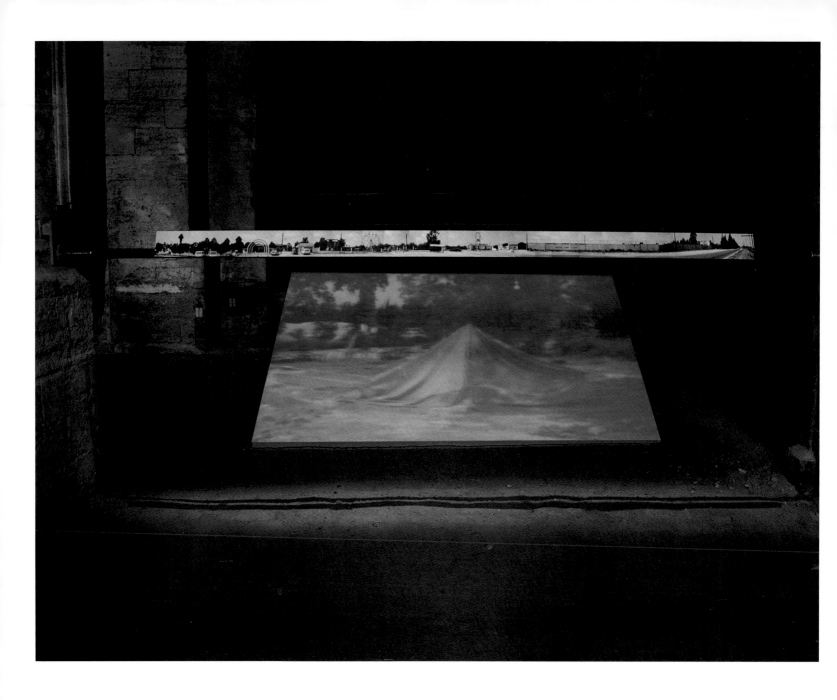

Ansar Recto Verso, 2009

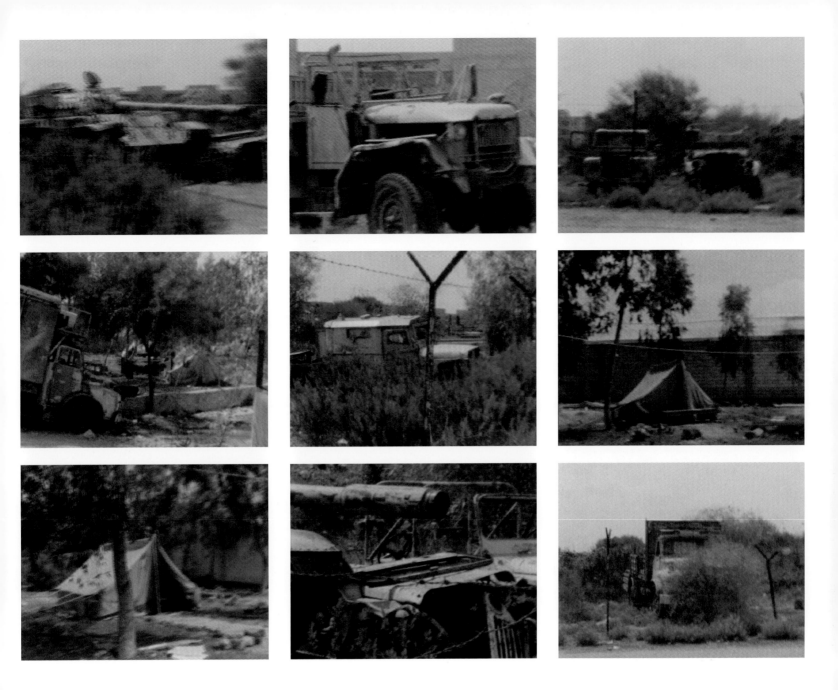

Ansar Recto Verso, 2009

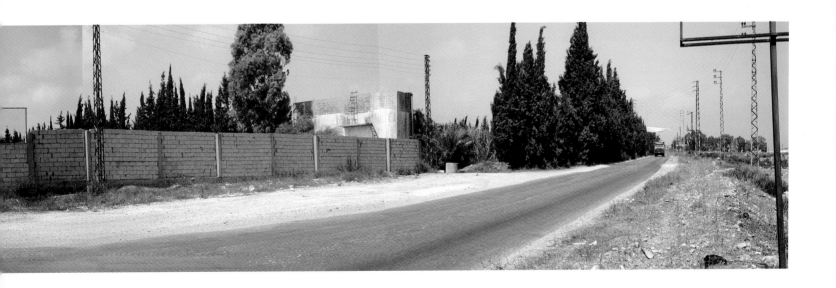

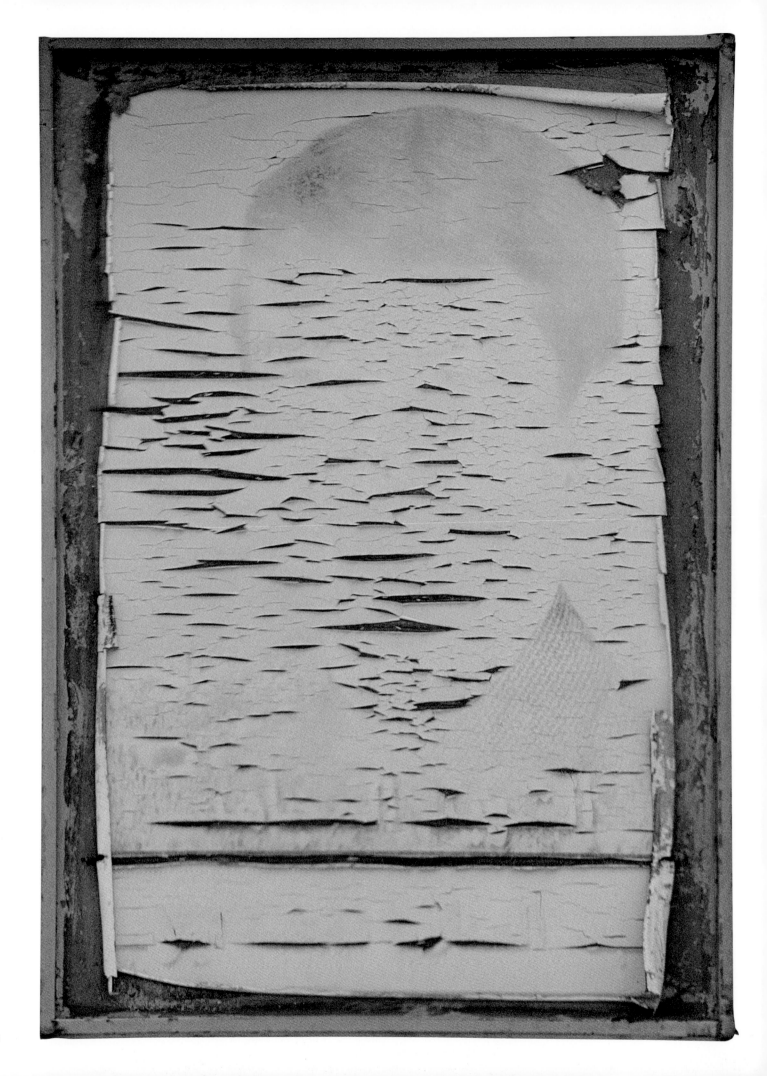

Faces, 2009

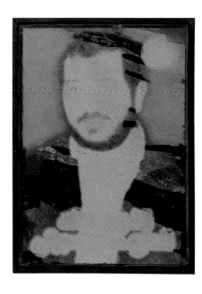

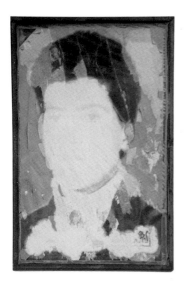 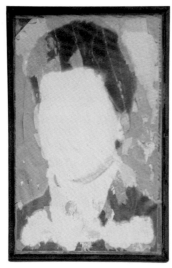 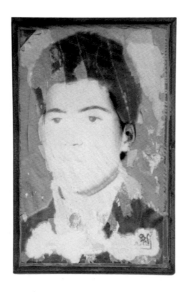

Faces, 2009

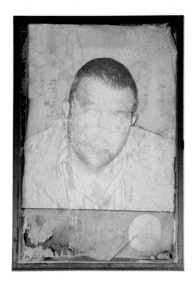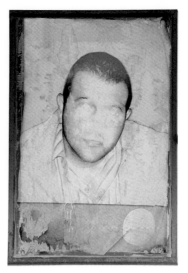

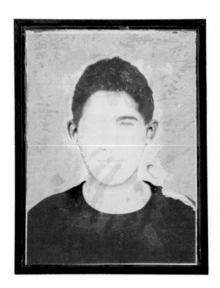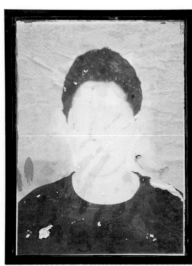

Faces, 2009

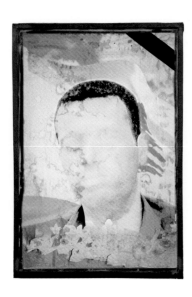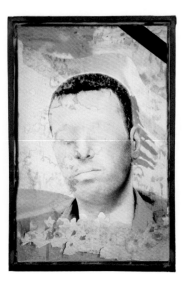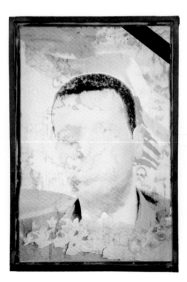

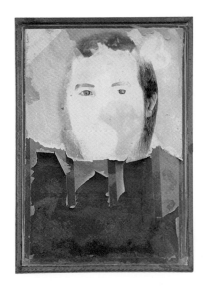

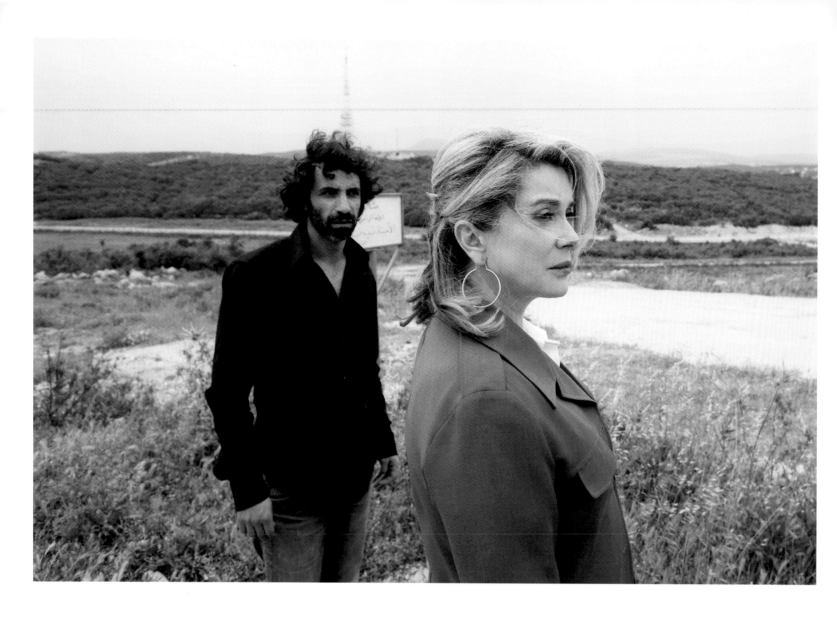

Film

Je veux voir (I Want to See)
2008
75 min

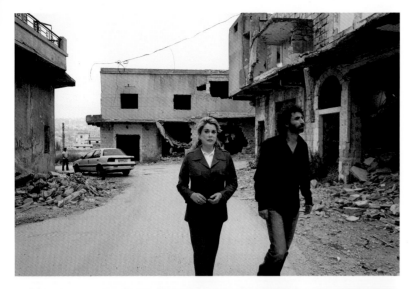

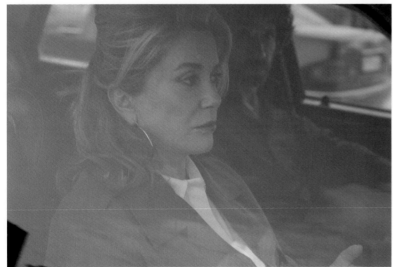
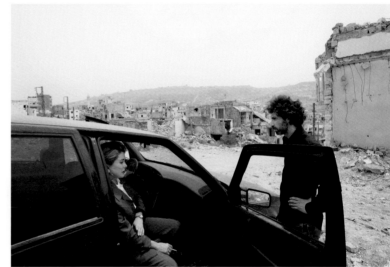

Making of

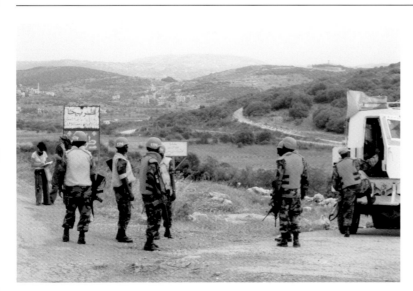

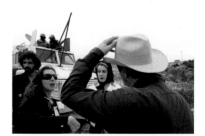

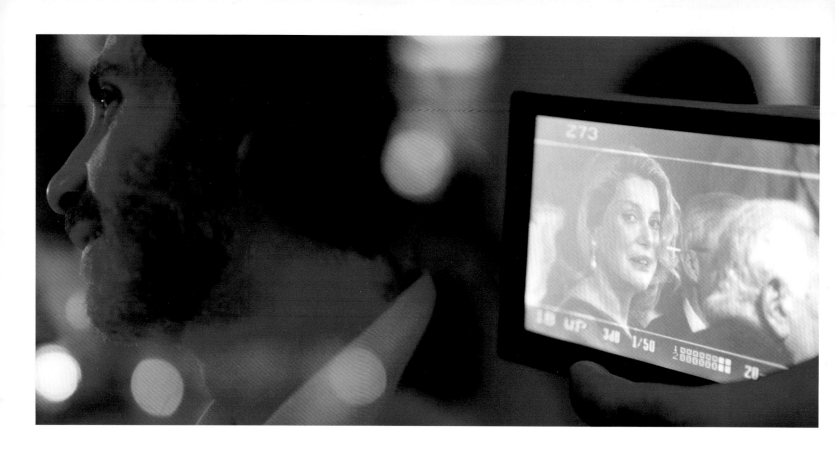

A Conversation with

Dominique Abensour, Etel Adnan, Rabih Mroué, Jacques Rancière, Michèle Thériault, Jalal Toufic, Anton Vidokle

JALAL TOUFIC

We live in a block universe of spacetime, where nothing physically passes and vanishes, but where occasionally things withdraw due to surpassing disasters [...] Your exhibition *Wonder Beirut* (Janine Rubeiz Gallery, Beirut, July 1998) revolves around a photographer who, along with his father, was commissioned by the Lebanese State in 1969 to do postcards, and who four years into the civil war and while shutting himself off in his studio takes down all these postcards, "which no longer referred to anything" since what they showed—Martyrs' Square, the souks, policemen on camels, etc.—either was destroyed or no longer existed, and "burns them patiently, aiming at them his proper bombs and his own shells [...] thus making them conform better to his reality. When all was burned, it was peace." Thus the following model sequence: photographs of burned buildings and scorched walls taken by him from the window of his studio a couple of years into the conflict; then, four years into the war, burned photographs that are later exhibited (this indicating that the war was then not yet a surpassing disaster, but just a localizable catastrophe); then in 1999, undeveloped photographs, a symptom of the withdrawal past the surpassing disaster that Beirut must have become: "Today, this photographer no longer develops his photographs. It is enough for him to take them. At the end of the exhibition [*Wonder Beirut*], 6452 rolls of film were laid on the floor: rolls containing photos taken by the photographer but left undeveloped."[1]

[...] I am aware that the burning of the photographs in *Wonder Beirut* has to do not only with matters relating to the medium as such, as in Frampton's *Nostalgia* (you state: "We wanted to return to an ontological definition of these images: the inscription of light by burning") but is also a reaction to the incendiary wars that were going on in Lebanon; and that the substitution of textual descriptions for the photographs is related not only to the

1 Quoted from Hadjithomas and Joreige's text "Tayyib rah farjîk shighlî" ["OK, I'll Show You My Work"], *Al-Adab*, January–February 2001.

problematic relation of words to images in audio-visual works, but also to the withdrawal of many images past a surpassing disaster. I had not expected the intermediary step of *Latent Image* between exhibiting rolls of undeveloped films in *Wonder Beirut* and a possible future exhibition of developed photographs. This intermediary step can be considered a contribution to the resurrection of what has been withdrawn by the surpassing disaster. The intended effect of the work of the one trying to resurrect tradition past a surpassing disaster is fundamentally not on the audience, except indirectly; it is on the work of art—to resurrect it. Such resurrecting works are thus referential. It is interesting to see when—if at all—you will feel the impulse to develop those photographs, this signaling the resurrection of tradition.[2]

JOANA HADJITHOMAS / KHALIL JOREIGE

In your question, there is a fundamental dimension of your thinking. Confronted with the "surpassing disaster," the images withdraw, they undergo withdrawal, their development time is delayed. And it is not the photographer's conscious, intentional will. In your book *The Withdrawal of Tradition Past A Surpassing Disaster*, you specifically write: "With regard to the surpassing disaster, art acts like the mirror in vampire films; it reveals the withdrawal of what we think is still there."[3]

You wrote that long before we met, but at the same time, thousands of kilometers away, we decided no longer to develop some of our images—and to attribute them to a fictional character, Abdallah Farah—but to make precise notes of them, like textual descriptions of photographs. Nonetheless, in our case, it was not the images that had withdrawn, it was we who had withdrawn them from the flow, who had left them in this in-between space, present but not visible. For years, we thought about this state of latency in which we found ourselves, which in a way affected our photographs as it affected our films. We were struck by the omnipresence of that latency in our lives, by the fact that this notion is so clearly related to the fact of making images in this city of Beirut. By definition, latency is the state of what exists in a non-apparent way, but can at any time manifest itself as something that is dormant and could perhaps wake up. Latency therefore has connotations that have to do with essence, but also with what is repressed, hidden, unfathomable, invisible.

In your thinking, you ask questions not only about withdrawal, but above all about what would signal the resurrection of tradition, which could interfere with withdrawal. In *Distracted* (2003), you consider that Abdallah Farah's very detailed description in a notebook about his photographs already constitutes a middle way that "can be considered a contribution to the resurrection of what has been withdrawn by the surpassing disaster."[4] We've waited and thought for a long time about the right conditions for the appearance of the latent images, the time when it would be right to develop these thousands of images, to surpass the disaster. The risk of latency is that the image may disappear, that it may not withstand the test of time, that too much time may have elapsed between the stimulus and the appropriate response. But some images come back to haunt us, as if certain representations did not vanish, like ghosts, traces of a mourning process that could not take place.

These lasting images are something we witnessed in particular with a Super-8 film taken by Khalil's uncle, Junior Kettaneh, kidnapped during the Lebanese civil wars and still recorded as disappeared. That film was a latent film. Junior must have taken it shortly before his

2 Excerpts reproduced, unaltered, from Jalal Toufic, *The Withdrawal of Tradition Past a Surpassing Disaster*, Forthcoming Books, 2009, p. 73–75.

3 Ibid., p. 56.

4 Jalal Toufic, *Distracted*, Tuumba Press, Berkeley, California 2003, p. 88.

disappearance, and had not had time to send it to the laboratory. It remained in its yellow bag for over 15 years, and suffered the consequences of the war and the house being set on fire. The various technicians we saw discouraged us. According to them, after such a long time the latent images would reveal nothing. And indeed, in spite of our precautions and prior research, when it was developed the film came out fogged. All that remained was a long sequence of blank images. But we decided to scan the 4,500 photograms of this three-minute film, one by one, and look for what was still there. And by dint of working on correcting the colors, on the contrasts, suddenly small variations appeared, movements in the image. Through the whiteness of the film, an image reappears, an image is still there, as if it could not be totally suppressed, and remained present although in a ghostly form. We had only to look at it for it to appear and go on revealing itself.

Thinking about the images, their disappearance, their latency, the conditions under which they reappeared, preoccupied us for a long time, as the titles of our works indicate: *Latent Images*, *A State of latency*, *Lasting Images*, *180 Seconds of Lasting Images.* But that preoccupation was disrupted by the 2006 war between Israel and Lebanon. Would it be another war, the 2006 one, that allowed the return of the images? After that war, we went back to see the Khiam detention camp; there wasn't much left of it, as the camp had been totally destroyed. It was a scene of ruin and there, all of a sudden, the image became imperative. We took photographs; there was the need to produce images, to make them visible. The Khiam camp had only six years of visibility. In the first part of our film about the camp (*Khiam*, 2000), we worked on evoking the camp because we could not go there, we couldn't film inside those walls. Today, those walls no longer exist, the camp is only a souvenir. So this question then arose: would it be the right time to reveal some of our latent images, to develop at least the images taken at Khiam by Abdallah Farah, five years earlier?

Is it definitive absence that makes it possible to bring back the past? But with the elapse of time, what state would we find those latent images in? Would the image return? And again, how would it return? In the end, no, it was not time, we didn't develop our images. Later, we talked a lot about it without coming to complete agreement. For you, even if that war could be seen as a catastrophe, it was not the disaster that brings the images back and allows their resurrection. We ourselves didn't manage to make the decision to develop our latent images. They are unchanged, still latent, including those taken at Khiam; our answer was different because something had changed within us, beyond us. It was time to emerge from latency. For us, it was the beginning of a different relationship to the image, for research to elaborate new strategies for representation, at the risk of a confrontation with reality, an attempt to widen the political and artistic territory.

ETEL ADNAN

I'd like to talk about *The Lost Film* (2003). It is an ideal film, seemingly relaxed, due to chance, but comprising several levels. A film about a film, it is the world of cinema, the movie theater, the reels, the intrusion, the magic, and the importance of the image in this society. Frozen image, photographs.

You don't really have reasons for making films, you find them afterward. *The Lost Film*, your film about the Lebanese Rocket Society (*The Lebanese Rocket Society*, 2012), the one where Catherine Deneuve says "Je veux voir" (*Je veux voir* [*I Want to See*], 2008),

they all have absence as their theme. Just as there is negative space, there is absence, as with the disappearance of Khalil's uncle. Absence is not a cliché, it is alive. For me, cinema is *The Lost Film*, with its illusory handmade aspect, whereas it is in fact very well made, and says a lot more about the Yemen than other films do. There is a whole hinterland, but nothing is emphasized. Your work is first and foremost about the image as such, and films, and here, by its absence, cinema shows its power—the image is so important that people are being prevented from seeing a film.

A major absence, the failure of something that didn't happen, just like the Lebanese Rocket Society's rocket. At the same time, *The Lost Film* is light; there is irony. We wonder if the story is true. I like this desultory, seemingly not serious side. If I was a filmmaker, I'd like to have made that film. It is an ideal film. It grasps the event, it follows it, it is journalism at its best. The thing takes place in front of us without being completely foreseen in advance. It is at the root of the other films. It expresses fascination with absence. Running after the thing that is absent. Giving importance to the invisible. We all live with the bus we have just missed, the journey that didn't happen, loss, or the impossible. It's a huge dimension of life.

This film adopts a very Arab attitude. American cinema would have turned it into a detective story. It's neither European, nor American, it's like something that stands alone. We search, even if we don't find ... A carefree attitude, but not couldn't-care-less. It's a film that grasps the event that happens. It approaches true documentary, reality. It impressed me greatly, and impresses me even more. It appears loosely constructed, but proves to be very skillful.

Your filmmaking touches on something essential. It focuses on a non-event. Non-events fill our lives; they are much more present than anything else. In the Apocalypse, there is the night of the non-event. It's the night that caused the Lebanon war.

JOANA HADJITHOMAS / KHALIL JOREIGE

For a long time we wondered what impelled us to go to Yemen. What exactly were we looking for under the pretext of investigating the disappearance of the copy of our first film? Taking a cine camera and setting off. There are things like that that you do because they have to be done. It isn't an impulse, an unconsidered act, it's as if it had to be. It's Catherine and Rabih on the roads of South Lebanon, at the frontier. It's reconstructing a sculpture representing the Cedar IV rocket and driving it round the city. They're not abstract ideas, we're physically setting an experience in motion. It's a question of embodying that experience. In the Yemen it involved retracing the film's exact movements, and trying from that search to question our status as filmmakers in that region of the world. How does one set about filming in regions one doesn't know, with what eyes do we look at an elsewhere?

We were supposed to shoot the film in October 2001; we'd checked the locations and already filmed certain scenes, but after September 11, the distributors pulled out of production of the film, arguing that the project was now anecdotal in view of the events. We were intrigued and disconcerted by the term anecdotal. There were to be certain subjects that would have to be talked about in the region, and everything else would be "anecdotal." We went back to the etymological definition of the term, that of a "story kept secret," that of a story you don't see, but which in a kind of way conveys our individuality, our existence as singular beings, not as identity or nationality. The anecdotal then becomes for us the extension of our work on latency, but also on our individual histories, claiming a certain lightness, far from the big subjects, a form of resistance to all that.

We made this film in Yemen to strike out at accepted ideas too. *The Lost Film* is a search for the challenges of representation in this part of the Arab world that we belong to, a reflection about the fact of producing images that try to redefine themselves far away from the often Western, Orientalist perceptions, far away from consensual clichés or local representations that generally convey the iconography of power and the authority in place, as well as the dominant discourse. Rather than being a film about Yemen, the film turns out to be more like a film in Yemen, a film made up of those questionings, but also of fragments, stories we experienced in that country and which challenge us, as well as our prejudices. In a kind of way it is our "our journey into Orient," for us who have criticized "Orientalism" so much.

The absence you talk about, that too determines our relationship to traces, to temporal inscription, to memory, to history and oblivion. It is the invisible aspect at the very heart of cinema. We edited the film from our location scouting, as after September 11 it became difficult on a production level to go back to Yemen and film there. In the face of that lack, the absent image, the one we hadn't filmed, was replaced by black images, research into the very material of the image. And it is that dearth and these figures of absence in the film that gave us the freedom to speak, to appropriate the images. This lack at the heart of the film, this failure of presence, expresses the difficulty of grasping a country, a culture, and displaying them. Above all it reveals an ambiguity surrounding images, how hard it is for them to "appear" in certain places and at certain times. It's not that they are not there, it is their visibility that is compromised.

When we're making films, it's important for us not to be frightened, to put ourselves in danger, to risk failure, and dare fragility. As is often the case, our films have very little to hang on to (what you refer to as "handmade"). We don't know if there will be a film, if anything's there, but we don't control the experiment, we take the risk of fragility, that of not being performative, but being involved in research. That's how we mostly see ourselves: as researchers. That is stressed in *The Lost Film* where we are searching in the literal sense of the word.

In each film, the desire is to dismantle, deconstruct one dramatic element—or even several—to work on the spectator's experience. This gives rise to "unidentified cinematographic objects" that attest to our urgency, our search at that precise moment. In this film, we treated figures of absence through black images, but also slow-motion sequences, voice-over, a non-linear narrative that develops through association, add-ons, to arrive at a very personal questioning, that of our own status as makers of images in the region.

That "non-event" you are talking about brings us nearer to the anecdotal. It is loss, the unfulfilled dream, the body that has disappeared. But also the minuscule, the detail, the unspectacular. At the same time it is the acting out of the consciousness each individual has of his/her own life, toward what is sometimes a "pseudo-life" often composed of illusions and phantasms imposed on us by today's society, with its frenetic capitalism, its latent colonialism, and the conflicts it helps engender, like those in the Middle East, like that Arab apocalypse one of your visionary poems describes:

When the sun will run its ultimate road
Fire will devour beasts plants and stones
Fire will devour the fire and its perfect circle
When the perfect circle will catch fire no angel will manifest itself STOP

The sun will extinguish the gods the angels and men
And it will extinguish itself in the midst of its daughters
Matter-Spirit will become the NIGHT
In the night in the night we shall find knowledge love and peace.[5]

DOMINIQUE ABENSOUR

It has not escaped our understanding that while the questioning of the image is at the heart of what you do, your country, Lebanon, is certainly the lungs. Your first works (shown in *Beirut, Urban Fictions*, Institut du monde arabe, Paris, 1997) straightaway demonstrate a desire to measure yourselves against the flaws and failures that run through this problematic territory like an open wound. Your subsequent work confirms all the interest you take in failure or the missing often at the center of your works. In this respect, we note all the importance given to the absence of writing about the Lebanese conflict in the contemporary history of that country, to the absence of pictures of the fearful prison that Khiam, to the absence of alternatives to the ever more spectacular media images of the war (*Je veux voir* [*I Want to See*], 2008)*,* but also to the loss of those who disappeared during the conflict, the loss of oneself during episodes of sleep apnea (*A Perfect Day*, 2005), and even the disappearance of one of your films (*The Lost Film*, 2003). One could think that you would set out to fill these absences. Well, that is not what you do. If you take on the role of archaeologist or historian, it is rather to present this lack of image and open up a space for "the emancipated spectator" that we can be, "capable of seeing what he sees and knowing what to think of it and what to do with it," according to Jacques Rancière.

Is that spectator not fully involved in your works? You call on them as far back as 1997 with *The Circle of Confusion*. Confronted with the 3,000 stick-on images that compose a view of Beirut, they do not try to move them around to reconfigure the city, preferring to carve it up, taking fragments of it. In doing so, they discover themself in the mirror concealed underneath. In quite different circumstances, in July 2006, at the time when Israel was going to war with Lebanon, the journal *Les Cahiers du cinéma* approached you in Paris. It was the first time that you were experiencing this war from a distance. "We don't know what to do," you wrote, "we try to act symbolically, perhaps desperately. Anything but remaining mere spectators in inaction." And you went into action by making *I Want to See*. Between fiction and documentary, the film features a spectator figure, Catherine Deneuve, an icon of French cinema, who travels through a country in ruins after the war alongside the Lebanese actor Rabih Mroué. Between these two characters, a space opens up for those who are watching the film *and* the traces left by the war. At the same time, *I Want to See* allows us to take the measure of the power and powerlessness of the image.

Is each of your works not made to impact on reality by displacing the givens of the question of the image and offering the spectator a productive position? The duo you form together is undoubtedly the active agent of an approach that always deliberately involves others.

JOANA HADJITHOMAS/KHALIL JOREIGE

For us, art is a life project. We live together and work together, we are continually discussing in a relatively uninterrupted dialectic, we think together in a personal and private way. Our collaboration is an active principle of stimulation, emulation—if we can put it like that. It is not simply the subjectivity of one or other of us that is involved, but an interweaving of

5 Etel Adnan, *The Arab Apocalypse*
 (1980), The Post-Apollo Press,
 Sausalito, California 2007, p. 78.

our concerns. What we produce emanates from both of us, that is from neither one nor the other, but from an organic, autonomous body totally ready for the meeting with the other.

We work very little on the past, on wars; rather we explore our present, and in a more literal way what happens to us, what we meet, what we experience. A latent film, works made in detention that Soha Bechara shows us when she comes out of Khiam camp, postcards still being sold in bookshops when they depict a reality that has virtually disappeared, the 2006 war and the way we experienced it abroad, or again the fact of having to declare someone close to us who has disappeared, dead … All those things are part of what we have lived, and help us to understand it, to ask ourselves questions about the manner in which it is in fact possible to live through this present. The sometimes hysterical way of living through it as a repetition of the instant, of living through the instant rather than enrolling in the long term, that too is something we have presented in our films. Their time frame is virtually always that of a single day. It is for that reason among others that our visual art and cinematographic works are very linked formally and thematically. They express what is preoccupying us at the same time.

There is a very considerable overlap between the personal, the intimate even, and the public or political. We are not thinking of the audience, but of the possibility of meeting the other, the one [Robert] Bresson calls "the spectator," that person we do not know, but recognize. There's the desire, the hope for that meeting, the call for the participation of the person looking, and this has been the case since *Circle of Confusion* in 1997. A spectator who thinks, appropriates the space, the void sometimes, who touches the work, transforms it, gives it meaning. The experience is intellectual, but physical and visual as well. Cinema raises the question of what can't be seen. That doesn't mean that we don't see, but that in looking we question ourselves about what we are seeing. For some time we've been trying to make films involving sensation, that make the spectator feel, almost physically, the invisible, the latent, the absent, but also the other.

There is a lot of space in our films, lots of room for the other. That space is left "pending," hoping that the spectator will actively take it over. He can choose not to occupy it; our works take the risk of that non-meeting. Some images refer us back to ourselves, they leave us alone, we have to project (or not project) our images, our emotions, identify ourselves without being particularly reassured or consoled. Our films, our installations, are not about consolation that would make us accept this world as it is and help us bear it, but more about the sharing of anxieties, emotions, the rejection of a certain order of things. Every project is therefore addressed to the other. Will the spectator occupy the space left vacant so that he can appropriate it? When the work becomes detached from us, we become spectators ourselves, spectators of one another. The other is often there. There is room. We're quite used to numbers. As Gilles Deleuze and Félix Guattari write in *Mille plateaux* (*A Thousand Plateaus*): "We work together. As each of us is several, that already makes a lot of people."

JACQUES RANCIÈRE
Your films subvert the debates about artistic commitment and the representation of oppression in an exemplary way. They do not wonder if war and its horrors should be represented—or how they should be represented. They are interested in the violence war does to images and the way in which it can be turned around. The Lebanon war has not only led to the disappearance of those men who, like the absent hero of *A Perfect Day* (2005), set out one day to go about their daily business and have never given any sign of life since. It has also made

a great many images invisible, those that remained in reels, like the images of the photographer Abdallah Farah: latent images that there was no longer any equipment, any paper to develop. In their place there are words that tell us what they depicted, unrevealed reels, almost blank prints. From this violence done to images you have drawn the principle of a new art of resistance. You play on the latency of the images to exempt them from the habits of domination. From the victims of the wars in the Middle East we expect testimony about their sufferings. You give us no such thing. You speak of what links the work of the image to that of war and memory: absence. *A Perfect Day* grasps the relationship of a woman and her son, of vivid memory and the impatient future, the day when it will be a question of declaring the father who disappeared 15 years ago, dead. *Khiam* (2000) speaks to us of a detention camp run by the occupying Israelis which it was impossible to penetrate just a short time ago, by filming six freed detainees in a strict studio environment—their spoken words alone have to provide a representation of this camp with no images. *The Lost Film* (2003) recounts your travels in Yemen, in search of a film you had sent there which had disappeared: the opportunity for moving to and fro between the images you were able to get hold of there, those you were not permitted to take, and the only images of the "lost film" you were able to recover, those that censorship had preserved by suppressing them. So an opportunity to confront the artistic interplay of the absence and reality of repressive acts. Art's policy does not serve the cause of those dominated. It subverts the positions of the conqueror and the victim by subverting the relationship between reality and fiction.[6]

JOANA HADJITHOMAS / KHALIL JOREIGE

Very early on, in Lebanon, we were confronted with all sorts of images instrumentalized by the different militias. Those images were partisan and militant. They set out to be illustrative, and even if they were fundamentally contradictory and opposite, they operated within the same conception of the image. So strangely enough those images were very politicized, but not political. As for the images shown by the regional and international media, their simplifications and their mapping were just as violent and partisan. Right from the start the image that intrigued us was the one that was not on the side of power, but had to find strategies of resistance and existence inside those monopolies, those hegemonies. Therefore we were critical with regard to images, and at the same time needed to produce some. Because of the war, certain forms of representation were disrupted. We had to take account of the complexity of the situations we were experiencing, of that loss of reference points.

It was perhaps in focusing on notions attached to architecture that we could come to terms with it in the most obvious way, and that may be one of the reasons why we've dealt so much with the question of ruin. What war does to buildings it does to all reality. With the impact of a shell, there is a loss of topography; recognition is impaired. The image too can relate its own transformation, not only at the level of what it represents, but at the level of its issues, its experience, its materiality even. That is how we came to destroy images by burning them or keeping them latent so that they would become relevant again. Our images set out to be rugged, not smooth, to take account of their very process of production. The loss of a referent results in the establishment of other forms of causality, narration; the logical relationships are overturned, irrationality can be the result. That is one of the reasons for the blurring of certain categories, including reality and fiction.

Later on, after the civil wars, our works consisted in reporting on what the other images didn't show, that is the part of the invisible, the repressed, in asking questions,

6 Extract from Jacques Rancière, "Joana Hadjithomas & Khalil Joreige," *Festival Paris Cinéma 2007*, 2007, p. 90.

casting into doubt. That is why, even if our images set out to be political, they cannot be militant, for they question themselves, they doubt, they do not know, they are searching. Nor are they in trauma or in affect since we are searching for a place for thought and work. It is not a matter of dealing with the victim, but of finding devices and protocols for being able to approach pain. The image thus becomes the site of an experiment, of an attempt to share and perceive certain realities. But in a singularity that escapes generalities and pre-conceived identities. To achieve this, it is a question of employing different strategies, in particular the change of perspective or rather the misalignment, the displacement of the gaze you speak of.

The image is a place of work, it is not just an affect, an emotion. The question of the face is no doubt more revealing. In the torment afflicting the region, the media show faces reduced to a function, to a form of reaction: the victim. A victim without a real story. Those faces that ought to touch us do not adequately succeed because they no longer have any singularity, history, or name; they are simply a status, the status of the victim we sympathize with but don't identify with, that we deplore without really seeing. In our part of the world we have, in a way, lost our faces. So our images have constantly to frustrate the scopic gaze, and undress the phantasm that today clothes the representation of wars, to fight against the very principle of the use of the mediatic image that sets out to be effective, or spectacular, and to develop a more intimate relationship, an experience perhaps intended for the "emancipated spectator."

ANTON VIDOKLE
An artist today aspires to a certain kind of sovereignty, to the freedom to work as one pleases. Unlike artists let's say before the French Revolution, who worked merely to satisfy a commission from the church or the aristocracy, or to serve public taste and critics, artists now understand themselves as being not only capable of deciding what kind of practice they want to have, what subject matter is important to them, what form it may take, and so forth, but also as fundamentally free to follow their own internal interests or to respond to urgent events in the world around them. And this fundamental freedom is understood as a basic condition of any work of art, as the pillar that the content and form of any artwork rests upon.

While it's tempting to assume that artistic and popular sovereignty are connected and interdependent, this is not always the case. Interestingly, claims to artistic sovereignty are often found in the works of artists in the most unfree circumstances. The capacity for artistic expression in conditions of extreme repression is movingly explored in your film *Khiam* (2000), which depicts works of art created secretly by Lebanese prisoners in a high security Israeli detention camp.

Much like popular sovereignty, artistic sovereignty is perpetually being contained, contested, recuperated, or co-opted. While as an artist you may think you are free to do as you please, in order for your work to be economically sustainable, critically acknowledged, or even simply brought into contact with the art public, it needs to conform to certain network protocols that dictate the forms of art production that circulate. With the ever-increasing professionalization of artists, curators, and other practitioners in the field of art, it seems that the industry of contemporary art is actually moving toward a certain restoration of a more prescriptive position vis-à-vis the artist. How can the artist reclaim sovereignty today?

JOANA HADJITHOMAS / KHALIL JOREIGE

We studied neither art nor filmmaking, we came to them through necessity, a necessity that was not really economic, but more existential: how to react to what was being reinstated, and fear that it would start all over again. Our work was critical and eminently political. For years, our interest was localized and allowed us to have meetings, to weave convergences, and have discussions and collaborations—with no market, exchanges are simpler and people give more freely because the value is not financial. As often as not, in our works it was a question of dealing with very specific situations in our present in Beirut. In a way, our work can be read as a reflection of the living conditions in the city.

Because no structures for contemporary practices existed, our work developed in parallel spheres that constantly had to be invented. Moreover, the first exhibitions with Ashkal Alwan and Christine Tohmé were often held in public places in a intermittent way. Our first exhibition at an art venue in Lebanon was in 1997, at the Galerie Janine Rebeiz, in the context of Photography Month. The works were sold. Strangely, that made us feel uncomfortable. Since our works had not been created for that purpose, we hadn't taken that aspect into account. That episode was exceptional, because there wasn't really a market or any real interest from the art world. The main consequence of that absence was that it freed us, protected us, and allowed us to find our own forms, and to invent ways and means of representation as well. We had a freedom of format, tone, processes. Our videos could last one minute or two hours, they depended solely on their intrinsic duration and underwent no formatting. The corollary of that situation was that it obliged us to have other sources of income. For most of our colleagues, this came from teaching. We got involved in multiple practices—cinema, art, teaching, criticism, performance—which saved us from having to depend on a single sector or source.

That also helped us to find our individual character and our working rhythm—without adhering strictly to an ever more crowded calendar of events. We exhibited more and more, often with Christine Tohmé in Lebanon, and with ever more curators abroad. Our work was circulating and making a confrontation between a localized practice and a contemporary dialogue increasingly possible.

There is something in the order of the exercise of freedom in the very idea of sovereignty, and more specifically it also strikes a chord with the notion of competence—in the legal sense. We mean that our sovereignty for us depended on the possibility of working here and now, on situations and specific aspects. Our freedom, in fact, was to be able to develop work that was very anchored in the specific Lebanese realities.

It would be possible to distinguish between two forms where the emergence of a market, of an international interest in Lebanon are concerned. The first form was not yet from collectors, but rather what preceded them: the attention from curators who took an interest in these practices. Then came a second period when the galleries and collectors stimulated the situation financially and marketed some of these works. The art market gave us certain production resources, the opportunity to work at different scales, but at the same time we are very aware of the risks, and of new sponsors who could have an adverse impact on research, or generate new ways of working. Today, and especially in our region, in particular with the financial strength of the Arab world, the art market is becoming dominant and getting ahead of practices and situations. Indeed, it creates new ones and induces transformations, changes such as the resurgence of nationality, to replace the notion of territory. We continue to depend on different sources, carrying on with our different activities; that

is why we still feel free. We are filmmakers and artists, and our works are strongly linked thematically and formally. We like this position, the fact of blurring the frontiers or the boundaries of marked spaces, invading territories where we are not expected.

We regard ourselves as seachers. While the art world has long regarded us as film-makers and the film world as artists, we like to invent this new territory and this position. Escaping definitions, categories, and not becoming cynical, thinking that art and filmmaking are places where things are still possible. While our freedoms are sometimes restricted at a political level in some countries of the region, it is by fighting for our sovereignty as artists that we today try to preserve the very conditions of our existence.

RABIH MROUÉ

In the film *Je veux voir* (*I Want to See*, 2008), the frontiers between fiction and reality disappear. It becomes hard to distinguish between what is scripted and acted on one side, and what is real and spontaneous on the other. I act the part of me. And I no longer know which is the real Rabih, and which is the character; everything gets mixed up. I no longer know what Khalil and Joana invented, and what they left as it truly was. In the film, Rabih goes and visits his grandmother's house in her village of Bint-Jbeil, in South Lebanon, which the Israelis had demolished. He is accompanied by Catherine Deneuve, who plays the role of Catherine Deneuve. He can't find the house, gets lost in the debris, and would have lost his way if Catherine had not caught up with him at the last minute.

In fact, my identity card states that I was not born in Bint-Jbeil. Nevertheless, everyone's convinced that I was. Their evidence? The film itself; consequently I believe it too. I wonder which document is strongest: the one I carry in my pocket, or the one issuing from the world of fiction? Are the title deeds that most Palestinians continue to keep on them, along with their identity papers and the keys to their houses, not sufficient proof of their rights to their land and nation which the Zionists despoiled and appropriated? Do these documents not therefore suffice to establish "the truth"? So would they need fiction to recover their rights?

The question has to do with documents and our use of them in art. Do we perhaps need the fictional world of art to write and confirm our history? Has the time perhaps come to let the latent images of our violent history appear and put them into fiction in order to convert a fictional artwork into an official document? Might there not be some means other than the fictional world to tell our true stories and reintegrate our names and complete our individuality in a state torn by belligerent confessions, and constantly threatened by interminable civil wars? In *I Want to See*, the frontiers between documentary and non-documentary, written and not written, personal and not personal, disappear. Might it be necessary to go into fiction to exist? Might I need the film to recover something from my lost memory? To remember that I'm from Bint-Jbeil?

In the moments when we oscillate between a past composed of defeats and nostalgia for a glorious past, we are condemned to make ourselves ridiculous, to act as hysterics. That's why I continue to prefer not to produce images, and I always seek to have my image written in words. For words respect absence and preserve the unfinished act.

JOANA HADJITHOMAS / KHALIL JOREIGE

For us your question brings to mind a thought that Soha Bechara, who was detained in the Khiam camp for ten years, expresses in our film *Khiam 2000–2007*: "When liberation took place and we entered the camp, I was able only to describe the image of the camp that persisted in my imagination. For example, prison no. 4, I'd never been there except in one room, or had seen nothing except through the crack below the door. When the liberation occurred, I saw that passage, that room, I entered it. But after that, after the visit, the image of that passage as I'd seen it through the crack under the door remained in me. The passage as it really was could not cancel the image of it I'd seen and imagined. Because that's how I'd seen it and lived it for ten years."

These notions of the imaginary and recognition are central to our thinking, especially in a context where history is being rewritten. They are not theoretical. The rewriting of history or its reconstruction are the subject of works like *Khiam 2000–2007* or the filmed performance *Aïda, Save Me!* (2009), in which the photograph of the father used in *A Perfect Day*—a character, an image reinterpreted and invented in this fiction film, shot like a documentary—is suddenly transformed at the moment when the film is released and becomes a document, and even an exhibit. This rewriting questions not only attempts by the political forces or victors to impose their version of history, but also our tendency to let imagination invade memory, or else let fiction replace the real, the document. For a long time, we also provided context for our images, accompanying them with texts, distrusting images left on their own. We found it difficult to trust the image, to believe in it, to recognize ourselves in it. For a question arises: does recognition withstand the time confusion we sometimes find ourselves in, the discontinuity of our history, and the violence of certain events we experience?

Given the violence of the 2006 war, in the face of the spectacular images on television, what kind of images can we still produce? What can cinema do? What can be done to express the pain, speak of the victims, bear witness? Very quickly we had the idea of the device of a film designed as a meeting, an experience: introducing fiction, through a cinema "icon," and an artist who, like you, represents our generation, in the devastated locations seemingly no longer capable of lending themselves to anything other than a scheme of images hurriedly named reality or documentary. Suggesting to Catherine Deneuve to go to the frontier of South Lebanon with you comes close to alchemy. In this context, what will this meeting lead to?

I Want to See works on the very nature of fiction, the very nature of cinema, and tries to induce a sort of chemical reaction between a fictional body, incarnated by Catherine Deneuve and by your body, and places where the weight of reality is very heavy. It is the meeting of your two stories, of your two faces. Each of you plays your own role, but those words alone are mind-blowing in their meaning and complexity.

The great difficulty of the film, and its strength too, is the presence of Catherine Deneuve amid the ruins. Her presence gives a sense of unreality to what we are filming. What is she doing there? Why is she there? Is what I am seeing true? Catherine's presence there, the improbability of that face opposite the ruins it is looking at, makes us envisage a specific way of filming. The images are continually impregnated with fiction, unceasingly. During filming, the team was intrigued at our way of always asking ourselves questions about the possible return of fiction. What imaginary thing could appear here again to question our images, our presence in the world as a singularity, as a face? The script of the film is very

like the finished film. Yet everything that happens in it is in the nature of a documentary adventure. You don't really know what's going to happen to you, where you are going. You weren't given a script, a text. You were placed in situations that we had already experienced, but there were accidents, things we didn't expect, which we integrated into the film. In our work as visual artists and filmmakers, we often explore that set up. It has always been our way of working: plant a frame, wait for something to happen, for a reality to crop up in the shot, accept being overtaken by it. Strangely enough, everything we had written took place, but as if it was happening for the first time.

On this shooting, it was necessary to oppose the adventure of the image to that reality, take the risk of that experiment and go with it totally, radically, choose to make an image, but an image hard to exhaust, which maintains a complex, emotional relationship with the person looking at it, and attempts to say, to represent differently, to shift the gaze, to work on states, situations.

 With *I Want to See*, it was the need to push back the boundaries we perceived every-where in a symbolic way, like a vital need to extend the territory of art and cinema. On the frontier, on a prohibited road, a few months previously, both with a camera and a tripod, we were almost shot at by the Israeli army. And that's when we wondered: how might it be possible to put a tripod on this frontier, to open up that road? Might it be possible with a cinema icon like Catherine Deneuve, with a film crew? Can cinema do that? And in the project centered on the Lebanese Rocket Society, it was again important to do something in the current context, not only to contemplate, admire the courage and tremendous hope of those Arab scientists who wanted to send rockets into space in the 1960s. Reconstructing today a rocket with the exact dimensions of one of the rockets constructed and launched in the 1960s, the Cedar IV, taking it through the city before giving it to Haigazian University where that adventure started … It is an homage to that space project, but rooted in the present, with no nostalgia—what is called a "reenactment," something that is present in our approach and our artistic practice today. To invoke the future, what lies ahead, it was necessary to reconnect with the dream—with projection into the future-that, in a way, has deserted our societies for many long decades.

MICHÈLE THÉRIAULT
Let us think not from the starting point of what is already there, but from what brings you to that point: film, photography, installation, etc., and focus on writing, its role, its status, its challenges in your process of conceptualizing and producing a work. Writing has been present almost from the start, even before you became a couple. Joana as a girl read and wrote, a perhaps salutary and stabilizing activity (the inner life) during the conflict of war, but also paradoxically noisy and disturbing (the shock of ideas, opening up to knowledge). There is the epistolary link between two cities, Paris and Beirut, and with the other, Khalil. And as you come to work together, there is *still* and *already* writing to set down your thoughts, which soon takes a public form through scripts, articles and lectures: the word written and read, the spoken word. Writing seems indispensable to and inseparable from what constitutes your artistic practice. How to explain that the space of writing is a necessity for doing and seeing, for *making* visible and heard? What is being articulated or has to be articulated in it? Michel Foucault says that in the 20th century "language is (or has perhaps become) a space phenomenon." Writing is a distinct space of signifying

traces that fits into the elaboration of works in a variety of ways. In the production process, what is its time and what are its demands?

When you operate in the field of the visible and of the image, what does thinking through writing signify in relation to thinking through the gaze? Writing seems to be both a field of action where social and political issues are articulated, and an epistemological field of action with repercussions on a film, an installation. How can gaps or even tensions be reconciled between the intimate, internal act of writing and its encounter, and its possible development in public works?

JOANA HADJITHOMAS / KHALIL JOREIGE

Our relationship to writing is central, but also very active. We write every day, but that writing, often more personal, is not visible. It covers possible lines of research, scenes, thoughts. There are two phases in writing: first, each of us writes alone in a form of solitude, separation. After that we come together, focusing on certain texts that we then work together.

Originally we studied literature; narration has always been a central interest for us, and a large part of what we write consists of film scripts, texts in the course of development. Oddly enough this cinematographic practice has its origin in an art project we wanted to carry out after the civil wars, focusing on memory, the layers of knowledge and history a city like Beirut conceals. Then we started writing something that resembled a script, and that became our first film, *Around the Pink House* (1999). Moreover, in the project *Wonder Beirut*, the character of Abdallah Farah is a cinema character in the true sense of the term; he is constructed, worked up as if he was part of a fiction film. That is another thing that interests us, the way a character slips from one universe to another, inhabits it, and prompts us to produce further art installations like *Postcards of War* or *Latent Images*.

Writing has become much more widespread among certain artists of our generation in Lebanon, for we started working in an artistic milieu where criticism relating to contemporary art was not widespread. Apart from one or two critics, the field was empty, people were not really interested in what we were doing. In the 1990s, we needed to exchange views regarding our works, our research. We likewise needed texts to define that research better, to understand and share it better, and very quickly the text became a component of the work: the one we wrote about latency or the anecdotal, the text of the performance *Aïda, Save Me!* (2009), the conversation we had with Pierre Ménard, the character we borrow from Borges's Don Quixote in our text "OK, I'll show you my work," or again our contribution "A State of Latency" in the catalogue *Iconoclash* (exhibition at the ZKM, Karlsruhe, 2002). Writing allows us to explore concepts, to help our artistic and personal research, to pinpoint approaches, and sometimes the imaginary worlds reflected in the images. Finally it allows us to work on nuance, for it is also through nuance that we can give an account of the complexity of our situations.

Furthermore, we used text or words very early on as a mental image, a palliative to the visual. Thus text was integrated into the work, sometimes becoming the work itself. We had been so bombarded with images during the civil wars that we distrusted images, we needed a time without a certain type of image. The postwar period was also the "post-image" period, or rather post a certain image. In that situation, writing very quickly established itself as a necessary way of telling a story.

Palliating the lack of images or speaking of a place without visibility, such as the camp of *Khiam* (2000) was at the end of the 1990s, bringing it into existence through evocation, the spoken word, the written word. Withdrawing our images from the flow, not developing them, but for more than ten years writing down everything we photographed in detail, would produce *Latent Images—Diary of a Photographer* (2009). Recently, the installation *A Letter Can Always Reach Its Destination* (2012) was based on more than four thousand letters, spam messages, and more specifically scams we'd collected in the past 12 years. What interests us here is narration. These emails appear like short scripts to us, with characters, locations, action, drama, subordinate characters. The stories that appear in scams reveal a multitude of imaginary worlds, with no images. Political changes, wars, and economic problems take shape through these imaginings, but the colonial relationship too, which is reenacted here. These texts, which we ask actors to embody, create a topography of the various conflicts, a chronicle of these past ten years, a way of recounting history differently. These fictitious utterances can be seen as symptoms of the state of the world.

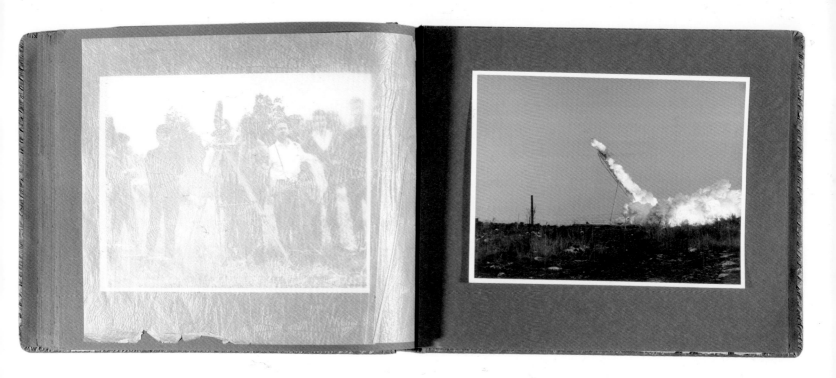

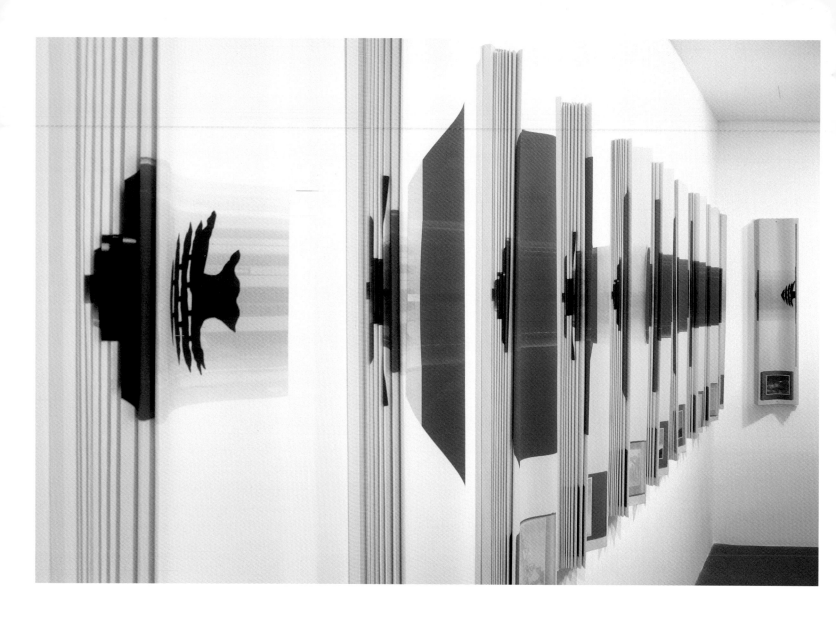

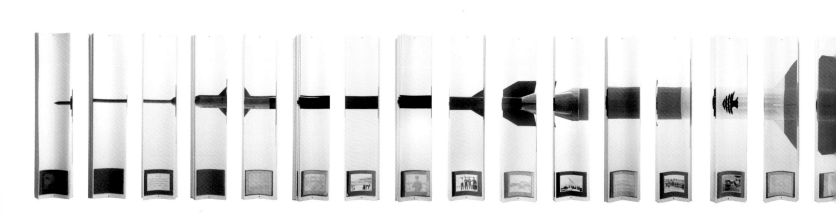

The President's Album, 2011

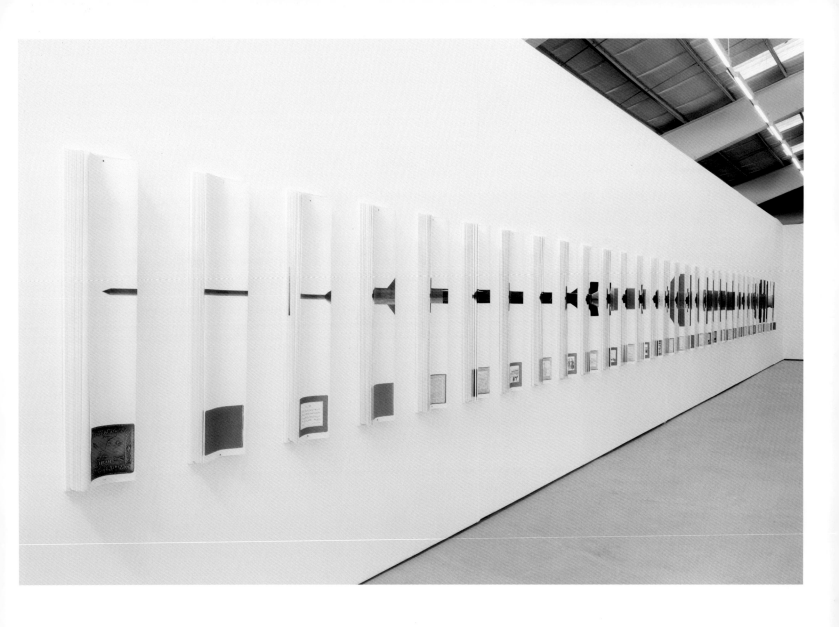

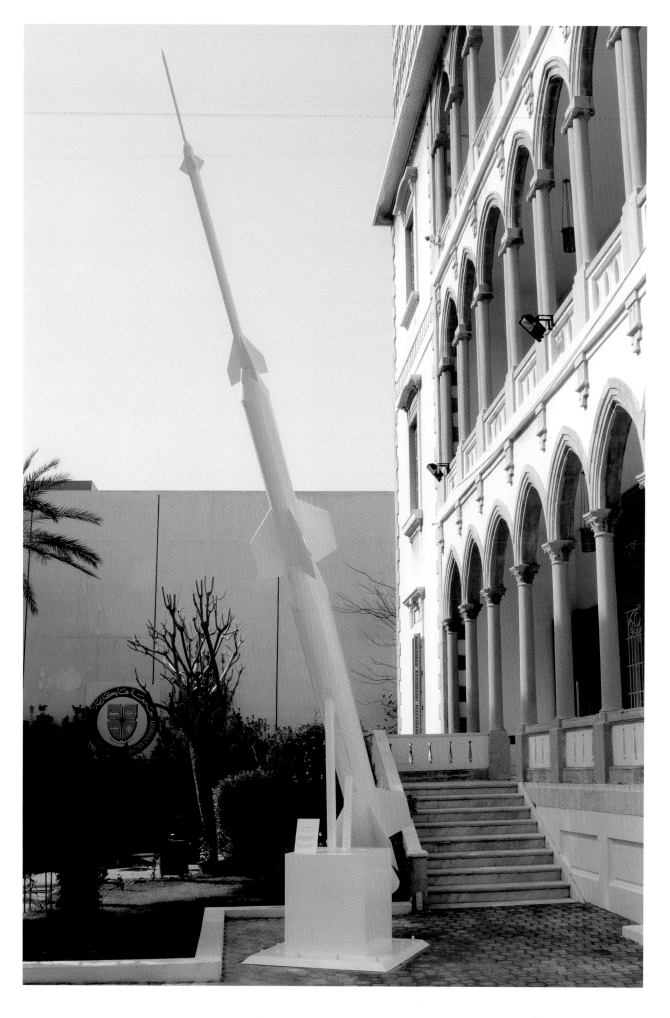

Cedar IV: A Reconstitution, 2011

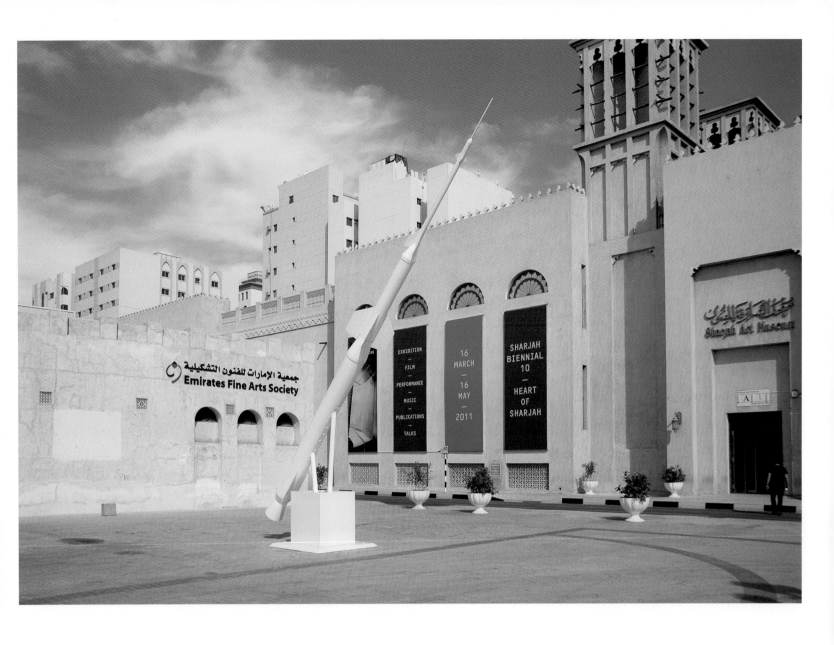

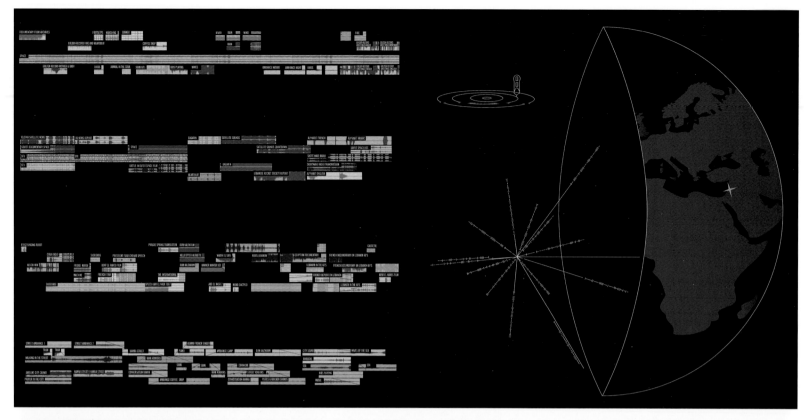

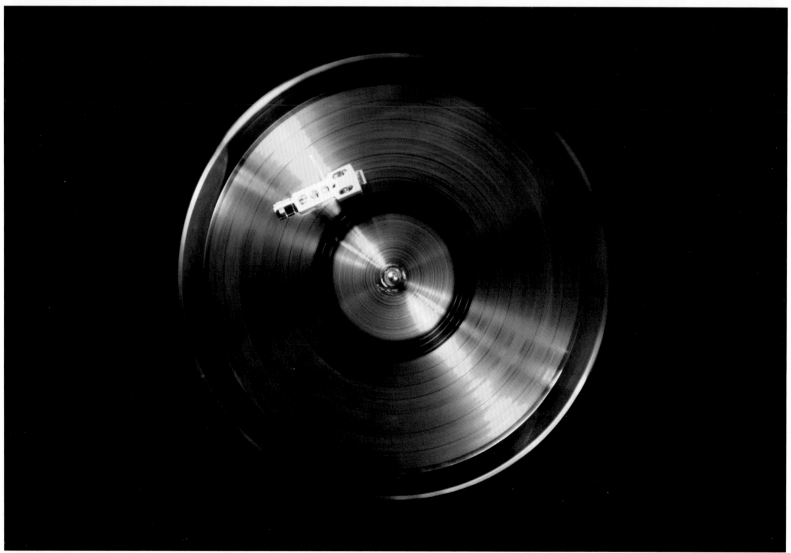

The Golden Record, 2011

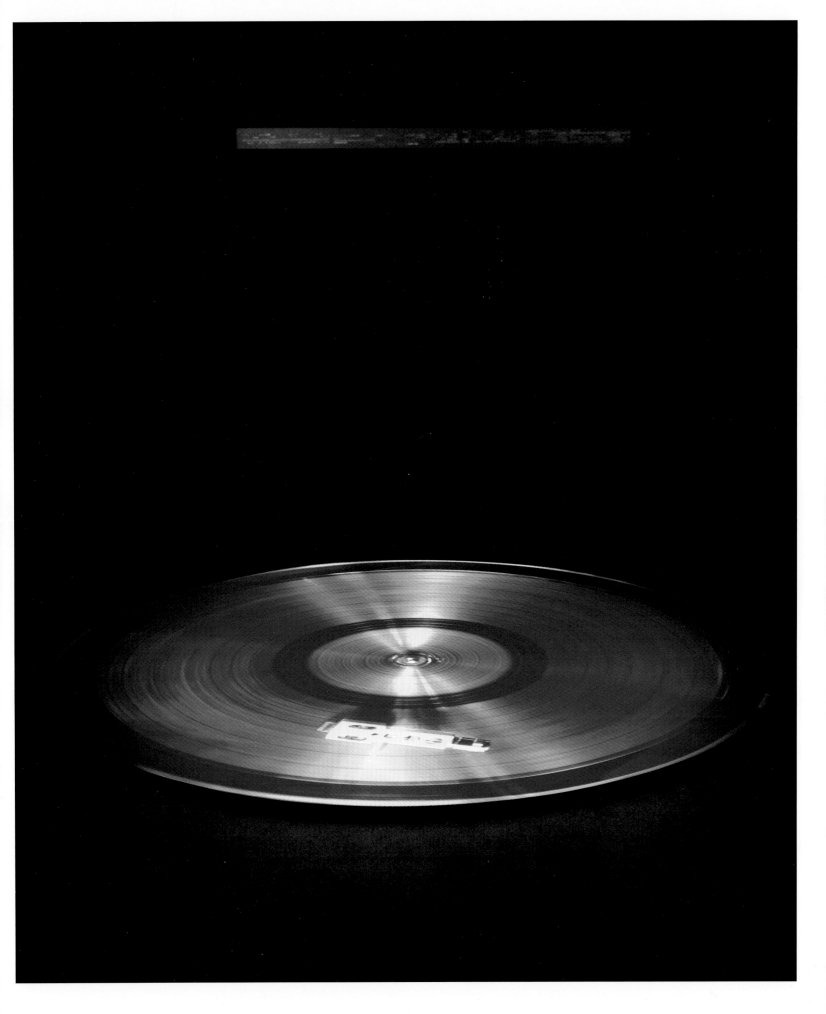

Restaged, 2012

Restaged, 2012 →

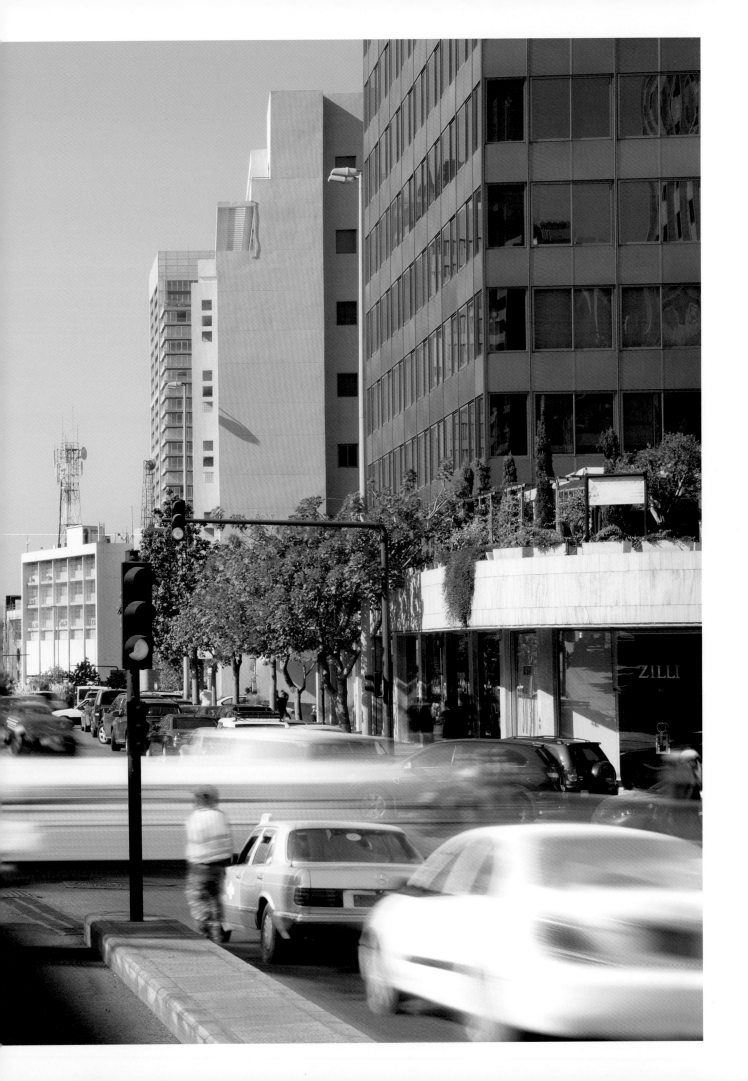

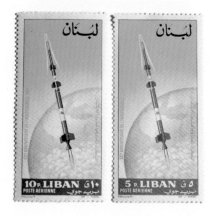

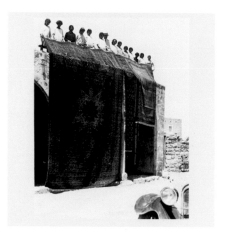

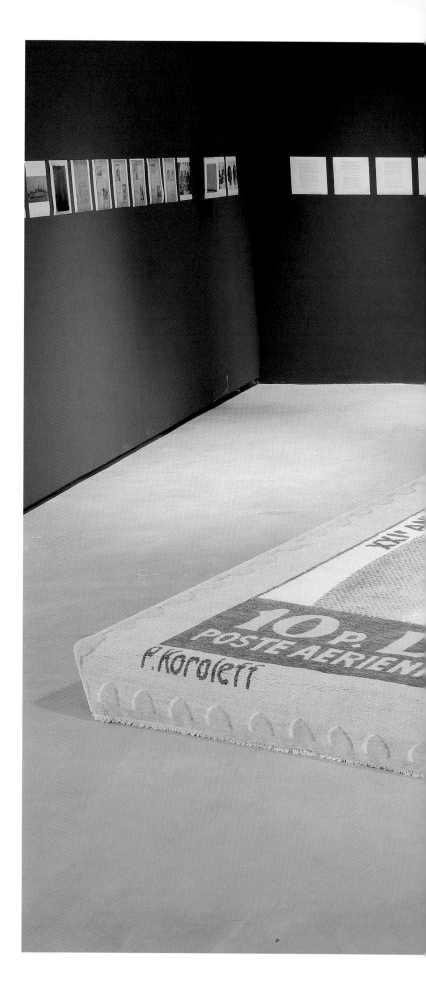

A Carpet, 2012

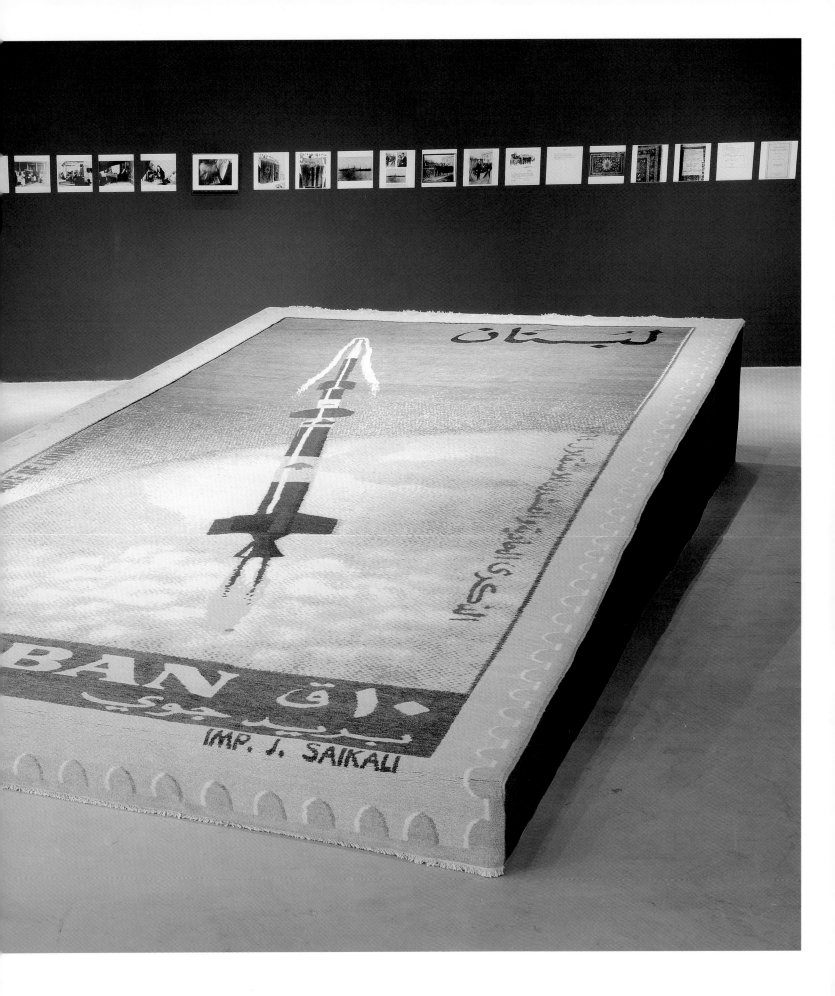

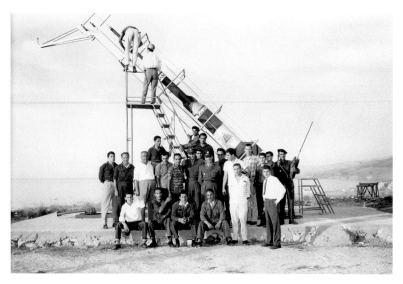
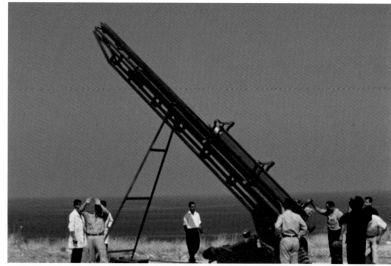

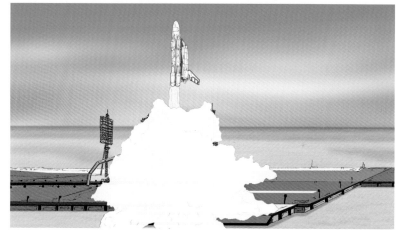

Film

The Lebanese Rocket Society (The Strange Tale of The Lebanese Space Race)	2012 95 min

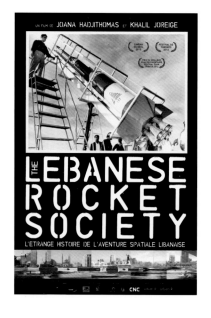

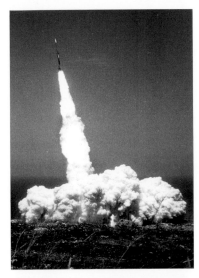

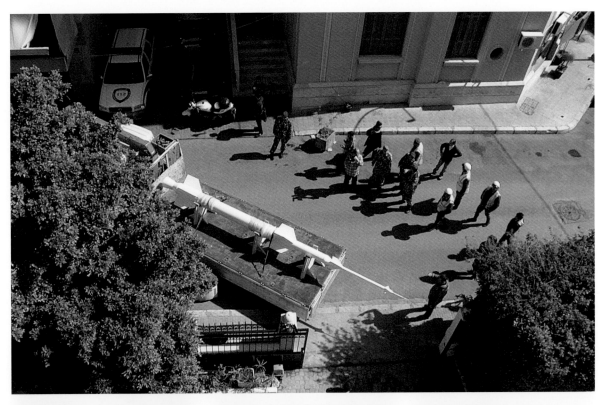

Making of

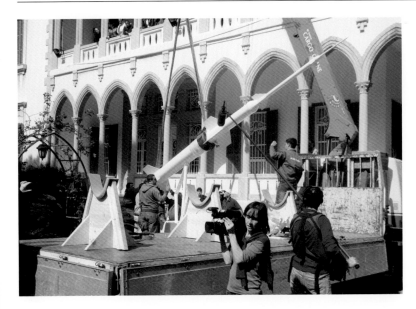

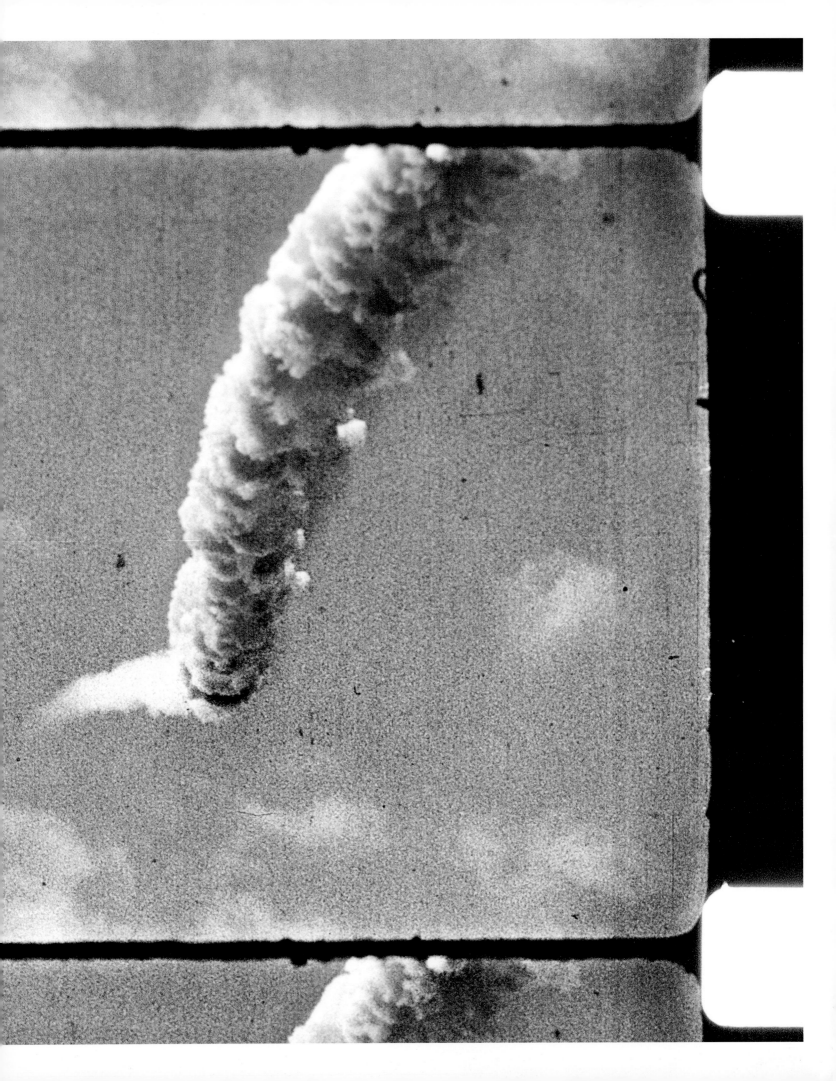

A Letter Can Always Reach Its Destination, 2012

"I am writing this mail to you with tears and sorrow from my heart, I know that this mail might come to you as a surprise because you don't know me, but due to unsolicited nature of my situation here I decided to contact you for help, please bear with me, while searching through world commerce and industry, I came across your contact address and decided to contact you; I want to present this proposal for investment in your country.
My name is Esther George Jacobi, I'm 20 years old. I am the only child and daughter of late honourable Dr. George Jacobi the former minister of transport and communication under the leadership of President Charles Taylor of Liberia."

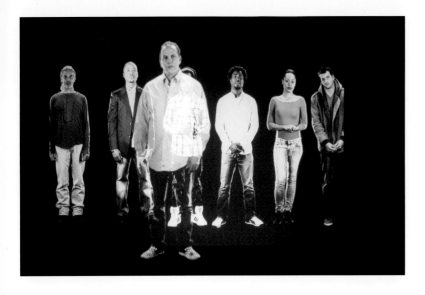

"Some money in various currencies was discovered in barrels at a farmhouse near one of Saddam's old palaces in Tikrit Iraq during a rescue operation. and it was agreed by staff Sgt Kenneth Buff and I that some part of this money be shared among both of us before informing anybody about it since both of us saw the money first. This was quite an illegal thing to do, but I tell you what? No compensation can make up for the risk we have taken with our lives in this hell hole. of which my brother in-law was killed by a road side bomb last week."

"How are you today?
Peace be unto you my good friend. I am the only surviving child of Abdullah I-calan, the leader of the Kurdistan workers party (PKK). My father actively fought for the liberation and unification of our people (the Kurds) under one sovereign nation which earned him the support of many and being branded a rebel by others. He amassed a lot of money garnered from supporters and sympathisers alike from which he kept quite a lot for his family's use. I will want you to go through this site and know more about Abdullah I-calan."

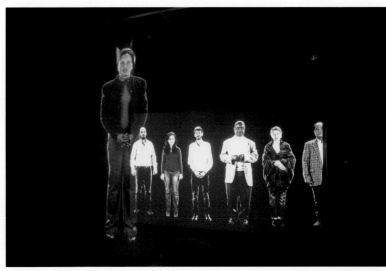

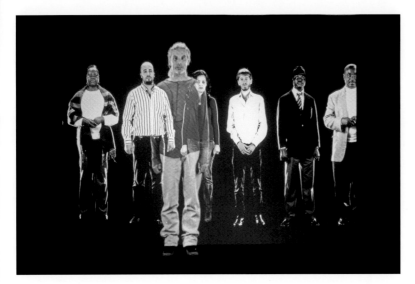

"If you are interested please send me your personal mobile number so I can call you for further inquiries when I am out of our military network. I am writing from a fresh email account so if you are not interested do not reply to this email and please delete this message, if no response after 3 days I will then search for someone else. I am doing this on trust, you should understand and you should know that as a trained military expert I will always play safe in case you are the bad type, but I pray you are not. {$16.2 million dollars cash} is a lot of money which is the dream of anyone. I wait for your contact details so we can go on."

A Letter Can Always Reach Its Destination, 2012

Annotated Chronology

Michèle Thériault
with Joana Hadjithomas
& Khalil Joreige

1969

Joana was born in Beirut on August 10. Her paternal grand-parents are Greek, from Turkey, exiled in Beirut since the 1920s. Her maternal grandparents are Syrian and Lebanese. Her parents were born and grew up in Lebanon.

Khalil was born in Beirut on September 26. His father's family originates from the north of Lebanon, his mother's family is Palestinian, and moved to Lebanon in the 1930s. These intermingled identities are conducive to raising questions about belonging, territory, and definition, developed later in their practices.

April 1975

Official start of the Lebanese Civil War.

Both families decide to remain in Beirut. "You don't go into exile twice in your life," grandfather Hadjithomas says.

1975–1988

Both live out their childhood and adolescence in a country at war, often changing homes and schools, depending on the fighting and its geographical shifts. Everyday life in this period is characterized by mobility, adaptability, and uncertainty in the face of extreme violence. They develop an awareness of the fragility of existence, and the sudden changeability of things. The notion of identity is likewise put to the test. They are politicized at a very early age in view of the successive civil wars that confront them with a multitude of points of view and convictions.

The Joreiges live in a block of flats at Tallet el Khayat, in the west of the city, where the heads of various militias are housed—pro-Libyan, Iranian, Syrian, Iraqi, right-wing, and left-wing. Their respective bodyguards patrol the corridors.

Abandoned house in Beirut city center, photograph, 1989

1982

Invasion by the Israeli armed forces. The conflict and violence intensify, as the Israelis make use of heavy artillery and aerial bombing. The siege of Beirut culminates tragically with the Sabra and Shatila massacres.

At the age of 13, Joana witnesses the implosion by the Israeli army of a block of flats located across from her bedroom and occupied by Palestinian refugees, whose bodies gradually fossilize under the debris.

A building in Wadi Abou Jmail, Beirut city center, photograph, 1993

Lasting Images, 2003, six light boxes with texts, films, images, and sound Exhibition view, SD Space in the context of *Homework 2*, Beirut, 2003

1985

Khalil's maternal uncle, at the time a member of the Lebanese Red Cross, is kidnapped. For more than 15 years, his family, like that of 17,000 other people reported missing, awaits his return or some explanation. He will never reappear. His family will declare him dead in 2002. Following this traumatic event, Khalil's family settles temporarily in Paris, making a great many journeys to and fro.

Often confined to her house because of daily bombing attacks, Joana does not attend school much during her teenage years. She spends this time reading a lot of literature and philosophy. She starts writing.

1988

Joana and Khalil discover the city center of Beirut, drastically transformed by 15 years of war. They both photograph a city in ruins that has become a no-man's-land, accumulating hundreds of photographs that will later provide material for their artistic practice.

Beirut becomes a "working sphere." The chaos that is lived at that time overturns the traditional dualities, making it necessary to rethink good and evil, reason and unreason, order and disorder, victim and executioner, and how all are represented.

Staircase of the security exit of the City-Center, Beirut city center, photograph, 1995

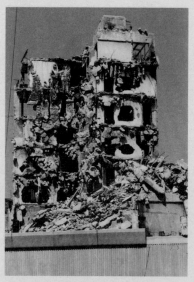

Reconstruction of Beirut city center, photograph, 1996

1983

First meeting of Joana and Khalil at the sports club of
the village of Beit Mery. They cannot stand one another.
Khalil starts taking photographs.

Abandoned house in Beirut city center,
photograph, 1990

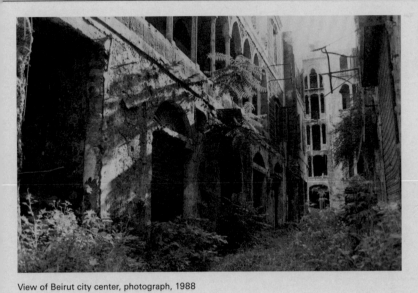

View of Beirut city center, photograph, 1988

1986

Joana and Khalil meet again, and this time become friends
and share their views on what they are reading, in particular
through an assiduous exchange of letters.

1989

Joana studies political science at Saint Joseph University in Beirut.
On a visit to Paris where she joins Khalil, she remains stuck
there for six months, following the intensification of the fighting.
Their life together starts between France and Lebanon.

Karím, "La Peau des hommes,
la peau des bâtiments" series, text on a scar, 1996

1990

Official end of the Civil War. Southern Lebanon is still occupied by Israel and the South Lebanon Army, its proxy militia (until 2000).

1990–1997

They study comparative literature and performing arts at the University of Paris X-Nanterre. They are particularly interested in the problems associated with narratology, the constitution of representations (Barthes, Foucault, Zizek, Deleuze), alternative philosophies to the dominant ideas and fields of knowledge, postcolonial studies, and the reinterpretation of the history of their region (*Orientalism* by Edward Saïd).

Working and thinking together become second nature. It is a lifetime project. The assumptions underlying their artistic and cinematographic practice allow them to glimpse the possibility of new areas of thought for conveying their feelings in view of the amnesia that prevails in Lebanon in a strange postwar period. Without having studied fine art or cinema, they commit themselves totally to those fields in order to question the place where they live.

1997

In Beirut, they prepare for the shooting of *Around the Pink House*. They continue systematically to photograph the city center.

Summer: *Beirut: Urban Fictions* at the Institut du monde arabe (Paris) is their first solo exhibition as a duo. They present an "archaeology of their photographic research," thoughts about ruin, and how it relates to the present. In it they question their photographic practice and how it has evolved since the beginning of the 1990s. They likewise state their rejection of definitions. Designed as a "theatrical journey" in five acts, a prologue, and an epilogue, the exhibition presents in particular *Equivalences*, *Bestiaries* and *The Circle of Confusion*. On this occasion, they publish the first book in which their photographs are reproduced in the form of postcards, an editorial format they will use frequently.

September: In the context of the Festival Ayloul at the Beirut Theater, they present *Poste restante*, an installation consisting of envelopes pinned to the walls, bearing the address of the Khiam detention camp (South Lebanon).

As members of the Committee for the liberation of the detainees in this camp, they question the legal and political status of the camp, located in a lawless zone, encouraging visitors to the exhibition to write to those held, and follow the course their mail takes.

1998

As part of the Mois de la Photo in Beirut, they exhibit the first part of the *Wonder Beirut* project at the Galerie Janine Rebeiz. The character of Abdallah Farah appears for the first time in a photographic story, *The Story of a Pyromaniac Photographer*. This detour through a fictional story allows them to question the writing of recent history, and to establish a bridge between their artistic and their cinematographic practice. It recounts the photographer's personal, sentimental, professional, and family story over more than ten years. This work turns out to be a sociological and political immersion in the Beirut of those years. The *Wonder Beirut* project takes the form of an edition of 18 *Postcards of War* and several photographic installations, including *Historical process*, *Plastic Process*, and *Latent Images*.

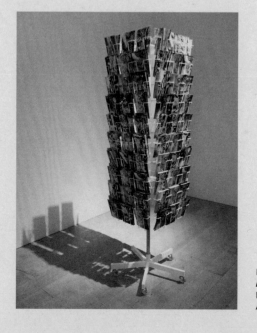

War Postcards display, *Wonder Beirut* project, 1997–2006 Exhibition view, *Arab Express*, Mori Art Museum, Tokyo, 2011

1993–1997

Their research leads them to write a story, which wins an award from the European cinematographic writing workshop "Sources." It becomes the script for their first feature film, *Around the Pink House*, which quickly finds a producer and funding. To avoid having to discover how a film set works on their first day of shooting, in 1995 they attend a workshop at New York University lasting a few weeks, their only training in filmmaking, and make their first short film, *Faute d'identités* ("Lack of Identities"), in Paris.

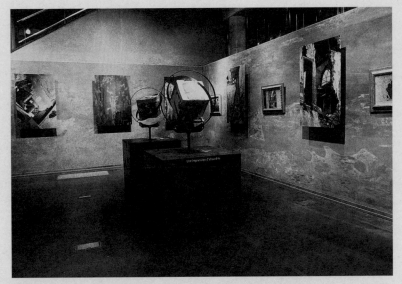

Exhibition view, *Beirut: Urban Fictions*, Institut du monde arabe, Paris, 1997

1997–2006

They teach at the Institut d'études scéniques, audiovisuelles et cinématographiques (IESAV—Institute of Theater, Audiovisual and Cinematographic Studies) of the University of Saint Joseph (Beirut). Joana takes over the scriptwriting department, overseeing the making of diploma films; Khalil teaches aesthetics and alternative practices involving the image.

During these years they get close to the artists of the new Lebanese scene. Every Tuesday evening, along with Walid Sadek, Bilal Khbeiz, Tony Chakar, Walid Raad, Rabih Mroué, Lina Saneh, Fadi Abdallah, and Marouan Rechmaoui, they take part in a group interested in political and aesthetic ideas. They also initiate their collaboration with Christine Tohmé and her artistic association, Ashkal Alwan.

Since they consider writing and thinking about their work as important as exhibiting it, they develop their writing practice, publishing regularly in art journals and participating in a great many lectures. In particular they explore, in their photographic and cinematographic work, the notions of latency, of lasting images, the anecdotal—in the sense of a "story kept secret"—strategies for writing history, the deconstruction of imaginaries and mythologies, the emergence of individuality in a communal society, all of them concepts at work in their practice.

Wonder Beirut, 1997–2006

1999

Their feature-length film *Around the Pink House* is the first Lebanese fiction film to question postwar developments, reconstruction, and its dead ends. It is a choral film featuring 23 characters and the same number of viewpoints. A popular success and the source of many encounters with the public focusing on the reconstruction of the country, it is selected to represent Lebanon at the Oscars. But the onerous nature of this production leads them to envisage a more "homemade" cinematographic approach from then on, closer to their artistic practice. Consequently they carry on with visual arts projects and cinematographic research, the two practices nurturing and complementing one another within corpora comprising photographic works, installations, written stories, fiction films, and documentaries.

1999–2000

During the last months of her pregnancy, Joana is confined to her bed. This situation leads Khalil and her to experiment with writing specifically intended for video camera, and editing it for the video: *Don't Walk*. The works consists of a diary with two voices in which a double inside/outside movement questions the artist's place with regard to the real and how it is represented, and what we recognize as and call an "event."

They make the documentary *Khiam*, in which six recently released detainees describe the camp: there is as yet no representation of it. Bearing witness to the extreme experience they have endured there, these detainees dwell on the creative practice developed during their detention. The film is a form of experimenting with the narrative, the way in which, through the speech and the principle of evocation, an image gradually succeeds in building up.

In 2000, the Israeli army and its proxy militia leave South Lebanon. The Khiam camp is dismantled, then transformed into a museum.

2002

They create Abbout Productions, a company producing and distributing films. In 2003, Georges Schoucair joins them as their main producer. Under his guidance, Abbout Productions becomes one of the most important production companies in the region.

2003

Returning to fiction, they shoot the short film *Ashes* in the apartment of Khalil's recently deceased grandmother. The film is inspired by the traditional ceremonial of condolences and the expressions of sympathy, and by the service—taking the place of a "burial," in the absence of a body—organized for Khalil's uncle, kidnapped during the Civil War and declared dead by his family in 2002. In *Ashes*, the relationship to the present and absent body is crucial; they develop a sensual cinema, based on physical feeling and incarnation. The film is selected to compete in the "best short" category at the César awards.

2005

From the balcony of Khalil's family home, they film Beirut during the celebratory firing of guns and fireworks. They record in this way several events giving rise to firework celebrations, creating the installation *Distracted Bullets*; through the sound and the trajectories of the fireworks and the bullets, it explores the abundant presence of firearms on Lebanese soil, and embodies the number of individuals who fall victim to stray bullets—"distracted bullets" as they are called in Arabic.

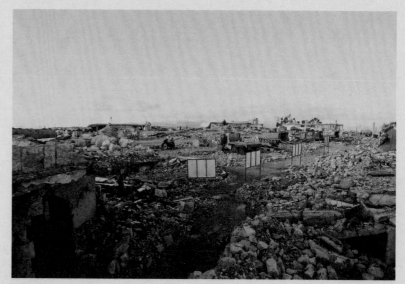

View of the destroyed Khiam camp, 2006

Bestiaries, 1997–2010
Exhibition view, *How Soon Is Now*, Beirut Exhibition Center, Beirut, 2012

2001

In March they make *Barmeh/Rounds* in the context of *Beirut Seen By*, a series of short films produced by France 3.

In May, following the theft of a copy of *Around the Pink House*, they leave for Yemen intending to film their investigation into the stolen copy. This "film-essay" entitled *The Lost Film* questions their position as image-makers in this part of the world. The September 11 attacks prevent them from going back to finish the shoot in October, as the film's financial backers regard the subject as anecdotal in view of the situation at the time. Taking into consideration the etymology of the term "anecdotal" (which means "story kept secret") becomes the moving force for developing a form of resistance to the writing of official history. The film is edited in 2003 using just the material (most of it location scouting) gathered on their first journey.

2004–2005

They undertake in-depth research focusing on the question of those who have disappeared, specifically following the discovery of an 8mm film shot by Khalil's uncle before his disappearance, which has remained in its yellow pouch ever since, waiting to be developed. Tying up with the practice they have been exploring for several years, this latent film proves to be a strange and very moving echo. They decide to develop it despite the risk that the film may turn out to be hazy, blank, and may have lost practically all information. Moreover, this is what has happened, but by dint of working on correcting the colors, an image reappears, and comes back to haunt the film. It is an image that refuses to disappear, a lasting image. It is the starting point for two installations, *Lasting Images* and *180 Seconds of Lasting Images*, but also, as so often, of a fiction film.

Entitled *A Perfect Day,* the camera follows a day in the life of Malek, a young man lost in Beirut, suffering from sleep apnea, and constantly nodding off, perhaps to avoid confronting his girlfriend—he cannot get onto the same pace and rhythm as her—or the fact of having to formally declare the death of his father, who disappeared 20 years earlier.

During the editing of the film, the Prime Minister Rafic Hariri is assassinated, the country is then divided by conflicting demonstrations. Two groups confront one another, the supporters of March 8, and those of March 14 (according to the date of two opposing demonstrations).

At the Locarno Festival, where it has its première, the film wins two awards, including the Fipresci. It is very enthusiastically received by the critics, wins more than 15 awards internationally, and is projected in a great many countries.

2006

In July, a 33-day war breaks out between Israel and Lebanon. Joana and Khalil are stuck in France and watch the conflict from a distance, on television and computer screens. This very violent conflict is a rupture to their position and their practice; they break off their "practice of latency." "We have to emerge from latency, bump up against reality, and accept the necessity of 'representing.'"

Once the war is over, they go back to Lebanon, in particular to Khiam, though the camp has been completely destroyed by the Israeli army. The idea of reconstituting the camp just as it was is under consideration. They then feel the need to find the six former detainees filmed for the first film and hear them talk about their memories of the camp that is now in ruins. Several works arise from this questioning of the trace, the reconstitution, the relationship to the image, to representation and imagination, to what makes and writes history: the film *Khiam 2000–2007*, and the installations *Landscapes of Khiam*, *War Trophies*, and *Ansar*.

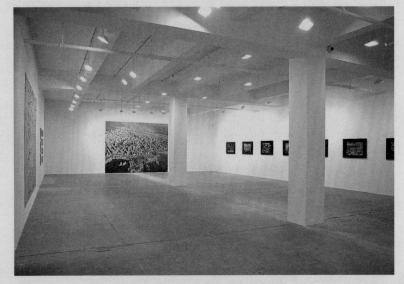

Exhibition view, *The Circle of Confusion*, CRG Gallery, New York, 2007

2007

They make the feature film *Je veux voir* (*I Want to See*) with Catherine Deneuve and Rabih Mroué. In it they question the possibility of seeing and showing war, destruction, and pain. They also question the possibilities of making images and films after the unbearable violence suffered in South Lebanon. The film slips continually from fiction to documentary, questioning the frontiers and assumptions of the two categories, trying to figure out a territory of art and cinema. They become involved with the Métropolis, Lebanon's only art and experimental cinema, run by Hania Mroué.

They present exhibitions at the Galerie In Situ–Fabienne Leclerc, Paris, and at CRG, New York. Between 2007 and 2012, retrospectives of their films are organized at Paris Cinéma, Nyon (Switzerland), Vila da Conde (Portugal), Gijon (Spain), Tate (London), MoMA (New York), Institut français (Tokyo).

Presentation of *I Want To See*, Festival de Cannes, with Catherine Deneuve and Rabih Mroué, 2008

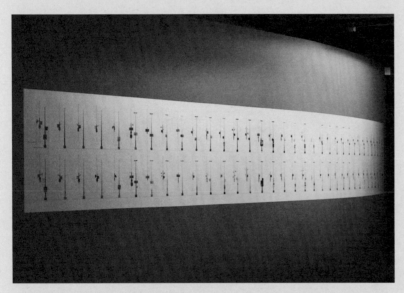

A Faraway Souvenir, 2001–2007.
Digital print, 100 600 cm, in collaboration with Ahmad Gharbiyeh
Exhibition view, *We Could Be Heroes Just For One Day,* musée d'Art moderne de la Ville de Paris, 2008

2009–2010

They become interested in heroes and the way martyrs are represented in Beirut, a city crisscrossed with images of men who have suffered a violent death, "looking at us." This is reflected in the installations *A Faraway Souvenir* and *Faces*, exhibited in 2010 for the Sharjah Biennial, and notably presented at the Leonard & Bina Ellen Gallery (Concordia University), Montreal, which devotes a solo exhibition to the duo (*I'm here even if you don't see me*). In the same year, they exhibit at the church of the Célestins in Avignon (*… Like Oases in the Desert)*, the Centre de la photographie in Geneva (*Wonder Beirut*), and the Space Gallery in Toronto (*Wish We Could Tell*).

They create the performances *Aïda*, *Save Me!* and *Latent Images—Diary of a Photographer*, developed following publication of an artists' book by Editions Rosascape. They likewise explore the ways and means of writing a story that leaves no trace, like performance, dance, or Tarab, that state of trance gripping a singer and his audience in Arab music. In 2010,

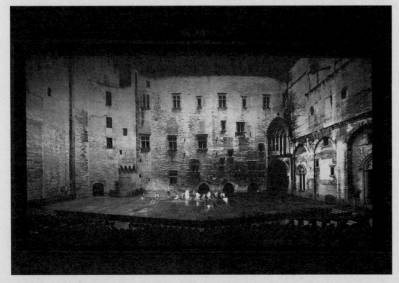

Histoire du vent, 2010

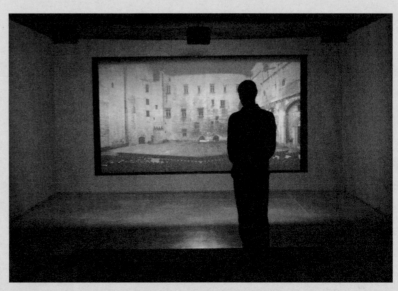

Exhibition view, *Histoire du vent, exhibition Panorama, Time Machine,* Le Fresnoy–Studio des Arts Contemporain, Tourcoing, 2010

2008

In May, *I Want to See* is presented as an official selection at the Cannes Film Festival in the "Un certain regard" section. In December, it receives the prize for the best singular film of the year, awarded by the Syndicat des critiques français.

Khiam 2000–2007 is presented at the Marseille International Documentary Film Festival where it is awarded the Prix Georges-de-Beauregard.

Several solo exhibitions are organized at the musée d'Art moderne de la Ville de Paris (*We Could Be Heroes Just for One Day*), during the *Homeworks* forum at Ashkal Alwan in Beirut (*Back to the Present*), at the Festival d'Automne *(Where Are We?)*, and the Fort du Bruissin (*Stories Kept Secret*).

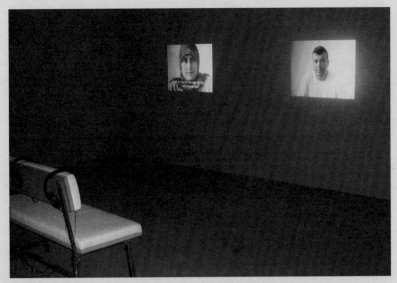

Khiam 2000–2007
Exhibition view, *We Could Be Heroes Just For One Day*, musée d'Art moderne de la Ville de Paris, 2008

they question this attempt to describe what is invisible in a public commission on the history of the Avignon Festival entitled *Histoire du vent*. They are guest artists at Le Fresnoy and teach there throughout the year.

In 2010, their second child is born.

In the autumn they start shooting a feature-length subjective documentary. *The Lebanese Rocket Society* looks at the Lebanese space project developed in the 1960s, and questions the spirit of that period: Pan-Arabism, the relationship to modernity, utopia and dreams.

Latent Images—Diary of a Photographer, 2009

2011

The "Lebanese Rocket Society" becomes an all-embracing project in several parts, including a film and several art installations. The two are closely linked, with some images from the film being used in the installations and some artworks occurring in the film.

To combat the oblivion that surrounds this project and reflect on the notion of a monument, they make a full-scale, very detailed reconstitution of the Cedar IV rocket. They then undertake to parade it around the streets of Beirut before offering it to Haigazian University—where the Lebanese space adventure began. *The President's Album* is an amalgam of photographs of the sculpture and an album of photographs documenting the launch of the Cedar IV rocket. It questions the reason why this space project has disappeared from Lebanese individual and collective memory. In a reference to the Golden Record, an interstellar message sent on board the Voyager 1 and Voyager 2 space probes in 1977 and addressed to a

potential extraterrestrial presence, they imagine and record a *Golden Record* disc based on the archived sounds of Lebanon and the world of the 1960s. These installations are presented at the Sharjah Biennial, then at the Biennale de Lyon. During this time, the Arab revolutions widen horizons and restore hope to the region, despite the uncertainty of the future.

In September HomeWorks Academy, the art school of Ashkal Alwan, begins its classes. They are very involved in this initiative. Joana is on the Curricular Committee.

Faces, 2009

Faces, 2009

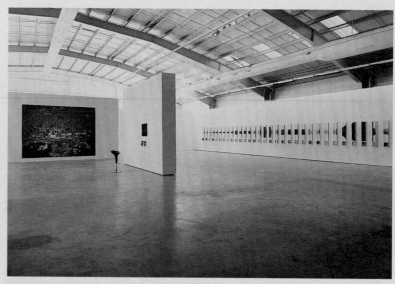
Exhibition view, *How Soon Is Now: A Tribute To Dreamers*, Beirut Exhibition Center, Beirut, 2012

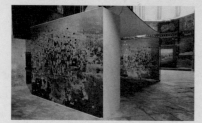
The Circle of Confusion, 1997, and *The History of the Circle of Confusion*, 2009

Wonder Beirut and *Lasting Images*, 1997–2006

2012–2013

They complete the subjective documentary *The Lebanese Rocket Society: The Strange Tale of the Lebanese Space Race* and present two new installations from the corpus devoted to the Lebanese space venture: the photographic sequence *Restaged* and *A Carpet.* They are awarded the Abraaj Capital Prize for their installation *A Letter Can Always Reach Its Destination,* designed around spam messages, and even more around scams, those "swindle" emails, generally immediately detected and removed by our computers; they have built up an archive of them for over ten years. Grouped together, they outline a certain aspect of the history of the contemporary world and its main political events, providing information about a vision and an imaginary world still tinged with colonialism. These texts become captivating, disconcerting monologues when interpreted by non-professional actors, whose images are projected on to screens like holograms, ghosts, absent presences.

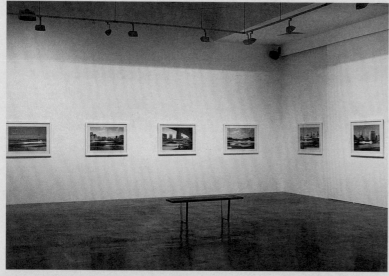
Restaged, 2012

146

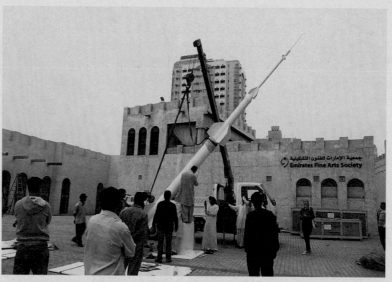
Installation of the sculpture *The Lebanese Rocket Society: A Reconstitution* in front of the Sharjah Art Museum, 10th Sharjah Biennial, 2011

List of Works
and Descriptions

p. 1
Color contact sheet of Beirut city center, 1993
30 × 40 cm

p. 2–3
Black and white contact sheets of Beirut city center, 1989
30 × 40 cm

p. 7–9
Bestiaries, 1997
15 photographic prints on Baryté paper, 30 × 40 cm

Street lamps twisted and sometimes destroyed by war or by accidents appeal to one's imagination or to a poetic, free act. The photographs playfully activate the viewer's perception, which is invited to identify animal shapes such as a dolphin, a snake, an elephant.

p. 11–13
Equivalences, 1997
Photographic print on Dibond, 80 × 120 cm

Depicting buildings that the effects of war have rendered chaotic, this series scrutinizes the detail, the photographed element, the way it frees itself from scale and topography, and the way it abstracts the object to represent something unexpected that challenges our point of view.

p. 14–15, 16–17, 18–19
The Circle of Confusion, 1997
3,000 photographic fragments, stamped, numbered, and glued on a mirror, 400 × 300 cm
p. 18–19: exhibition view, 9th Gwangju Biennial, 2012

A large aerial view of Beirut is divided into 3,000 fragments stuck on a mirror. The visitor is invited to take a piece away. Each piece is numbered, and inscribed with the phrase "Beirut does not exist."

As the fragments are gradually removed, an underlying mirror is revealed, reflecting the viewer and the installation's surroundings.

The expression "circle of confusion" refers to a technical term that relates to a camera's ability to distinguish two focal points for a particular image format. The installation embodies a reading of the city, which is in perpetual mutation and movement, as a site for the production of multiple meanings and fantasies. The installation recalls the impossibility of truly grasping Beirut; it resists definition.

p. 17
A History of The Circle of Confusion, 2009
Installation and video projection,
400 × 300 cm
Developed in collaboration with Keeward
and Cyril Hadji-Thomas
Exhibition view, 9th Gwangju Biennial,
2012

In 2009, a second part was added to
The Circle of Confusion to present the
performative process of the installation:
a camera captures the movements of
visitors as they take fragments of the
image during the exhibition. Then, using
a special program, it generates directly
and every hour a film reel made of 3,000
images (2 minute duration) projected on
a screen of the same size, showing how
the work evolves during the exhibition.
The image that disappears in *The Circle
of Confusion* reappears simultaneously
as a reverse reenactment, producing an
immediate and evolving archive through
the recording of this specific process.
While the image disappears, the trace
remains, and the film is created.

p. 20–21
Around the Pink House (*Al bahet
al zaher*), 1999
Fiction, 35 mm, 92 minutes

Beirut is under reconstruction. A surprising
pink palace is threatened with destruction
in order to build a commercial shopping
center. This ambitious project divides the
neighborhood. As the personal stories of
those living in the pink house are unveiled,
the wounds and dreams of a strange
postwar period appear.

Produced by Mille et Une Productions
 (France) and Les Ateliers du Cinéma
 Québécois (Canada)
With Hanane Abboud, Fadi Abi Samra,
 Asma-Maria Andraos, Nabil Assaf,

Tony Balaban, Issam Bou Khaled,
Joseph Bou Nassar, Nicolas Daniel,
Chadi el Zein, Hassan Fahrat,
Zeid Hamdan, Raymond Hosni,
Georges Kehdy, Maurice Maalouf,
Tony Maalouf, Majdi Machmouchi,
Hassan Mrad, Nicolas Mrad,
Rabih Mroué, Zeina Saab de Meleiro,
Mireille Safa, Ziad Said, Nagy Sourati,
Gabriel Yamine
Image: Pierre David
Editing: Tina Baz Le Gal
Sound: Ludovic Hénaullt, Louis
 Desparois, Robert Langlois
Premiere: Montreal International Film
 Festival

p. 22
The Lost Film (*El film el mafkoud*), 2003
Documentary, Beta SP, 42 minutes

A copy of *Around the Pink House*
disappeared in Yemen, on the day of the
tenth anniversary of the reunification of
North and South. A year later the artists
go to Yemen, following the traces of
the lost film. An enquiry that takes them
from Sana'a to Aden, a personal quest
centering on the image and the status of
filmmakers in this part of the world.

Produced by Idéale audience (France)
 and Abbout Productions (Lebanon)
Image: Joana Hadjithomas &
 Khalil Joreige;
Editing: Tina Baz Le Gal;
Sound: Rana Eid
Premiere: Rotterdam International
 Film Festival

p. 23
Don't Walk, 2000–2004
Video, 17 minutes

Don't Walk is an intimate correspondence
filmed between October 1999 and
February 2000, while Joana Hadjithomas

was pregnant and bedridden for four
months. The artists actively record their
strikingly different daily lives. During
these months, it rained almost constantly
and the closed universe of her room is
disturbed only by what she sees through
her windows. Immobile, Hadjithomas
searches with her camera for the smal-
lest of details, for some action to occur
in her room or beyond, for a possible
meeting with her neighbors who become
the heroes of a daily fiction. She pursues
the world in her room. But this is not like
a movie, there are no murders and few
events. Joreige, on the other hand, films
the outside world, its movements and
fluctuations, in an attempt to bring the
city into her room. Outside, the center of
Beirut in full reconstruction is "one of the
biggest construction site of the world,"
a desert where bulldozers are in action.
They attempt to share images, or rather,
more precisely, their relation to images.
Alternate journals, mingled one with
all sorts of correspondences, the video
explores expectations as they transform,
and the differences in how we each
relate to interior and exterior spaces.

p. 24–25
Wonder Beirut, 1997–2006
Diasec, photographic print aluminum,
100 × 70 cm, number 1

Wonder Beirut is an ongoing and multi-
faceted project that includes *The Story
of a Pyromaniac Photographer*, *Postcards
of War*, and *Latent Images*. The project
is based on the work of a fictional
Lebanese photographer named Abdallah
Farah that the artists created as a cine-
matographic character and who, at
the end of 1960s, produced images that
they would use in this project several
years later.

p. 26–34, 36–37
The Story of a Pyromaniac Photographer,
1997–2006
p. 26–27, 32–33, 34, 36–37: Photographic
prints on aluminum, Diasec, 100 × 70 cm,
number 2, 6, 13, 12, 20, 21, 9, 23, 7
p. 34: Light boxes, 70 × 50 × 8 cm
p. 28–31: Historical Process, "The Battle
of the Hotels," number 2, photographic
print on aluminum, Diasec, 30 × 180 cm

Between 1968 and 1969, Abdallah Farah
was commissioned by the Lebanese State
to take pictures to be edited as poscards.
They represented the Beirut Central
District, mainly the Lebanese Riviera and
its luxury hotels, which contributed to
form an idealized picture of Lebanon in
the 1960s and 1970s. Those same post-
cards are still on sale nowadays, although
most of the places they represent were
destroyed during the armed conflicts or
by the reconstruction. Starting in autumn
1975, Abdallah systematically burned
the negatives of these postcards, in
accordance with the damage caused to
the sites by shelling and street fights.
Abdallah photographed each image after
each new burn he inflicted on it, produ-
cing a series of evolving images, which
is called the "process." Two types of pro-
cesses are distinguished. The first, called
the "historic process" follows the events
very faithfully, for example the battle of
the hotels that occurred between 1975
and 1976. The second derives from the
impact that Abdallah inflicted willfully
or accidentally to certain images; these
are grouped under the name "plastic
process."

p. 35
Postcards of War, 1997–2006
18 postcards, 10 × 15 cm

A selection of pictures taken between
1968 and 1969 then burned between
1975 and 1990 by Abdallah Farah depen-
ding on the shelling and destruction
caused by armed conflicts. By publishing
and distributing these *Postcards of War*,
the artists are trying to fight the trend
which denies the realities of the Lebanese
Civil War, includes the Lebanese conflict
only marginally in our contemporary
history, and which prefers to idealize the
past and project itself into an uncertain
future.

p. 38–43
Latent Images, 1997–2006
Photographic prints on aluminum,
Diasec, 47 × 58 cm, and 38 digital prints,
30 × 40 cm
Exhibition view, *Is There Anybody Out
There?*, Galerie Fabienne Leclerc/In Situ,
Paris, 2010, and details

Since the war years, when he was often
short on products, fixatives, or paper,
Abdallah Farah stopped developing his
films, being content with simply taking
pictures. The rolls piled up; he felt no
need to reveal them. For years, although
the situation improved, he continued
to do the same thing. Even if he did
not develop the rolls, he nevertheless
documented each photograph he took
in small notebooks. He described it
minutely. His pictures can therefore be
read, giving free rein to the reader's
imagination. Displayed as contact sheets,
the rolls of latent films form a personal
diary and a photographic investigation
into the history of contemporary Lebanon,
relaying transformations in the city, the
photographer's mixed feelings of enthu-
siasm and disenchantment, and his
lost love—but also the important political
changes of those years. Perpetuating
the photographic act, but subtracting
the result of the flow of consumption,
the work is symptomatic of a new
relationship with the image and raises
questions about the conditions under
which such imagery might be revealed.
At what moment will the latent images
be developed and subjected to light?

p. 44
Rounds (*Barmeh*), 2001
Video, fiction, 7 minutes

A strange driver filmed steering through
the streets of the city. Beirut is mention-
ed, evoked through the driver's stories
and through sound, but never seen.
Invisible in overexposed whiteness,
Beirut escapes definition. Like his circular
driving, the stories of the driver spin in
a circle. He seems to be a ghost, insepa-
rable from his car, haunting the streets
of a city where a reconstruction project
is in progress in this strange postwar
period.

Produced by France 3 (France)
 and Future TV (Lebanon)
With Rabih Mroué
Image: Ahmad al Jardali and
 Khalil Joreige
Editing: Nada Abdallah
Premiere: Les journées cinématogra-
 phiques de Beyrouth

p. 45
Always With You, 2001–2008
Video, 6 minutes

The video shows the poster campaign
during the 2000 parliamentary elections
in Beirut, and its invasion of the urban
scenery. Slogans such as "Always with
you," "For your eyes," "I'm not lonely,
you're with me," have a sentimental
connotation that is rather unusual in an
electoral campaign. The accumulation
and saturation of images lead to a form
of disappearance. Little by little, these
innumerable posters are superimposed,
blend, and merge with each other.

p. 46–49
Distracted Bullets, 2003–2005
Symptomatic video, 15 minutes

"Distracted bullets" is a literal translation of the Arabic term "Rassassa taycheh," i.e. "stray bullet." Beirut is aflame with the fires of victory. The sounds of the fireworks and firearms, their quality, their orientation, make it possible to establish the topography of the town and its divisions: the parts of the town which joyfully celebrate and those which remain silent in the face of that same event. Where do all those firearms come from?

In 1994, military men turned in their heavy and light armaments, and were authorized to keep one firearm in exchange for another they relinquished. On some occasions, the firearms appear, are used, and then put away until the next time. Watching Beirut on fire, one wonders how many people who were happy to survive the war became the victims of stray bullets during the various festivities? This is impossible to determine, as there are no official traces of these victims. Why don't these parallel events appear in the archives of History? How and why does an event become a document? How to keep track of these stories kept secret?

p. 58
Any Recognition Would Be Purely Fortuitous, 2005–2011
Digital print on photographic paper, 150 × 260 cm

Originally this image was an illustration for a notice of disappearance that was prepared for the feature film *A Perfect Day*. This reconstruction of a facsimile to be used in a fiction had repercussions in real life, becoming even an exhibit in criminal proceedings. This story developed in the performance *Aïda, Save Me!*

The image published in the reconstitution of the newspaper was blown up until the screen could be seen. Then extracts from censored films created strips used to hide the eyes, forming a mask that prevents recognition of the person and at the same time reveals the impossible images.

p. 61
Aïda, Save Me!, 2009
Performance-lecture, 60 minutes
Coproduction: Les Halles de Schaerbeek, Chantier Temps d'images

In April 2006, during the premiere of *A Perfect Day*, an extraordinary incident, "unbelievable but true," was to disrupt the film's release and resonate strangely with the work of the artists. A series of disappearances followed. This story measures the distance between recognition and representation of oneself, and recounts this adventure whereby fiction has, all of a sudden, taken the appearance of a document.

p. 65–67
Lasting Images, 2003
Video installation, variable dimensions, 3 minutes

On August 19, 1985, Khalil Joreige's uncle, Alfred Junior Kettaneh, was kidnapped during the Lebanese Civil War. He is still officially reported missing today, like 17,000 other Lebanese. In March 2001, the artists stumbled across the archives, photographs, and films that once belonged to Khalil's uncle. Among his things they found one "latent" film, a super-8 film still undeveloped. It had been stored in a yellow bag for 15 years, surviving the ravages of the war and a fire that devastated the house where it was kept. They considered for a long time whether or not to send the film

to be developed; whether or not to take the risk that these latent images might reveal nothing. After much hesitation they decided to send it to the lab. The film came out veiled, white, with a barely visible presence that vanished immediately from the screen. The artists searched within the layers of the film itself, attempting to create the reappearance of a presence, of images. After much work on color correction, an image appeared through the whiteness, an image is still there, a lasting image that refuses to disappear. A shadow, a hand can be seen, a boat, the port of Beirut, the roof of a house, a group of three people, soon joined by a fourth … A lasting image evoking the impossible mourning of wars of which memories are denied.

p. 68–69
180 Seconds of Lasting Images, 2006
Lambda photo print on paper, wood, Velcro strip, 408 × 268 cm, 4,500 photograms, 4 × 6 cm each

The work derives from the video installation *Lasting Images*. The artists printed all the images of the super-8 film. Each photogram is treated as a separate entity, cut out and placed on a spiral forming a mosaic of 4,500 vignettes. Each photogram is stuck on a Velcro strip, and seems to quiver as if the images were coming back, giving the work a quality of extreme fragility.

At first sight, the work appears to be a white abstract painting with some purple hues. The picture develops and reveals itself all at once in a temporality different from that of the film, allowing each viewer to grasp the images at their own rhythm, seeing through the opalescence, the sign of a presence, traces of the past.

p. 70–71
Ashes (Ramad), 2003
35 mm film, fiction, 26 minutes

Nabil returns to Beirut with the ashes of his father who died abroad. He tries to overcome his bereavement while his family insists on respecting rites and customs by burying a non–existent corpse …

Produced by Mille et Une Productions (France) and Abbout Productions (Lebanon)
With Rabih Mroué, Nada Haddad, Ali Cherri, Nadine Labaki
Image: Jeanne Lapoirie
Editing: Tina Baz Le Gal
Sound: Chadi Roukoz, Raphael Sohier, Emmanuel Croset
Premiere: Locarno International film Festival

p. 72–73
A Perfect Day (Yawmon Akhar), 2005
35 mm film, fiction, 88 minutes

Stuck in a traffic jam, Malek catches a fleeting glance of the beautiful Zeina, the woman he loves. Tapping text messages into his mobile phone he desperately tries to get through to her, but she no longer wants to see him. She vanishes into the throng of midday Beirut traffic. Suffering from a syndrome of apnea that interrupts his breathing during sleep, whenever he stops moving he dozes off, adding to his disorientation. His mother Claudia has still not accepted his father's disappearance after 15 years. She stays at home just in case her husband should return; Malek drives around the city alone in his car. Each of them is trying to live with a void of lost love. But today may be the "perfect day " to lay their ghosts to rest. Malek is taking his hesitant mother to declare her husband officially dead

in the "absence of a body." And that evening, in a trendy nightclub where the young of Beirut go to dance and forget their troubles, Zeina looks ready to give Malek a second shot at the love he so yearns for.

Produced by Mille et une Productions (France), Abbout Productions (Lebanon), and Twenty Twenty Vision (Germany)
With Ziad Saad, Julia Kassar, Alexandra Kahwaji, Rabih Mroué
Image: Jeanne Lapoirie
Editing: Tina Baz Le Gal
Sound: Guillaume Le Braz, Sylvain Malbrant, Olivier Goinard
Premiere: Locarno International Film Festival (Fipresci and Don Quijote Award)

p. 74–75
Open the Door, Please, 2006
35 mm short film, fiction, 11 minutes
Part of the *Childhoods* series, 80 minutes

At the age of 12, Jacques is more than six feet tall while his friends are 12 to 15 inches shorter. This morning, the traditional class photograph is being taken. The photographer tries to create a harmonious and symmetrical frame, according to the "rules of art." But how can Jacques be integrated in the same frame as the others?

Produced by Tara Films (France) and Arte TV
With Maxime Juravliov, Bernard Lapene, Gilbert Traina
Image: Benoit Chamaillard
Editing: Tina Baz Le Gal
Sound: Lionel Garbarini, Simon Poupard, Stéphane de Rocquiny
Premiere: Paris Cinéma

p. 76
Khiam, 2000
Documentary, 52 minutes

How can one survive in the detention camp of Khiam in South Lebanon? Six detainees describe how to live, sleep, dream, and think between the four walls of a cell for 6 or 10 years. Deprived of basic necessities and forbidden to communicate, they managed to disobey and to secretly create a needle, a pencil, flowers, a chess game. Through the testimony of the six freed detainees, the film is a kind of experimentation on the narrative, on the way the image, through speech, can be built progressively on the principle of latency and evocation. Rather than a political condemnation this document, filmed with a certain urgency before the end of the Israeli occupation and the dismantling of the camp, attempts a metaphysical reflection on man's willpower and wish to live.

Produced by Abbout Productions (Lebanon).
With Rajaé Abou Hamain, Kifah Afifé, Sonia Baydoun, Soha Béchara, Afif Hammoud, Neeman Nasrallah
Image: Joana Hadjithomas and Khalil Joreige
Editing: Michèle Tyan
Sound: Rana Eid
Premiere: FIPA

p. 77
Khiam 2000–2007, 2008
Documentary, 103 minutes

In May 2000, when the camp of Khiam was dismantled, it was possible to go to Khiam. The camp was later turn into a museum. During the July 2006 war, the Khiam camp was totally destroyed by Israeli raids. There is some talk of rebuilding it exactly as it had been.

Eight years later, the artists met again with the six prisoners they had filmed in 1999 to recall and discuss with them the liberation and subsequent destruction of the camp, memories, history, reconstitution, and the power of the image.

Khiam 2000–2007 is both a film and an installation. The installation is made up of two screens put up side by side. *Khiam* (2000) is shown on the first screen. *Khiam 2000–2007* can be seen on the second screen.

Produced by Abbout Productions
 (Lebanon)
With Rajaé Abou Hamain, Kifah Afifé,
 Sonia Baydoun, Soha Béchara,
 Afif Hammoud, Neeman Nasrallah
Image: Joana Hadjithomas and
 Khalil Joreige
Editing: Michèle Tyan and Tina Baz Le Gal
Sound: Rana Eid, Sylvain Malbrant
Premiere: FID Marseille (Georges
 de Beauregard Award)

p. 78–81
Landscapes of Khiam, 2007
14 photographic prints, 120 × 90 cm
View of the exhibition *Où sommes-nous?*,
Espace Topographie de l'Art, Festival
d'Automne à Paris, 2007

The *Landscapes of Khiam* were taken over the period of a year in the Khiam camp, which was totally destroyed after the war of July 2006. In the middle of the ruins rise steel boards bearing photographs of the camp before it was razed, thus transforming it once more into a museum. The artists photographed the 14 existing boards from the same distance, using the same setup through the four seasons of the year. Set side by side, the boards as photographed recreate the topography of the camp. But strangely, the posters on the boards do not give a general view of the camp,

and give practically no information about the destroyed sites. They simply illustrate details of little significance that distort the idea of before/after. The extraordinary staging of that same destruction resembles an artistic installation but without an artist. This setup creates a temporal confusion and challenges our position as viewers, our relation to the image, to its mise en abyme. How can History or memory be related to if, whenever faced with the past, another image is superimposed on the ruins of an image, one temporality on another, one reality on another.

p. 82–83
War Trophies, 2007
Photographic prints on Baryté paper,
30 × 40 cm

The *War Trophies* show, according to a precise photographic setup, military vehicles that were used during various wars and repeatedly destroyed. In 2000, for example, they were destroyed because of their function; the second time, during the 2006 war as they were exhibited at the museum of Khiam, because of their symbolism or, perhaps, as collateral damages. They seem to be denouncing the use they have been put to and, photographed from the same frontal setup with particular attention to the depth of field, they appear anachronic and pathetic. Producing a strange feeling of being out of touch with reality, they become symptomatic. They also cause a temporal shift: they are the indicators of a former war, the witnesses of a new one.

p. 84–87
Ansar Recto Verso, 2009
Photographic and video installation,
dimensions variable
p. 84: installation view, Tels des oasis
dans le désert, Église des Célestins,
Festival d'Avignon, 2009
p. 85: Super-8 film, 3 minutes
p. 86–87: Photographic composition,
15 × 300 cm

During the Israeli occupation of the South Lebanon, several camps were used to detain thousands of Lebanese and Palestinians. One of them was Ansar, which was opened in 1982 and closed in 1985. The Khiam camp succeeded it. In *Khiam 2000–2007*, several former detainees evoke the Ansar camp. On the question of how a trace can be kept of the destroyed Khiam camp, they remark that there is practically nothing left of Ansar, which was a camp of tents. Now, on the site of the former camp, there is a restaurant, an amusement park, a soccer field, a swimming pool for women, and even a zoo. There is nothing to the left or to the right of these limits, as if these places were established strictly on the site of the former camp. Behind this facade is Boy Scout's camp, its tents in the middle of the still-visible traces of the Israeli army. Filmed in 2008 using film stock that expired in 1985, the images are strange, and blur the notions of document and the temporality implementation, creating bizarre gaps.

p. 89–93
Faces, 2009
47 photographic prints with drawing,
35 × 50 cm

Since the beginning of the civil wars, posters have covered the walls of the city. They are images of men who died tragically, while fighting or on mission

or who were political figures and were murdered. In Lebanon they are called "martyrs." For years, the artists have been photographing the posters of martyrs belonging to different parties, religions, or creeds, in various regions of the country, from south to north. However, they only select posters greatly deteriorated by time. Hung high, often in places that are difficult to reach, the posters remain there; the features, the names have disappeared, but the rounded shape of a face, a barely perceptible silhouette hardly recognizable, remain. The artists photographed those images at various stages of their progressive disappearance. Then, with the help of a graphic designer and various illustrators, they attempted to recover certain features. The drawings were made on the basis of study, attempting to retain a relation to reality, or on the basis of a sketch, referring more to a feeling or an impression in an attempt to bring back, through the drawing, the image, a face, a trace, matter, a lasting image. But can the image come back? Is the image up to the promise it carries?

p. 94–96
Je veux voir (*I Want to See*), 2008
35 mm film, fiction, 75 minutes

July 2006. War breaks out between Israel and Lebanon. The filmmakers no longer know what to write, what stories to recount, what images to show. They ask themselves: "What can cinema do?" They decide to ask that question with the help of an "icon," an actress who, to them, symbolizes cinema, Catherine Deneuve, and with their friend and the actor from several of their films, the artist and performer Rabih Mroué. Together, they drive through the regions devastated by the conflict. Through their presence, their meeting, they hope to find what

their eyes no longer perceive. It is the beginning of an unpredictable, unexpected adventure …

Produced by Mille et Une Productions (France), Abbout Productions (Lebanon), and Tony Arnoux
With Catherine Deneuve, Rabih Mroué
Image: Julien Hirsch
Editing: Enrica Gattolini and Tina Baz Le Gal
Sound: Guillaume Le Braz, Sylvain Malbrant, Emmanuel Croset
Premiere: Festival de Cannes, Un Certain Regard section

p. 113–131
The Lebanese Rocket Society, 2011–2013

The project includes a documentary feature film, *The Lebanese Rocket Society, The Strange Tale of The Lebanese Space Race*, and a series of installations. It tells the story of a group of students from the Armenian Haigazian University of Beirut, led by a professor of mathematics, Manoug Manougian, who, in the early 1960s, launched, with success, the first rocket in the region. Between 1960 and 1967, more than ten rockets, bearing the name Cedar, were designed, produced, and launched, each performing better than the last and rising to more than 600 km as time went by. This project, which aimed at "designing and launching rockets for space study and exploration" was very popular at the time and made the front pages of the newspapers. In 1964, a series of stamps reproducing the Cedar IV rocket was issued. The space project was brutally interrupted in 1967, after Israel defeated the Arab armies, and its story was totally forgotten. The documents, photographs, and especially the films concerning the project practically disappeared from Lebanon, and mainly from our

imagination. The film and the installations deal with our perception of past and present as well as the very notions of the imaginary, but also highlight the great historic events and the mythologies of those years: Pan-Arabism and its decline after the defeat of 1967, as well as the Cold War, the space conquest, the great revolutionary ideas, and the yearning for modernity and contemporaneousness.

This tribute to dreamers attempts to recall this forgotten space adventure and, to avoid the temptation of nostalgia, tries to reactivate it in present times, by giving a physical and material dimension to absence in order to enlarge the territory of art and cinema, to fight the dominant imagination, and the one we have of ourselves. It is also a manner of narrating stories kept secret, which perforate History and illustrate the faith and the hope of those times and the notion of a collective dream. Film, documents, and archives, as well as art installations, attempt to question this story and explore the ideas of reenactment, reconstitution, and restage.

p. 113–117
The President's Album, 2011
32 digital prints, 800 × 120 cm each
Co-production: 10th Sharjah Biennial, 2011

The President's Album is a photo-installation consisting of 32 identical 8-meter-long photographs, folded into 32 parts. Each photograph presents a different fold to the viewer, and as a whole the installation displays the entirety of the image. Each segment is a composition of two images. The first is an image taken from the 32-page Lebanese Rocket Society photo album that documented the Cedar IV rocket's launch, and that was offered to the

then-President of Lebanon, Fouad Chehab. The second is a part of an image of the Cedar IV rocket reproduction installed at Hagazian University, but painted in its original Lebanese flag colors. Each strip represents only a small fragment of the rocket but, potentially, the whole image is there, hidden in the folds. The album unveils itself, the rocket is seen in pieces, just like the memory of this adventure. The album was returned to General Youssef Wehbé after the death of President Chehab 55 years ago. It has always been in private hands and no one has ever seen it since. This historic document served as a basis for the construction of the sculpture reproducing Cedar IV. *The President's Album* posits the image, its fragmentation, reconstitution, and recognition as a tool for understanding this history. In each part lies the reminder that while the visible fold represents only a fragment of the rocket, the whole image, and its forgotten history, is potentially there, hidden. It needs only to be unfurled to re-emerge.

p. 118–119
Cedar IV: A Reconstitution, 2011
Steel and corian, 800 × 120 × 100 cm
Co-production: 10th Sharjah Biennial, 2011

Produced in 1963, the Cedar IV rocket was one of the most impressive developments by the Lebanese Rocket Society. It ultimately traveled a distance of 600 km and reached a height of 180 km; it is symbolic of the adventure and appeared on the set of stamps issued to commemorate the 1964 Independence Day in Lebanon. *Cedar IV: A Reconstitution* is a scale reproduction of the rocket, over 8-meters long, differing from the original in its white color only. It traversed the streets of Beirut to arrive at Hagazian University where it all began and where

the artists installed it permanently. It conjures the temporal distance between the rocket seen as a scientific research, and how collective imagination perceives it today, as an evocation of missiles. It is only within the territory of the university and museum that the rocket is recognized for what it is, an artistic and scientific project. The sculpture exhibited in the public space of the university is a reminder of a historical moment and becomes a place of sharing, of meeting, of evocation and questioning: a strange "monument," a tribute to dreamers.

p. 120–121
The Golden Record, 2011
Video and sound installation, 19 minutes, and digital print
Co-production: 11th Lyon Biennial, 2011

Upon their launch, it was said that the Cedar rockets transmitted the message "Long Live Lebanon" to be broadcast on the national radio from a device installed in the rocket heads. On the other hand, a few years later, American space exploration missions such as Phoenix and mainly Voyager 1 and 2 (in 1977) transmitted messages engraved on golden records, and addressed to potential extraterrestrials. These records broadcast sounds selected "to represent the diversity of life, history, and culture on earth" as a message of peace and liberty. *The Golden Record* presents the artists' own version, engraved with a repertoire based on archival sound material dating from the 1960s and prompted by the memories of various Lebanese scientists who took part in Lebanon's space adventure. Similar to a time capsule, it enables us to discover a portrait and a sound representation of Beirut and of the world in the 1960s.

p. 122–125
Restaged, 2012
9 C-prints, 100 × 72 cm each

The photographs represent the reenactment of the transport of the Cedar IV rocket through the streets of Beirut, going back to the act itself without resorting to digital software. Using a white wood silhouette of the sculpture reproduced in two dimensions and using the same system to cross the center of the city, the idea is to replay what was replayed, to once again find the trace of a trace. The speed of the rocket's passage captures ephemeral traces of strange apparitions in the city.

p. 126–127
A Carpet, 2012
Handmade rug, 555 × 285 cm
Co-production: Marseille Provence 2013

During the 1920s, young Armenian girls, most of whom were survivors of the Armenian Genocide of 1915, produced magnificent carpets at an orphanage workshop in Lebanon. More than 3,400 carpets were produced. One of the largest carpets that these girls wove was offered to the White House as a token of gratitude for American support of their workshop. The carpet measures 5.5 by 3 meters in size and represents the creation of the world, with an inscription at the back: "the golden rule of gratitude."

After initially being displayed in the White House, in the Blue Room, under the Coolidge administration, the carpet is now, for various reasons, rarely shown; few people are aware of its existence. The Lebanese Rocket Society was born in an Armenian university where many students were the children of these orphans. Produced by the artists in Armenia in the same dimensions of the rug offered to the White House,

A Carpet bears the image of the national Cedar IV rocket stamp issued in 1964 in celebration of the program. Presented in the exhibition alongside the rug are documents relating to the original carpet's history. *A Carpet* is an evocation of these two stories, or two generations, representing the ability of a group to persist, aspire, and dream, a hymn to life in spite of everything, a token of gratitude.

p. 128–131
The Lebanese Rocket Society: The Strange Tale of the Lebanese Space Race, 2012
Documentary film, 95 minutes

The film tells the story of the *Lebanese Rocket Society* through various testimonies by the protagonists, archives, pictures and film, and through the way both directors choose to escape from nostalgia and to activate this story from the past in the present and the future.

Produced by Mille et Une Productions
 (France), Abbout Productions
 (Lebanon)
With Manoug Manougian, Youssef
 Wehbe, John Markarian, Joseph
 Sfeir …
Image: Jeanne Lapoirie, Rachel Aoun
Editing: Tina Baz Le Gal
Sound: Chadi Roukoz, Rana Eid,
 Olivier Goinard
Premiere: Toronto International
 Film Festival

p. 133–136
A Letter Can Always Reach Its Destination, 2012
Double projection with hologram, 122-minute loop, dimensions variable
In collaboration with Keeward, Cyril Hadji-Thomas, and Benjamin Bellamy; choice of texts and publication with Franck Leibovici

For over a decade the artists have been collecting spam and scam emails instead of relegating them automatically to the trash. These unsolicited emails are particularly effective: several million dollars are transferred every year, the victims believing in the promises of these scams. They prey on empathy for donations of money, or promise easy riches. Pretending to be sent often from countries where corruption is rife and tainted with a neocolonialist vision, these emails are stories and documents rooted within specific historical and geopolitical moments, as a mapping of the history of the last few years. As such these narratives of fraud can be read as imageless representations of our time, told by characters who constitute a fictive presence, but who are ultimately real people doing the sending. The installation tries to articulate an imaginary embodiment of these emails that clutter our inboxes on a daily basis. The textual source material of selected spam and scam are transformed into visual narratives, image representations that become pieces of fiction in themselves, and demand the viewer's suspension of disbelief. Working with non-professional actors, the emails have been transformed into scenarios for monologues; stories that become captivating, or even moving because they are told by what seems to be a "real" person. Nevertheless, the absent presence and complex layering of technological communication is echoed in the display where one projection is ephemerally superimposed on the other, creating a ghostlike sensibility where the virtual and physical meet.

The installation is a double projection: on the one hand, a slow stream of various people, like a choir in which each waits for their cue to begin acting and narrate their story. On the other, each person appears on a "holographic"

screen on a human scale and addresses the viewer, a fleeting presence soon followed by another incarnation.

p. 144
Histoire du vent, 2010
2 films of 84 minutes each synchronized and screened on the two sides of a slide, 280 × 150 cm
Public commission by the Centre national des arts plastiques

Conceived in response to an invitation from the Festival d'Avignon, this installation takes into consideration the history of a festival that maintains a particular relationship with trace and memory. How can this history be taken into account? The mistral, which often blows during performances in the courtyard of the Palais des Papes, offers a clue. The wind is a form of metaphor of the live spectacle; as soon as it is captured it disappears. The presence of the wind alters shows, magnifying them or destroying them, but leaving a lasting trace in the minds of the spectators. The wind is like a double echo: at the theatrical presentation in Avignon with its particularities, to the challenges of the writing of a history of live performance.

The installation regroups the testimonies of certain actors in this history of wind and archival images of performances at which the wind was present. The images are digitally reworked and put back into the courtyard of the Palais des Papes like a passing breath, a transcendent or critical relation, a trace of history.

p. 145
Latent Images—Diary of a Photographer,
2009, Editions Rosascape, Paris

This artists' book gathers together a
selection of 38 contact sheets of those
latent images taken by Abdallah Farah
from 1997 to 2006 proposing a possible
narrative. This artists' book is the point
of departure for several performances
(Fondation d'entreprise Ricard, Khiasma,
Meeting Point, KVS) in which it has
been read by several actors, among
others Geoffrey Carey, Laurence Mayor,
Françoise Lebrun, Frédéric Fisbach,
Mireille Kassar, Etel Adnan, and
Franck Leibovici.

p. 146
Faces, 2009
Exhibition view, *Je suis là même si tu
ne vois pas*, Galerie Leonard & Bina Ellen
Art, Concordia University, Montreal,
Canada, 2009

Faces, 2009
Exhibition view, *Like Oases in the Desert*,
Église des Célestins, Festival d'Avignon,
2009

The Circle of Confusion, 1997, and
A History of the Circle of Confusion,
2009
Exhibition view, *Tel des oasis
dans le désert*, Église des Célestins,
Festival d'Avignon, 2009

Wonder Beirut and *Lasting Images*,
1997–2006
Exhibition view, *Wonder Beirut*, Centre
de la photographie, Geneva, 2009

Exhibition view, *How Soon Is Now: A
Tribute To Dreamers*, Beirut Exhibition
Center, Beirut, 2012

Restaged, 2012
Exhibition view, *Lebanese Rocket Society,
Parts III, IV, & V*, The Third Line, Dubai

Installation of the sculpture *The Lebanese
Rocket Society: A Reconstitution* in front
of the Sharjah Art Museum, 10th Sharjah
Biennial, 2011

PUBLIC COLLECTIONS

Abraaj Capital Art Prize, United
 Arab Emirates
Barjeel Art Foundation, United
 Arab Emirates
British Museum, London
Fond national d'art contemporain,
 Paris-La Défense
Fond régional d'art contemporain
 Bretagne, Rennes
Fond régional d'art contemporain
 Lorraine, Metz
Guggenheim Museum, New York
Khalid Shoman Foundation, Amman
Musée de Mariemont, Morlanwelz
 (Belgium)
Museo Reina Sofia, Madrid
Musée d'Art moderne de la Ville de Paris,
 Paris
Musée national d'Art moderne,
 Centre Pompidou, Paris
Sharjah Art Foundation, United
 Arab Emirates
Victoria & Albert Museum, London

EDITORIAL
Clément Dirié and Michèle Thériault

TEXTS
Suzanne Cotter, Jean-Michel Frodon,
and Dominique Abensour, Etel Adnan,
Rabih Mroué, Jacques Rancière,
Michèle Thériault, Jalal Toufic,
Anton Vidokle

TRANSLATION FROM THE FRENCH
Judith Hayward for Jean-Michel Frodon's
text, the Conversation and the Chronology

DESIGN
Nicolas Eigenheer, Vera Kaspar

TYPEFACE
Univers

DUST JACKET
Historical Process, "The Battle of the Hotels,"
number 3, photographic print on aluminum,
Diasec, 30 × 180 cm, from The Story of a
Pyromaniac Photographer, Wonder Beirut,
1997–2006

PHOTO CREDITS
Nadim Asfar, Marc Domage,
Rebecca Fanuele, Joana Hadjithomas,
Anne Haenie-Cousse, Ghassan Halwani,
Khalil Joreige, Asaad Jradi,
Hagop Kamledjian, Jeroen Kramer,
Harry Kundakjian, Dorine Potel,
Alfredo Rubio, Édouard Tamerian,
Patrick Zwirc, and the Arab Image
Foundation.

COLOR SEPARATION & PRINT
Musumeci S.P.A., Quart (Aosta)

ISBN : 978-3-03764-240-5

A French edition is available:
978-3-03764-294-8

This publication received the support of
Centre national des Arts Plastiques
(French Ministry of Culture and
Communication), as well as of the
following partners:

Galerie In Situ/Fabienne Leclerc
6, rue du Pont-de-Lodi,
75006 Paris, France
www.insituparis.fr

CRG Gallery
548 W 22nd St,
NY 10011, New York, United States
www.crggallery.com

The Third Line Gallery
Al Quoz 3, PO Box
72036 Dubai, United Arab Emirates
www.thethirdline.com

ACKNOWLEDGMENTS
Joana Hadjithomas and Khalil Joreige thank
the editors, the partners, and the contribu-
tors to this book. They thank all those who
have helped them, supported them, accom-
panied them, and stimulated them over the
years. They thank those who were, those
who are, and those who will be.

PUBLISHED BY

JRP|Ringier
Limmatstrasse 270
CH–8005 Zurich
T +41 (0) 43 311 27 50
F +41 (0) 43 311 27 51
E info@jrp-ringier.com
www.jrp-ringier.com

IN COLLABORATION WITH

galerie leonard
& bina
ellen
art gallery

Leonard & Bina Ellen Art Gallery
Concordia University, Montreal
1455, boulevard de Maisonneuve O
Montréal H3G 1M8, Canada
www.ellengallery.concordia.ca

JRP|Ringier books are available internation-
ally at selected bookstores and from the
following distribution partners:

Switzerland
AVA Verlagsauslieferung AG
Centralweg 16, CH–8910 Affoltern a.A.
verlagsservice@ava.ch, www.ava.ch

France
Les presses du réel
35 rue Colson, F–21000 Dijon
info@lespressesdureel.com
www.lespressesdureel.com

Germany and Austria
Vice Versa Distribution
Immanuelkirchstrasse 12, D–10405 Berlin
info@vice-versa-distribution.com
www.vice-versa-distribution.com

UK and other European countries
Cornerhouse Publications
70 Oxford Street, UK–Manchester M1 5NH
publications@cornerhouse.org
www.cornerhouse.org/books

USA, Canada, Asia, and Australia
ARTBOOK|D.A.P.
155 Sixth Avenue, 2nd Floor
USA–New York, NY 10013
dap@dapinc.com, www.artbook.com

For a list of our partner bookshops or for
any general questions, please contact
JRP|Ringier directly at info@jrp-ringier.com,
or visit our homepage www.jrp-ringier.com
for further information about our program.